ABOUT THE AUTHOR

"ROB THE BOUNCER" is ROB FITZGERALD, the author of the popular Clublife blog. He lives on Long Island, New York.

standingonthebox.blogspot.com

CLUB LIFE

ROB THE BOUNCER

ENTERTAINMENT

An Imprint of HarperCollinsPublishers

CLUBLIFE

THUGS, DRUGS,

AND CHAOS

AT NEW YORK

CITY'S PREMIER

NIGHTCLUBS

TO MY MOTHER, WHO WILL READ THIS
AND REMAIN DISAPPOINTED, AND TO THE
MEN WHO WORK THE DOORS

HARPER ENTERTAINMENT

A hardcover edition of this book was published in 2007 by HarperEntertainment, an imprint of HarperCollins Publishers.

FIRST HARPER PAPERBACK PUBLISHED 2008.

Designed by Chris Welch

Library of Congress Cataloging-in-Publication Data has been applied for.

ISBN 978-0-06-112389-4

08 09 10 11 12 DT/RRD 10 9 8 7 6 5 4 3 2 1

CONTENTS

AUTHOR'S NOTE

Clublife is a memoir of my experiences as a bouncer in New York's West Chelsea club scene over the past three years. Certain people, places, and incidents in this book are composites—combinations of actual people, places, and incidents that I encountered in several of the clubs that I worked in. "Axis" is not an actual club, but rather an amalgam of my experiences and observations in clubs. I have changed all names to protect the identities of both the innocent and the guilty.

SEEDS

The troubles, such as they are, begin with their eyebrows. When I started doing this—this bouncing shit—it was the eyebrows I noticed first. The way I was raised, a man wouldn't touch his eyebrows unless he needed surgery and one of them stood in the way of the scalpel. The shaping of the eyebrows is a trap. It's a ruse. A man, if he wants to be thought of as a man, should take pains to avoid falling victim to the shaping-of-the-eyebrows fallacy. A timely pluck with tweezers is acceptable now and again, when stray pieces begin springing out with age. Basic maintenance draws no notice.

Club customers wax their eyebrows. They shave them and they have little Indian women tie their edges and yank them. I came to find out, involuntarily, that this process is called "threading." The shaping and threading of the eyebrows become a problem, because they lead to disagreements with bouncers. Those finely sculpted points on the brow-ends in question are bound to bog us down somehow. They'll bring us to sidewalk impasse—a Mexican standoff on a Saturday night in Lower Manhattan, my ability to see your side of things swept away by the absurdity of what you've done to the fur atop your precious sight-organs.

It started my first night, with the eyebrows, and it's something I still can't get past. I won't ever get past it, I think. It's too much to digest for a guy who considers shaving a major hygienic sacrifice. Do this business to yourself—I've heard the Staten Island Mall does fine work, incidentally—and our points of view will have diverged to such an extent that should we somehow find ourselves *in situation,* I'll need you gone from my presence as quickly as I can wrench you and your manicured ass-coiffure out the door.

If you've never been to a nightclub in Manhattan, it's possible you wouldn't know such things as waxing and threading exist. You could *say* they exist, and claim to understand the *concept* of their existence, but you simply wouldn't know. You wouldn't know about any of it, in fact—the myriad absurdities taking place on any given night in Gotham. You can live out a contented, ful-filling life in a trailer park somewhere on the outskirts of Junction City, Kansas, and the things that happen in New York's nightclub-riddled West Chelsea and Meatpacking districts won't fuck with your existence in any way.

You can head out the front door of the double-wide, down the plywood gangplank, start up the Buick, drive on down to the local convenience store, and pick yourself up a case of Budweiser and a bag of Doritos. Throw in some dip while you're at it. Sour cream and onion meshes best with nacho cheese and a hint of re-peating cheap beer. Come on back home, fire up the satellite dish, plant your ass on the couch, and you've got the whole world at your fingertips and nobody grinding their ass into your nuts un-less you've invited them to.

Maybe at some point during all the fun you're bound to have, you push open the screen door and mosey outside for a cigarette. You smoke out there because you don't want the tobacco smell lingering in the curtains and because it's quiet. There's nothing in the air here on the threshold of the plain—just an endless parade of semis on the interstate and the occasional chain of Burlington Northern freight cars passing through the far side of downtown,

en route to places where the rest of the world isn't banished so readily.

You flick your cigarette into the drainage ditch that runs beside the road they paved last year, and you glance up at the stars. You take for granted how bright they are out here—and how many of them you can see when it's clear—but you don't know you're doing it because you've never been to a place where they can't be seen. You turn back and move inside, leaving the night out on the plain, never considering that those same stars—the ones I can't see from my spot on the sidewalk—are over my head tonight, too. And the world, from where I'm standing, sure as hell doesn't seem to be at *my* fingertips.

Three years ago, I stayed home and left the New York night outside my door, just like you. I went inside, turned the deadbolt, and kept it all at a comfortable distance. If you want to chase the quiet here, you can, even when you live in the middle of the city. Quiet, you see, is a relative term. If you don't want to find yourself in Chelsea at two in the morning, with your space and your sanity no longer yours to claim, nobody's going to force you to go. And if nobody ever forces you to go, and financial necessity doesn't bring you to that part of town looking for work, you won't ever need to know what it's like.

You're better off that way. Trust me on this.

Circumstances happen, though. You know a guy who knows a guy who knows a guy, and one morning you wake up and find out you're on the schedule at some club downtown, slated to stand on a box and play zookeeper for eight hours. That's what happened to me. I didn't know *it*—the "scene"—was there, either, so I went about my days and nights without ever knowing the depth and breadth of the Manhattan nightclub subculture that now seems to come to the surface every time I turn over a rock.

I don't know where the world keeps nightclub customers when they're not drinking and dancing, because I don't see people like them anywhere else but inside. Before I became a bouncer, I hadn't

seen people like that walking the streets, at least not in such over-whelming numbers. Originally, I thought maybe they all lived at the club, but now I'm sure they don't, because I see them all leave at the end of the night. Clearing the room at closing time—four A.M. here in New York—is part of my job, so if they really did live there, I'd know. They roll out of our doors by car, by cab, by train, and on foot. They don't all leave together, but they *do* eventually leave. Where they go is anyone's guess. They don't follow *me*.

None of that matters right now, though. What matters is get-ting from Point A to Point B. Point A is all that quiet shit I told you about earlier—the Doritos, the satellite dish, the cigarette, and the stars. That's the part I prefer. Point B is when you open your eyes in a room filled with three thousand drunken, sweaty, diseased, drug-addled dickheads, many of whom are threatening you, and all you want to do is close your eyes and think really hard about what went wrong to land you here.

I DIDN'T WANT to leave my apartment. I couldn't.

Kate made certain I knew this was the problem right before she moved out, leaving me handcuffed—with six months remaining on a lease I never wanted in my name in the first place—to a one-bedroom rat trap in the heart of warehouse Queens. Utilities were *not* included, but misanthropy was cultivated by the truckload.

"Why would I want to come out of the fucking house around here?" I asked at the beginning of what would be the final argu-ment of the unhealthiest relationship since Leo Tolstoy and Sophie Behrs. "So I can go outside and put up with people's bullshit and not get paid for it? I hate these fucking people around here. What the fuck's wrong with staying home?"

"What's wrong? What's *wrong*? I'll tell you what's wrong. What's wrong is that I'm unhappy. I've been unhappy for a long, long time, but you can't seem to notice because you're too busy being pissed off all the time."

Jesus, my back hurt. My entire body hurt. My shoulder twinged

simply from searching for the two remotes necessary to work the television. My main problem, as I saw it, was this unification that needed to happen. *Unifying my remotes.* "Is this about the lady in the supermarket? 'Cause if it is . . ."

"No! What's that got to do with anything?"

"Listen," I said, refusing to turn and face her. "I admit I was a little out of line for yelling at her like that, but was I wrong? What the fuck was she touching me for anyway? When you're in a public place, and people are trying to get through . . ."

"God, will you stop? Do you ever listen to yourself? You've turned into the most miserable human being I've ever been around. You have to fucking stop. I can't live with this shit anymore."

I think she would have called me misanthropic, if she'd known what the word meant. She would have taken the word, embraced it, and dropped it on my head like the leaden safe she wished would someday fly out someone's window and flatten me on the sidewalk. "There's nothing out there I wanna see," I insisted. "I'm fucking sorry if I want to sit around and relax after working all fucking day, but I'm tired, and I don't need any of that bullshit out there."

"Working?" she asked, standing over me for effect. She looked more drawn than usual, probably because she'd been planning this for a while. The blond hair she'd cut short against my wishes was stringy, the way I required it to hang whenever we argued. When she said things I didn't want to hear, I wanted her to be tired and *cheap* in my mind's eye, just like this. The last thing I needed here was a conscience, which was what I'd had in those moments when her hazel eyes—the ones I'd always preferred without makeup but never got to see that way—weren't as dull and lifeless as they were now. "You call that a job? Driving around all day in a truck delivering furniture with those people you scrape up every morning? That's what you call a *career*?"

"That's not work? Seems like work while I'm fucking doing it."

"No, it's not work. Not for you. It's treading water, and it's

beneath you and you know it. You're the smartest guy I've ever met, but you're too lazy to make people stop treating you like shit, and so you take it out on me. I can't deal with it anymore, you coming home and taking out all your bullshit on me. It's not fair."

"Lazy? *Lazy?* Are you fucking kidding me? I'd like to see you haul a fucking sofa bed up a flight of stairs. You know how heavy those things are?"

"No," she replied. "I don't, and that's my point. I don't *have* to know how heavy they are because unlike you, I'm not too lazy to handle my responsibilities."

"Again with fucking calling me lazy," I said, laboring to sit up so I could shout her down, as usual, and make this stop. My back was starting to spasm from her screeching. "You think my life is easy?"

"No," she replied softly. "I know it's not. But it's a hell of a lot easier to show up on time every morning to some brainless job and let yourself get abused than it is to stand up for yourself and see something through to its conclusion for once in your god-damned life."

"Awesome. Here we fucking go again."

"That's right. Here we go again. School, football, relationships, your family. All this stuff you're always saying you're gonna do, and nothing ever happens. Nothing ever gets done. Everything you've ever started, you've given up on. All you ever do is talk shit."

I shrugged. "I've got my reasons. And if you wanna sit and tell me all the shit I'm doing wrong, get in fucking line, because there's a shitload of people ahead of you, believe me."

"Oh, I know," she said. "Trust me, I know. But this is my life we're talking about here, and there's too much I want to do for me to allow you to make me your goddamned victim all the time. *That's* what this is about."

"That's not fair." I wished she'd go to the store. Or take a shower. Something. *Anything.*

"No, it's not fair. It's not fair what you do to me. I've wasted four years of my life waiting for you to come around, and I know it's not going to happen. I have to cut my losses here. Do you not understand that?"

"You can't blame me for making you stick around all that time," I said, venturing, as always, down the most inappropriate possible road. "It's not like I had you locked in the fucking closet this whole time. You've always had a choice."

"Yes, and because of asshole comments like that, I'm making my choice and getting the fuck out of here before I get any older. I mean, you just have *no* idea, do you? Do you have any idea how sad this makes me? Do you have any idea how much I see in you?"

"You're right," I said, and turned off the television. "You're just so fucking right."

"Yeah, you mean that."

SO THAT WAS that. Kate had a point, of course, every goddamned word of it ringing true, but I felt cheated. It meant something that she could actually screw up the courage to move out on me. She wouldn't yield to the learned helplessness I'd tried so hard to cultivate, and the message came through loud and clear: *there was still some life in her that I hadn't sucked out yet.*

The end of our relationship signified failure at the one thing in life I had always taken for granted: my ability to bleed people dry—emotionally, mentally, and physically. It hurt, because my capacity to do this wasn't something I had come by easily. You don't just wake up some random morning and decide it's time to emotionally cripple your loved ones. No, the ability to alienate has to be cultivated through years of burying your own ambitions in the basement, estranging yourself from your family and friends, and perfecting the art of heaping abuse on anyone foolish enough to think they can help you.

I had essentially left every task I'd ever undertaken in life unfinished, finding pleasure only in breaking down people like

Kate—someone who had her life together in all the areas I didn't. And when you're as good at it as I'd become, any remaining spark of resistance comes as a complete surprise.

Planning life-as-a-shithead takes time. It's not some haphazard process. I had to put a great deal of work into receiving my official shithead certification. To disappoint everyone, I needed them to expect something out of me in the first place. With promise to spare, and potential in spades, I aced every standardized test I ever took, did *just* well enough in school, and excelled at sports. I gave the establishment a little taste of something it could attach itself to, which is how you get the world to believe it should make an effort to guide you along the path. My parents, in turn, took the time to teach me enough social niceties to pass as a "good kid." People made the mistake of liking me.

Everything was a setup. From the way I presented myself to the things I'd say to keep people hanging around, the only way I knew how to live was to hustle the world every chance I had. Problem was, my particular hustles had no coherent structure. They weren't conceived with beneficial end results in mind—a lack of foresight that almost always left me sans payoff after cobbling together such intricately detailed mounds of bullshit.

Even in the very beginning, back as far as high school, my entire life was a painstakingly constructed scam to get people hooked so I could set the stage for the string of disappointments to follow. These orchestrated letdowns were works of master craftsmanship for someone so young, and my bullshit wouldn't become transparent enough for people to give up on me until well into my adulthood. I had refined the art of subtle disgrace at a tender age—never quite living up to the standards of those generous enough to apply their guidance, but never exactly reaching that critical fuck-up mass that would drive them away. And the dumb bastards never even knew it was happening.

Still, how did I get *here*? From slamming the door on life in the tranquility of my metaphorical trailer park to the midst of a teem-

ing dance floor in the heart of a city I'd grow to despise—yet have as the backdrop to countless masturbatory fantasies involving my alleged "future"—and then, when all is said and done, probably ending up back where I began?

The framework for my flameout was in place long before I ever attempted college, but once I decided to scrap the notion of higher education—or, for the purposes of accuracy, had it forcibly scrapped for me—the complexity of my plan grew in scale. I needed to target someone else, someone new, because all the people I screwed back in high school and college had caught on. Not even my family would take the bait anymore. When you've hit your mid-twenties without having done a damned thing to justify the space you're taking up, the world of authority no longer feels the need to take you under its wing. Nor, it should be pointed out, will you have the resources to convince it that it should.

What I needed to do then was adjust my aim, and there's no better target for the malevolent aims of a shiftless, ambitionless, twentysomething male than a vulnerable, attractive, twentysomething female.

The first thing you need to know is that certain professions are particularly rich target environments for the assaults of lifeblood-poachers like me. Nurses and teachers, especially—the helping professions. I had worked my way through dozens of both types over the years, eventually coming upon the lovely Kate, a pediatric nurse who worked in the intensive care unit of a major New York hospital. Kate was perfectly suited for my purposes—a boundless reserve of professionally trained compassion, caring, and humanity. What better abyss in which to squander all those wonderful attributes of hers than my sorry excuse for a "life"?

The process of hooking Kate, RN, worked in much the same way it did when I was running the disappointment game on the people who tried to help me as a kid. I fed her addiction to caring and helping, filtering in the negatives gradually—making them seem more manageable—and rigging things in my favor with line

upon line of utter bullshit: "It's not your fault," she'd say tenderly. *Sure it is, honey. You just don't know it yet.* "It's your family. You've had disadvantages, but everything's okay now. We can do this together. You're not alone anymore." *Yes, but you are, dear. You just don't know it yet.*

Kate listened when I told her I was "still" hanging on to ambitions that, in truth, I'd never had—grandiose ones that included a life with her as the centerpiece. I cooked up a giant list of dreams that I knew would never leave the safety of my roach-pit of an apartment. "I think about the future nonstop, baby," I'd say. "I'll go back to school, we'll get married, and then we'll get a great big house up on the North Shore and start having kids."

This is the nonsense you need to feed a girl when your objective is to keep her around for a while. When you're really trying to sink your tongue into their marrow, it's necessary to check in with this garbage every month or so in order to let them know the treatment's taking hold. They come across, they make their rounds, and when they assess your chart, the key is to get them thinking your vitals are improving across the board.

Mine weren't, and they never would. When Kate and I moved in together, she figured this out for herself. When you live day to day—paycheck to paycheck—it's virtually impossible to phony up thoughts of a sunshine-and-rainbow-filled future when all of it, at least for you, is completely delusional. When the things coming out of your mouth have no basis in reality, women notice, especially when the two of you are sleeping in the same bed every night. I had drawn Kate into my miasma, and she had predictably acted on her instincts and moved to offer me all the comfort she could, but I was on the clock after a while, and I knew it.

Still, when she finally opted to *choose life,* and told me she was breaking away, my failure to produce stung. It wasn't so much the heartache of losing her that did this, because I had been through this sort of thing before. With a dead-end life, this process becomes a repeating loop, and with each successive person who

bails out, the resultant sense of loss becomes increasingly dulled. You get used to it. Adopt the marrow-sucking lifestyle, and you're bound to lose people over and over again. No, it was the *failure to win* that would leave a scar.

"Where you gonna go? Back with your parents?"

"Don't worry about it," she snapped. She was tired of the exchange, and looked as though she wished I hadn't been home when she began packing. "Unlike you, I never fucked up my credit, and I'll go get my own place. I'll be fine."

"Wow," I said. "This sucks. I don't know how I'm gonna be able to afford to keep living here." I had already started calculating my rent increase, and things weren't looking promising.

Kate shook her head. "That's no surprise. You're *such* a fucking *asshole.*"

"What now?"

"You couldn't care less that *I'm* leaving. You're just pissed that half your rent check's moving out."

"You think this is fun for me?"

"No," she replied. "I know it's not, because I can already see the wheels turning in your fat fucking head. Forget about getting a roommate, because it'll never work."

"Why not?"

She was standing now, making a conspicuous show of her advantage. "Because you won't be able to live with anyone, ever, until you stop being so fucking miserable to people. Maybe you'll learn something from this, so the next girl who comes along won't have to go through the same shit I did. Forget getting a roommate, because you need to be here by yourself, wallowing in your own shit in the peace and solitude you're always yelling about. Now that I'm gone, you'll have as much as you want."

"That's such bullshit," I said weakly.

"No, it's not. It's not bullshit. Do yourself a favor and go get a second job so you can stay here and be miserable. Lord knows it'll make you happy to get that much closer to martyrdom."

What Kate had neglected to consider in all this was that it was never my intention to actually *be* a martyr. Martyrdom is painful, especially in a financial sense, so it's not exactly a condition I've ever wanted for myself. Giving off the *perception* of martyrdom, though—that's the stuff. The perception I could live with, so long as I didn't legitimately have to go through with the act of going down. Solvency has its charms, even for the mired and the stagnant.

"Go be a bouncer again. At least it'll get you out of the house."

2

BAR CAR

Fuck your life up for long enough, and you'll end up in a bar. Go off track, even just a little, from the conventional schedule of "things people want from you," and the next thing you know, you're there. Which side of the bar you're on is a matter of chance—or of timing, looks, or physical capability—but it seems to me that bars and clubs are where people tend to land when the *real world*—the one where people wake up early in the morning, wear suits to work, and come home and grill steaks—doesn't want them around.

I knew several people from my neighborhood who were in the bar business, and some of them had tried to convince me to become a bouncer for years. The concept of "knowing a guy who owns a place" comes with the territory when you're raised in a working-class Irish-Italian neighborhood in New York. We all know *a guy* who owns *a place*. And when I did actually suit up and work the door at a few local dive bars, the job turned out to be a perfect fit for what I had become after college—an outsized, angry kid who had a major bone to pick with society, without knowing exactly why.

For three years, during my early twenties, I worked at an Irish-

themed bar in Queens owned by Jim Hughes, a former neighbor who, rumor had it, had some connection to the Westies—New York's old-school Irish mob. When I was a kid, my mother would tell us Hughes made his living as a "shylock"—a loan shark—but she'd never tell us how she'd found that out. By the time I was hired to work at the eponymous Jim's, the place catered primarily to a crowd of local college kids, with a smattering of mid-twenties locals sprinkled in on busy nights. And, from what I could tell, no Westies in sight.

Hughes, who knew my history of screwing things up for myself, set strict ground rules for my employment at Jim's, and I followed them to the letter for all three years. I became what you might, if you're apt to liken bar work to war—which I'm not—call a *good soldier*. I showed up for work on time—a rarity in the bar business—never missed a shift, and, taking Jim's warnings seriously, wouldn't touch a drop of liquor during working hours. I'd remain in my assigned place no matter what, holding my bladder for hours, even when I desperately needed someone to come and spell me.

As a reward, of sorts, for showing that I actually gave a shit about the job, Jim Hughes taught me how to be a bouncer. "Don't stand there and listen to them," he'd say, his dark eyes blazing. "Either turn around and walk away, or put your hands right on 'em and get 'em the fuck out. You can't argue with these motherfuckers, 'cause you ain't ever gonna win."

Jim's became my bouncing laboratory. As much as I picked up from listening to Hughes, I learned significantly more just by keeping my eyes open and trying every approach to problem-solving that came to mind. With college kids, bouncers can improvise. There's margin for error, because nobody's looking to stab you—most of the time, at least—or put a bullet in your head because of some meaningless bar fight. The clientele at Jim's never took things seriously enough to hurt themselves. If something I tried didn't work out as planned, I'd walk away with my black eye or

my fat lip and approach things from a different angle the next time around.

Bouncing's like anything else—you learn it only by doing. I waded into situations, did what I thought I had to do, and absorbed everything I'd seen so I'd be able to handle things better when they happened again. Most of all, I figured out how to assert myself with everyone—even people I wouldn't ordinarily fuck with. I found that I could talk just about anybody out of anything—even people who wouldn't otherwise give me the time of day—because I was a bouncer. The title, along with the big, block-lettered STAFF sign across the back of my shirt, seemed to make people listen. When they didn't, all I needed to do was get behind them and choke them until they did. There's a ratio you eventually learn: the harder you work to obstruct a drunk's breathing, the wider their ears seem to open.

After two years of standing inside, Hughes decided he wanted me at the front door, which is as close to serious responsibility as you're going to come as a bouncer. It takes time to get a door spot, because there's money involved, and Hughes was fiercely protective of his supply lines. "I need," he declared, "somebody up here who ain't gonna rob me blind."

For all my faults, I've always found it easy to get hooked on being trusted, at least in situations where I'm genuinely making an effort to get on someone's good side. I'll work for something, prove myself to people over some requisite span of time—this *has* happened, contrary to what you're probably thinking—and when the thing I want finally comes my way, I'll do everything I can to justify their investment. I know this sounds a touch hypocritical coming from me, but what you have to understand is that my relationship with Jim Hughes was purely a financial one. I wanted Hughes to like me so he'd continue paying me. Impressing him was the *means*. My troubles, unfortunately, have always come with the *ends*.

I STOPPED WORKING at Jim's after a Latino kid I had refused at the door decided it was in his best interests to slash my arm with a box cutter. He wouldn't show me any identification, so I didn't let him in. I wasn't watching him when he attacked, because my head was turned in the direction of a group of young girls leaving the bar. I was looking at their asses, because that's what bouncers do when women leave. Even if you're the nastiest, foulest-mouthed, most obnoxious bitch in New York, I'll still be checking out the contour of your ass when you walk away. You know, just in case.

Why being turned away from a bar or club requires the use of weaponry in retaliation, I have no idea. Rejection happens to everyone at some point. You walk up, you show us your ID, and you take your chances. If the bouncer decides you're not getting in, you slide your wallet back in your pocket and make your way to the next place. Here in New York, there's *always* a next place, and, in all likelihood, you'll have a better time *there* than you would've had *here*.

New York, however, is what it is: the city where size does count. The city where a simple sidewalk discussion between a customer and a bouncer in front of a bar will always devolve into a comparison of the lengths of our respective genitalia. That's why, fifteen stitches later, with a lovely crescent-shaped scar to commemorate my time as a bar bouncer, I decided to call it quits. Getting cut open can change your mind about your employment status in a hurry, but you wouldn't know that if you've got a *real* job, because people don't slash each other with box cutters on Wall Street.

I could handle taking a punch. Even being thrown to the floor and kicked in the ribs was fine, because when you're operating on the adrenaline that flows through your system during a fight, nothing hurts as badly as you'd figure it would. Weapons were a different story, though. I was an unarmed bouncer. I wasn't a cop

with a Glock 9-mm and a bulletproof vest, and if I *did* make the mistake of providing myself with some means of protection—one bouncer at Jim's actually carried a stun gun—the law certainly wouldn't be on my side if I ever used it on a patron.

When I stopped working at Jim's, I assumed I'd never work as a bouncer again. They may have been delusions, but I still had plans to finish college and go to grad school, or law school, and eventually start living the life that everyone had envisioned for me when I was younger. I'd be awake and showered before dawn, standing on a Long Island Rail Road platform, wearing an overcoat and carrying a briefcase, and worrying about bond futures and commodities and interest rates and all the other important shit that people concern themselves with when they're smart enough to stay on track.

To this day, I couldn't tell you exactly why this hadn't happened. If I had any answers, I'd never have known a damned thing about West Chelsea or the Meatpacking District in the first place, unless Goldman Sachs or Lehman Brothers—the firms I work for in those masturbatory fantasies I mentioned earlier—decided to give me an expense account so I could show our Japanese investors a fine time in the city. Even then, roped off in somebody's VIP room with a bottle of Cristal and a bucket of ice, I still wouldn't know a fraction of what I'd eventually come to learn on the job.

The years removed from bar work gave me some perspective on what was really involved. When I first started doing it, I wasn't capable of thinking about bouncing on anything but a purely emotional level, when I should have been concentrating solely on the amount of money I was bringing home every night. The most important thing to me back then was earning, and maintaining, the respect of the other bouncers on the staff. The events of every shift were taken home and analyzed to death for any discernible breech in alpha-male etiquette: Did I get to that fight on time? Was I late? Was I standing behind someone? Did my voice shake when I felt threatened? Did anyone notice?

Surprisingly enough, I managed to end my run at Jim's on good terms with Hughes. My bouncing career represented my first unburned bridge. With Kate gone, and my bills about to double, I needed another income source immediately if I wanted to stay afloat. I wanted to keep my apartment and didn't want to subject myself to all the bullshit involved with screening potential roommates or moving into some beer-and-weed-saturated shithole with one of my friends because I thought I couldn't afford the alternative. I was determined to stay where I was, on my own, and bouncing seemed a convenient alternative to "real" work. It was relatively easy money, I already knew how to do it, and at least one person connected to the industry had formed a high opinion of me that hadn't been corrupted by my self-destructive tendencies.

In theory, none of the dick-swinging masculinity aspects of bouncing would matter if I were to start working again. I needed the money too desperately to worry about all the peripheral nonsense, and the idea of testing myself—and the composition of my testicular sack—in a bar was foreign to me after working full-time and supporting myself as a financially independent adult. There wouldn't be any psychic investment in the job this time around, because my priorities had shifted. The only validation I'd need, or so I thought, would be the contents of the envelope I'd receive at the end of my shift. All the little dramas of my first incarnation as a bouncer would necessarily play themselves out on somebody else's time. Not mine.

"Hey, man! Great to hear from you! How you been! How's the job goin'?"

"Pretty good, Jim," I replied, taking a deep breath and trying to get this right. I was genuinely nervous, because I had no backup plan if Hughes couldn't help. "Listen, I need a pretty big favor."

"You comin' down? I'll get you right on the list. How many?"

"Not exactly," I said. "I need a job. You guys looking for anyone right now?"

"Bouncin'? You gotta be kiddin' me. I thought you were done with this shit after you got slashed."

"So did I," I said, "but money's getting a little tight, and I'm looking to hook up a couple of nights a week. Maybe Friday and Saturday if I can. It'd really help me out."

"I wish I could throw you the work, I really do, but we're closing the place down in about a month to remodel, and I'm about to lay all my guys off. I got nothin' until we open back up for the summer." This happens constantly in the bar business, and it wasn't the first time Hughes had redone the place. Most "rooms" in New York are on at least their tenth incarnation by the time you walk through their doors, and Jim's was no exception. For the majority of places, a renaming and a redesign is akin to spooning whipped cream on a pile of shit, but that's how the business works. I knew Hughes was telling me the truth.

I stayed silent for a few seconds. "Yeah? Shit."

"Tell you what, though," he said. "You ever thought about workin' in the city?"

"Not really. I don't know anyone there, and I know it's a bitch getting hired unless you've got friends on the staff." Which it was. In Manhattan, you can't simply walk in off the street and get a bouncing job, at least not anywhere you'd feel safe working. The entire borough seems to work on a voucher system, where someone already employed by a bar or club has to provide an introduction before they'll ever consider hiring you.

"That's what I'm tryin' to tell you. You *do* have friends on the staff."

I sat up straight. "Who? What staff? Where?"

"You remember Joe Migliaro? Used to work for me here years ago?"

"Hell yeah, I remember Migs," I replied. "He was the guy at the door when I first started working for you."

"He's the head bouncer at Axis now. Does all their security,

even the after-hours shit. I'll give him a call. I know he'd hire you in a second."

"Axis? No shit. I can't believe Migs is still in the bar business," I said, recalling one of the most perpetually angry human beings I'd ever met. "That guy acted like he hated every minute of it when I worked with him. Where is that place, anyway?"

"Chelsea, over by Tenth Avenue where all those other places are. Twenny-seventh, maybe? I haven't seen it yet. They just opened up last month, and I been so busy here with all the work we're doin' that I haven't had a chance to get in there yet."

I inhaled deeply again, then let it out. I wanted this now. Working at a newly opened club in Chelsea definitely qualified as *something,* and the way things had been going, *anything* would be just about perfect. "He need people?"

"Probably not, but he'll take you if I ask him to. Don't worry about it. Lemme just give him a call tonight, and I'll pass along your number. Just sit tight, kid. I'll get you in."

I'VE LIVED MY entire life in New York, but I've never been much for Manhattan nightlife. Growing up in Queens and on Long Island, I've never been able to shake that distinctive aura of fraudulence which seems to attach itself so aggressively to the so-called B&T, bridge-and-tunnel, parade when we venture downtown on weekend nights. Something about the process sets me on edge, as though Manhattan is the province solely of those who've achieved enough to be able to live there. People who, unlike me, had educations and lives. Sophisticates. Stainless, shiny acculturates for whom outerborough life holds little relevance aside from the occasional trip into Queens to visit one of our airports.

After a night spent in the city, the disappointment of going home would get to me. You step off the train at Penn Station, ride the escalator to Seventh Avenue, and the entire world is right there in your face, directing you downtown to suck it all in, meet some chicks, and *get some ass.* Which, when the stars were aligned, my friends

and I had managed to do on occasion. Lord knows those of us from the B&T set have figured out how to look the part. The reality of the situation, however, is that it has to end. None of it belongs to us. No matter what you accomplish on a Saturday night in the city, you inevitably have to make your way back over the river, or under it, to Brooklyn, Queens, Long Island, or whatever meaningless suburban letdown from which you and your posse had made your trek.

The idea of working at a Manhattan nightclub evoked an entirely different vibe, and this excited me. With a purpose, the commute into the city would be free of the sucker stigma plaguing every train ride I had taken since turning twenty-one. I'd be going in to *make* money this time around, as opposed to surrendering half my paycheck in exchange for a vapid evening spent chasing around the Village herds of women who wanted no part of what little I had to offer. Submit, in search of a good time, to New York's unrelenting attempts at fiscal sodomy, and you're no better than a tourist. Worse, in fact.

I knew next to nothing about Axis, or about any of the dozen or so other nightclubs in the West Chelsea area. From what I *did* know, the entire neighborhood was a hit-or-miss proposition in terms of whether specific clubs had been overrun by the B&T crowd or not. According to Hughes, Axis had been operating for about a month, which I regarded as a positive sign. The place was simply too new to have been ruined yet, and the outerborough and suburbanite locals—the "short money" people—wouldn't stand up to the scrutiny of the sidewalk review common to any Manhattan nightclub looking to build a reputation for drawing a high-quality crowd. Admitting locals isn't necessary so early in a club's evolution, and the main idea for doormen, while a place is still peaking, is to make a concerted effort to keep them out. The locals themselves, knowing the game all too well, would avoid wasting time trying to get in, which was perfectly fine by me. I wasn't looking to take a bouncing job at a high-end club in the city so I could keep an eye on my neighbors.

I WASN'T SURE where Migs had picked up the scar on the side of his head, but his hair wouldn't grow over it. He'd always kept it cropped short, which I suspect he did to accentuate the fact that the scar was still there. It started at the edge of his hairline, arcing atop his temple until it came to an abrupt halt just short of his left ear. The scar scared the living shit out of people. It had to. If you were hell-bent on causing a problem in the club, it wasn't Migs's height—he didn't have much—or his unassuming build that would dissuade you. It was the scar and the *look*. Migs was *hard*. He'd lived a difficult life, the details of which you'd never know but could readily discern in that look, which elicited immediate respect.

SCENE: Inside Axis, Migs led me through one taste-fully appointed room after another. A decade after I last saw him, he looked not older, but more danger-ous—and slightly out of place amid such luxury. The contrast, however, seemed to suit him.

ME: Damn, man, this place is fucking amazing.

MIGS: Yeah, it is. Christian and his partners spent a fortune on the redesign. They probably blew a million on the lights alone. We get a good crowd in here.

ME: Christian?

MIGS: Christian Gold. Serious fucking guy, man. He used to be the biggest promoter in the city, and then he started investing in clubs. Guy fucking knows *everyone*. This place is his baby, and he treats it like that. Operates as the general manager most nights. He owns it with two other guys, and they're doing everything they can to blow the place up and make it the best spot in the city.

ME: You're not kidding. You're *really* not kidding. I've never seen anything like this in my life.

MIGS: Long way from Bellerose, man.

ME: Thank God for that.

MIGS: That goes two ways. The standards in places like this are a little higher than what you might be used to.

ME: I need this job pretty bad, Migs. I'm not gonna fuck around, if that's what you're saying.

MIGS: No, I know that. I know you're responsible with this shit. You always were. But it's not just me that's gonna be watching you. That's all I'm saying. You gotta understand that this is a big-money place with a lot of management assholes walking around all the time, and you gotta make sure you're on top of shit every minute you're in here. You can't get away with nothing here.

ME: I'm not planning on trying.

MIGS: I know you're not, and that's why I'm hiring you. I just wanna be sure you know what you're getting into. Christian don't fuck around with the image here, you know? That's all they give a shit about, these people. I've seen guys get fired on the spot for chewing gum. If Christian don't like you, there ain't shit I can do about it.

ME: Okay.

MIGS: Look, you'll be fine. I go back a long ways with you and with Hughes, and I'm not gonna let you get fucked. Just show up on time, do what I tell you to do, and keep your eyes open, okay?

ME: Thanks for the job, man. And the advice.

MIGS: Anytime. Glad to have you. I'll see you on Saturday.

———

3

SUFFUSION

Anew workplace imprints itself on your consciousness the moment you walk in the door for the first time. This first, fixed instant is the way things are supposed to be, because this is where your memories start. It doesn't matter that most of the people you'll meet have become irredeemably jaded, or that the place is rife with infighting among everyone on the payroll, or that half the management team is engaged in a scheme to embezzle truckloads of money from the owners. You're at absolute zero—square one—and the entire scene is perfect. From here on, instinctively, you'll know that *that* sofa belongs there, and that *that* table goes there, and that the procedure for *this* runs exactly like *that*. You'll know these things because first impressions are the ones that stay with you, and because scenes never remain as perfect as they appear the first time you take them in.

Axis was a virgin. It was clean, and had no appreciable history because I hadn't been there to experience anything other than what they want the customer to see at first glance: an immaculately presented *tableau vivant* that lets you know, from the second you arrive, that you've landed in a Manhattan nightclub.

That money—*real* money—has been spent in developing the show, and that, in a sublime suspension of workingman's logic, the show is somehow important.

It's not important, of course. Nothing about the nightclub business is important, but it's the job of a skilled management staff to deceive you into believing that it is. That it has to be. They know, at inception, which pieces will fit, and where, in order to cultivate "it": the de rigueur veneer of illusory New York dash that convinces you to loosen your pocketbook strings and *spend* in order to *belong*.

Axis had "it," and the "it" that I was seeing served to intimidate the living hell out of me that first night. Expecting little more than the offer of some bullshit hundred-dollar-a-night door spot in the bushes out in Queens, I'd now be playing the bouncing equivalent of centerfield at Yankee Stadium, a fact that hadn't occurred to me until I found myself, glove in hand, waiting for the first pitch.

Who the fuck did I think I was? More important, who the fuck did *they* think I was? The way I saw it, city nightclubs didn't hire people like me—guys with regular jobs, who'll cross the street to avoid getting in fights because we can't afford the deductible if we lose. Professional "pride" doesn't permit me to say it like this. I questioned my qualifications for this. Wasn't this business the place, as I had always suspected, where retired WWE wrestlers were put out to pasture? Sure, Migs had hired me without a second thought, but shit happens in Manhattan. Real shit. Shit of a sort I wasn't accustomed to. If you're destined to someday get your ass kicked—or sliced, or stabbed, or shot—it's going to happen in New York, and the people who'll be doing it to you are the best in that particular field—which is why the people you hire to protect your investment necessarily have to be better.

There's a rancid, stinking miasma of self-doubt that my mind seems to enjoy churning out whenever I'm under pressure. I say "enjoy" because it seems as though whoever's up there pulling

levers and pushing buttons with such gleeful abandon is doing so, most times, beyond my control, and I get the impression he takes a great deal of pride in making certain I enter every unfamiliar situation with my self-confidence tank squarely on empty.

My miasma has a voice, and I hear it all day long. The little fucker—that goddamned ruiner—speaks through the fog. He gives it a mouth. "If you were actually worth a shit," the miasma told me back at the beginning of all this, "you wouldn't have to be a nightclub bouncer in the first place. You wouldn't have to do this to yourself.

"And the irony of it all," the miasma whispered, "is that you're probably not even a good enough bouncer to work in a place like this. Sure, you know how to do heavy, physical shit, and you're pretty good with fighting when you need to be, but you're no professional, that's for damned sure. So what's gonna happen is you're gonna put your hands on the wrong guy and get your ass handed to you. That's what's gonna happen. And there's a whole hell of a lot of *wrong guys* in Manhattan."

Trouble is, I can't ever answer the little prick. He doesn't listen to me unless I've been drinking, heavily, and even then the message won't penetrate far enough into the fog to let the bastard know I'm against him. All I can do is just go to work, and do my job, and show the little son of a bitch how far off base he is. Of course, I didn't exactly have a proven record of doing this, so all I realistically had to go on, when starting to work at Axis, was the notion that maybe I could shut him up if I tried really, *really* hard.

"How you making out so far?" asked Migs. "Ready for tonight?"

I shrugged. "Yeah, man."

"I'm gonna stick you in the back of the main room with John for tonight, until I can find you a regular spot," he said, nodding toward a tall, older bouncer leaning against the back wall. "Go back there by the ropes and talk to him. He knows you'll

be working with him all night, and he'll show you the way things operate inside. John's a good guy. Just watch what goes on, pay attention to your radio, and follow his lead."

Money helps shove the little bastard down where he belongs. It buries him way down deep beneath whatever layer of brain matter it is that emits the miasma through which he talks all his shit. It shuts his sorry ass up when he knows he's potentially getting in the way of the paychecks that keep him comfortable. See, when money's at stake, I begin thinking rationally. I knew that nobody at Axis was expecting me to come in and lead the staff to glory. Migs, bless his heart, had that role locked down. I was hired strictly on the basis of being a "does what he's told" sort of guy, and I knew, after considering my options, that if I simply played that role—to function as support personnel—I'd be an afterthought as far as the rest of the staff was concerned. No fanfare had accompanied my arrival, but then again, none ever does.

IF I HADN'T already been told he was a bouncer, I would have thought for certain that Johnny was management. He was older than any bouncer I'd ever seen—I'd later find out he was forty-five—and his height, his bearing, and his gray mustache gave him what we call "presence in the room." In a room full of shaven-headed men in their twenties and thirties, he was the only member of the staff whose grooming practices still necessitated the use of a hairdryer—a holdover, perhaps, from some brand of mulleted, comb-in-back-pocket eighties glory, only in a different shade now, and receding ever so slightly. Envision a menacing version of Tom Selleck, wearing a black suit and standing on a box, and you've captured the essence of Johnny, at least in the way I perceived him when we first met.

"Rob, right?" he asked, extending his hand. "My name's Johnny. Nice to meet you."

"Good to meet you, too."

"Just starting tonight, right?"

"Yeah," I replied. "First night."

I could tell I was being sized up, but that's how things work among alpha males, and especially so in the bouncing profession. I wasn't uncomfortable with it, because I was doing the same to him. *I may have to depend on this guy one day. What's he got?*

"How'd you get the job?"

"Migs hired me last week," I replied. "I used to work with him at Jim Hughes's bar in Queens. Why do you ask?"

"It's a typical question here. Everybody who works here knows somebody who brings them in. You can't just walk in here off the street and get a job, so I figured somebody had to vouch for you. I'm just curious who it was."

"Migs a good guy to know, then?"

"Hell, yeah," he replied, laughing. "He's the head bouncer. You can't really know anyone better than that. And not for nothin', Migs's word is good with me, so you're off to a pretty good start if he's the one that got you in."

"How long you been working here?"

"Since they opened up last month, but I been working at Christian's places for years. I'm what you might call a *fixture,* or some shit like that. I try to get out of this fuckin' business, but every time they open a new place, they call me back in, and I can't turn down this kind of money, you know?"

As he spoke, Johnny began to set up his area, placing stanchions along the floor and kicking a carpeted "bouncer box" into place along the back wall. I felt uncomfortable watching him work, and wondered whether I should be doing something to help.

"You do this full-time?" I asked.

"No. Fuck no, man. I got a day job."

"Mind if I ask what you do?"

"I'm on the job," he said.

"NYPD? Shit, I thought you guys weren't supposed to work in bars and clubs."

"We're not. We can't work anywhere where the main source of

income is from alcohol sales. We can't bartend, or bounce, or wait tables or any of that shit if there's a lot of liquor around."

"Why are you telling me you're a cop?" I asked. "Aren't you guys scared to death of getting ratted out?"

"Listen. First of all, I know *you're* not a cop. I've known Migs for years, and he would've told me if you were, so I don't have to worry about that."

"Right."

"As far as getting ratted out goes," he continued, "it's all part of the game. There's fucking rats everywhere in New York, and they're all looking to get ahead by fucking with *your* job. You learn that real quick the first time it happens to you, and you figure out who you gotta watch out for. First time, you get warned. Then it's a thirty-day suspension, and then you're done. I'm not gonna fuck with my pension, believe me. It's all I got."

"You married?"

"Yeah. I got two kids, a boy and a girl, and I got a mortgage to pay. That's why I been doing this shit for so long. You don't see a lot of guys my age hanging out in nightclubs. *Normal* guys my age, at least. Just these desperate, divorced, three-in-the-morning blue-flame specials walkin' around, lookin' for seconds. That's how I know I'm lucky. How 'bout you? Are you married?"

"Nope," I replied. "Never even close."

Johnny grinned. "Own a house?"

"Nope."

"Oh, man. You got a whole *world* ahead of you, my friend. You'll see what it's like. Try paying the mortgage on a house in Nassau County, with two kids, on a civil servant's salary. You gotta supplement it any way you can."

"Any other way you could do it?" I asked. "It doesn't seem like you hate doing this, but isn't there some other way you could balance it out without taking so many risks?"

"How the fuck am I supposed to do that? I can't do anything else. I never went to college, and I never learned how to do shit

other than police work. The city don't pay us what we deserve, our contracts fucking suck, and then they take the only thing you're actually good at and they order you not to do it. All I'm tryin' to do is keep my house until my pension kicks in and I can move the fuck out of this piece-of-shit state. What choice do I have?"

What choice? There isn't any choice to be made. New York will stuff you in its mouth, gnash its fangs until you're pulp, choke you down its gullet, then shit you and your pension out somewhere in the Florida Panhandle, where you're welcome to paint houses and roust-the-fuck-about for the remainder of your days. Expenses will kill your spirit around here, especially when you stop to dwell on them, because New York never turns off the meter.

"Buy a house," goes the refrain. "Quit paying rent. You need equity." People say these things, I think, mostly to convince themselves of their validity. I wouldn't know. It's not advice I can take, because I'm still just a tenant. I'd like to reach the point, one day, where I'm qualified to piss and moan about fixed rates and points and *re-fi*. Who wouldn't? For now, I continue to blindly pay.

Still, in Johnny's case, you'd think there would be a better way for a family man to even things out than standing around like a trained gorilla for eight hours at a clip, right? Better ways, however, aren't easy to come by when you're an unskilled, untrained, undereducated blue-collar guy whose parents swallowed the keys to the house you were supposed to inherit. When it's like that, and you don't want to pack up everything you own and move someplace foreign—like upstate, for instance—life in New York is all about putting in the hours. It's about finding a niche, or maybe getting desperate enough to sell your integrity, and your morals, by involving yourself in something that's not quite aboveboard. Whatever you do, the payments are just about the only things that ever remain constant.

"Hey," I said, "I'm in the same boat without the mortgage and the family. I'm just trying to keep a roof over my head."

"What do you do?"

"I drive a truck all day. I got a commercial license and shit, but the money's not worth the fucking hours I gotta put in. Thing's a fucking sweatshop on wheels, man. It's like I tell the Mexicans at work: *Mucho trabajo, poco dinero,* you know?"

You walk into a nightclub, and you look around, and you wonder what makes guys become bouncers. You'll have—assuming you care—a whole list of questions you'd like to ask. Problem is, you've been too corrupted by the *bouncer stereotype* to screw up your courage and approach. You're afraid to ask the only people who could give you the right answers, because you're convinced we're all just *itching* to throw you, bloody and battered, in a Dumpster out back.

What's the psychology behind this choice we've made? Are we childhood bullies who, in adulthood, can't get past some inherent need to physically enforce our will on random strangers? Are we some bizarre subculture of gargantuan misfits who are too thuggish and too criminally inclined to make our way in the world doing anything else?

Your typical bouncer doesn't have the time to consider the problem as analytically as all that. To a man, we're usually too busy working to stop and reflect on why we're doing what we're doing. We're paying our rent. We're taking care of the mortgage, and the taxes, and the new garage doors we need when our daughters forget to apply the parking brake. We're resealing our driveways and forking over the co-payments for the kids' trips to the dentist, and getting it up the ass, just like you, when insurance companies deem us "assigned risks" in a city whose roads are crawling with baffled Bangladeshi cab drivers.

It's a job, is what it is. That's all. For most of us, bouncing is simply a part-time second job, and not a grand social experiment we've undertaken in an attempt to satisfy some Neanderthal urge to impose order on the "weak." Most of us in the club industry can't stand the places where we work. I wouldn't hang

out at Axis unless they paid me, which doesn't really count as a hypothetical, because *getting paid* is the only reason I'd ever set foot in a club to begin with. I don't like waiting in lines on sidewalks to get inside. I go out of my way to avoid subjecting myself to excessive crowding, and I refuse to compete for the attentions of bartenders who'll charge me three times the amount I'd pay for a drink someplace where I'd actually feel comfortable.

"How long you been doing this?"

"I did it for about four years back when I was trying to go to college," I replied, "but that was years ago. I haven't bounced since then."

"You must've been pretty good, otherwise Migs wouldn't have hired you here. The one thing I can say for him is that he doesn't fuck around when it comes to putting the bouncing staff together. Every guy here's pretty good."

"I *was* pretty good, I guess. My only problem is that I've never worked in Manhattan, so I don't exactly know what to expect here, and it's tough, because I need this job to work out, you know?"

"Yeah, I know," he said. "We all need this job to work out. I wouldn't worry about it, though. It's all the same shit. People in Manhattan just have a little more money, and the women are better-looking. You'll see less fat ones here, anyway. That's about the only difference you're gonna find. Scumbags are scumbags, and when you gotta lay your hands on somebody, it's not like everyone in the city knows some secret kung-fu or something. They'll go down just like anyone else."

"Good point."

"Come on, man. Are you fucking kidding me? This place ain't shit. This whole atmosphere they're making here? It ain't shit. These people are nothing but dollar signs to me, and that's how you gotta start looking at them when you're working. You'll see."

"Dollar signs," I repeated. "I like that."

"That's right. Nothing but fucking dollar signs. Listen, man. Don't be worried about this job. It's a fucking joke. Easiest money you'll ever make. If you did it right before, you'll be able to do it right now. Like ridin' a bike, you know what I mean?"

4

SWELLED

For new bouncers, the initial fight call of your first night can go one of two ways. Either you're dreading it, and would rather not have anything break out until you've familiarized yourself with your new environment for at least one shift, or you welcome the action with open arms, knowing you need to break your cherry at some point in order to release the tension that goes along with the waiting. Or, ripshit as I was with nervous energy but unsure of exactly what I wanted at any given moment, you can do as I did and choose a third option, vacillating in the middle ground somewhere between fear and aggression.

When the call does come, however—"Middle bar! Middle bar! Middle bar! Middle bar!"—the only thing you *do* know for sure is that you have no idea where the fuck the middle bar actually is, so you simply break toward movement, following the line of black-suited giants into the chaos and hoping to hell you've gone the right way.

The ability to discern what's happening as you approach a fight from across a crowded room is something bouncers can only develop with experience. From above—standing on a platform or a

box—finding the necessary information is easy, because the signs of trouble are easy to distinguish. Sudden movements, too quick to be mistaken for dancing, will catch your eye. Rhythms will develop within the mass on the floor, and you'll notice any deviation, no matter how subtle, provided you're paying attention. A good bouncer can sense the hostility in these deviations. A tidy little half-moon pattern will form in a crowd when two people are arguing and about to square off. You see these things, and you call them in. You call in a location, you request whatever help you need, and you jump down and run to the problem.

On the floor, when you're running to a fight you didn't call, that you haven't yet seen, things are different. You don't know what you're running into, and when you're struggling through a crowd of drunks to get where you need to go, there's no real way of seeing everything you need to see until you've stumbled into the middle of it. And once you're there, with the whole tangled clusterfuck in your face, there's no time to stop and assess and choose the correct course of action. Your job is simply to grab someone and get them out the door any way you know how.

"Middle bar! Middle bar! Middle bar! Middle bar!"

Johnny took off, running toward the center of the room. I followed, staying on his heels as he roughly shoved dozens of customers aside. My plan was to loiter, at least for this first one. I wanted to stand aside—making it look like I was getting involved, of course—and let someone else take care of the problem while I studied the situation and figured out which bouncers were the ones the others on the staff would defer to. I'd linger around the edges, along the fringe, and get a feel for how things worked. That was my plan, but you know the rap by heart now: *if any of my plans had ever worked out, I wouldn't have needed to become a bouncer in the first place.*

"Don't fucking touch anyone." A voice in my ear, and a hand on the back of my collar. *Fuck.* "You don't know who we are."

I turned around, batted his hand away instinctively, and took

a long look at what I'd be dealing with. He was a "jag." *Just another guy.* I'd been here before. Medium height, medium build, collared shirt, jeans, gel in his hair, and trying to look hard. *So, you're the first.*

"Don't fucking touch *me*," I said, trying to look harder, like a bouncer. "I don't give a fuck who you are."

"You don't know who I am" and *"You don't know who I know"* are the last refuges of the stupid and the helpless. People trot these out when they're nobodies who know no one and can't fight. They're desperation moves, not to be believed. Bouncers hear this sort of thing every fifteen minutes, and if we capitulated to every knucklehead who threatened us with his "connections," nothing would ever get done. The customers would run wild, and we may as well just pack it in and go home.

But because I was working in Manhattan, though, the notion crawled into my head that some of the people who threw these lines out could, in fact, know someone or even *be* someone who could make my life difficult. This wasn't much of a stretch. If you had the kind of money necessary to VIP it up at Axis, you could, conceivably, have the resources to seriously fuck with anyone who gave you a hard time. That scenario could obviously be expanded to include some Catholic-school-reject bouncer from Queens who has no right to tell you a damned thing anywhere else but inside the club.

You can't buy into random attempts at intimidation if you want to be able to do the job properly. It's also very difficult to live with yourself if you're going through life constantly backing down because you're afraid you'll lose, or get hurt, or be embarrassed. For most people, the "moment of truth"—the classic fight-or-flight scenario—comes around once or twice in their lives, if ever. For bouncers—and, to a much greater extent, cops, firemen, and soldiers—the "butterfly reflex," as I like to call it, is something that happens at least twice per night. You're directly challenged, your heart jumps into your throat, and now you have to do something or you'll be going home unemployed.

Despite my anxieties about starting work on such unfamiliar ground, I wasn't about to let myself get bitched out on my first night, especially when people were watching. I knew they were watching, because that's what bouncers do when someone new gets hired. We watch, just in case there's something we need to see. If there *was* anything they needed to see out of me, though, they weren't getting it that night. I wouldn't let them. I grabbed the guy by the shirt, shoved him toward the door, and barked, "We gotta go."

He wasn't having this. Wasn't having any bit of it. I thought he'd just start moving easily, the way I was directing him to, so I stupidly hadn't taken any control of his arms when I locked him up. Using this advantage, he tried to shove my head away with his right hand, lodging his thumb in my eye in the process.

A thumb to the eye is one of those moves that will elicit an immediate instinctive reaction from the recipient. Another is a kick to the testicles. When someone kicks you in the nuts, it hurts like a motherfucker, and the first thing you'll do is vomit, profusely. Likewise, when someone sticks his thumb in your eye, you'll swing. Trust me on this one. There's no thought process involved when something's in your eye, especially when that something is another man's thumb. All that matters to you is getting it the fuck out as quickly as possible, and when you're being thumbed by someone who in the moments before the thumbing was openly hostile toward you, you'll very rapidly ball your fist, raise your arm, and swing away, which is exactly what I did.

Momentarily stunned, he let go of my eye socket and dropped to one knee, covering his face with both hands. I pulled him to his feet, dragged him toward the nearest door—about twenty feet away from the periphery of the original fight—and shoved him out onto the sidewalk.

"You hit me, motherfucker!" He was bent over, feet together, holding his head. "What'd you fucking hit me for?"

"Dumb fuck had his thumb in my eye," I muttered to the door bouncers on my way back inside.

Once you have them out, the worst of it is usually over. Hostilities may flare up again when they try to argue their way back in, or if they turn around and attack, but if you get them out of the club proper, you've won. You've accomplished what you're being paid for, and it's time to stand down and assume a more *defensive* posture. I learned from my time working in Queens that bouncing can't be made personal, even if you end up having to hit someone. The only thing post-ejection sidewalk shit-talking accomplishes is getting people hurt when the mind-altering substances they've been cramming in all night make them do something dangerous. Once it's done, there's no sense in taunting people or staying outside to listen to all the bullshit they'll be throwing your way.

Hitting him was a major mistake. It's a mistake a more experienced bouncer wouldn't have made. Instead of responding with a swing, my main objective should have been to simply get his thumb out of my eye. That would have been better accomplished by making a move on his arm, or his body, instead of his face. Nightclubs fire bouncers who hit customers in the face, because customers who get hit in the face tend to call the police. After they call the police, they call their attorneys, and the club, because of some overzealous meathead who maybe had a bad day, is locked up in litigation for years.

It's nearly impossible to work as a bouncer in New York without a state security license unless you know people in the right—read: management—places. Even then, they'll likely require you to obtain one. Migs had hired me conditionally on Jim Hughes's recommendation, but I'd filed for licensing before I'd ever set foot in Axis. The preferred jobs in town have always been hard to come by—there's not much you can do without a connection—but bars and clubs are increasingly disposed to covering their respective asses now, and even run-of-the-mill $150-per-night slots require proper documentation. This documentation—coming in the form of an official New York State license—requires a significant time investment on the part of the prospective bouncer.

There's a comprehensive background check involved, and it can take upward of three to four months before your paperwork arrives in the mail.

Licensing requirements are a positive development in the industry, and I have no argument with the state's criteria. Bouncing occasionally requires some modicum of good judgment—on the fly in most cases—and I'd rather work with a staff of guys diligent enough to spend the time and money the process requires. Not that going through the licensing process automatically renders you rational, mind you, but it's a start.

License or no, however, bouncers are perpetually handcuffed—in the eyes of the public, the media and the law—by something I'll call the *angels fallacy*. The angels fallacy assumes that every customer walking into a bar is a perfect little model citizen—a nonthreatening, unassuming, productive member of society who, before being assaulted by a bouncer, was simply out with his or her friends to have a good time. Conversely, the fallacy would have you believe that every bouncer who lays hands on an "angel" is a predatory misanthrope who'd better serve society from behind bars.

What's usually ignored, when bouncers find themselves in court facing assault charges—with some precious little angel looking on in his fucking first communion suit and his father's tie—is each party's rationale for being in the establishment in the first place. We're there to earn money. The customers are there to consume mind-altering substances. I'd have to crunch some numbers here, but I think if someone was to conduct some sort of statistical analysis on the subject, odds are they'd find the person with the altered mind to be at fault in the vast majority of cases.

See, the guy who wins the fight isn't always at fault, but the law, most times, claims otherwise. What bouncers know, however, is that the first combatant to demand legal satisfaction is usually the one who's just had his ass kicked. I won't hit someone for refusing to leave the club when asked. I *will* hit someone if they spit on me or stick their thumb in my eye. There's only so far you

can let these things go. I won't hit someone for saying "Go fuck yourself, juicehead," but I *will* hit someone if they hit me first.

Still, in a perfect world, I wouldn't have had to physically express these convictions my first night on the job.

What troubled me about my reaction was that I *knew* the first fight was coming, *knowing* I'd be watched, and judged, as the new guy on the staff, and yet I reacted poorly and excessively when confronted by someone I should've been able to handle with ease. Simply put, I had fucked up royally, and when I was called to the upstairs offices at the end of the night, I figured my latest bouncing incarnation was about to come to an end.

"SIT DOWN," SAID the little gray smudge, working through what appeared to be his fiftieth unfiltered Camel of the night. "You know who I am?"

"No. It's my first night, and . . ."

"My name is Zev, and I'm the general manager of this fucking place. Anything that goes on here, goes through me. I'm your boss, and Migs's boss, and everyone's boss you see working down there. In other words, I'm fucking God, at least to you. Christian is God to me, but I'm God to everyone else, because I'm the one you have to deal with."

I nodded. Zev was exactly what you'd expect to see in the upstairs offices of a Manhattan nightclub—a decaying body in an expensive suit, complete with a lacquered comb-over, a thick gold rope around his neck, and an unkempt strand of hair hanging over his collar in back. I knew, without ever having met the man before, that I'd never see him without a cigarette. Even the hallway leading to his office reeked of lung cancer.

"First off, I didn't bring you up here to fire you."

"Okay."

"Are you relieved?" he asked.

"I guess."

"You guess? I watched what you did on camera, and we can't

have that shit here. Any bouncer ever throws a punch, we usually fire him on the spot. I spoke to Migs about you, and he said it was your first night and that you were a good guy. Is he right? Are you a *good guy?*"

"I'm here to work, if that's what you mean," I replied. "I've never hit anyone bouncing before."

"Okay, I'm not gonna be an asshole here. I *am* an asshole, but I'm not gonna be that way right now, because Migs told me you're a man who's capable of listening, which is rare in this fucking industry. What you have to understand is that I need *tough guys* here. You know what a tough guy is? Can you tell me what a tough guy is?"

"Yeah. It's someone who can get a thumb in his eye without thinking he has to throw a punch if it means he's gonna get fired for it."

"Good," he said. "You're a fast learner. That's exactly what a tough guy is. It's someone who can take a punch, or someone spitting at him, or someone saying something about his wife, and laugh at it and do his job. That's what I need from my bouncers. You see these people that come in here?"

"Yeah?"

"They're the fucking scum of the earth, is what they are. They're fucking useless. I've been in this business goin' on twenty years, and I've never met anyone who goes to clubs who's worth a shit. These motherfuckers are gonna say shit to you, and do shit to you, like you couldn't even imagine. And what you gotta do, since we're payin' you to do it, is sit there and put up with it, and not lose your fuckin' head like you did tonight."

I continued nodding. Figuring it was the thing to do, I'd been nodding since I walked in the door.

"You see me? You see what I look like? I'm a dumpy little chain-smoking fuck. I haven't done a day's physical labor in twenty years, you know that? But I've taken that punch I need you to take. You're a big, strong fuckin' kid. If you wanted to jump

over this desk, you'd take me the fuck out inside of five seconds. 'Course, I'd put a bullet between your fuckin' eyes before you even got out of the chair, but that's not the point. The point is, this shit's only gonna get worse. This crowd that comes in here now? This is as good as it gets. We're on top right now, but in a few months, we're not gonna be, and you're gonna be seeing a lot more shit like you saw tonight. You need to know, from me, that whether you keep your job or not depends on how you handle yourself."

"It won't happen again," I said.

"Look, this ain't a bad job. It's a nice place to work, you're making more money than any bouncers in the entire fucking world, and if you play your cards right, you can walk out of here every night with more pussy in hand than you know what to do with. All we ask you to do is play by *our* rules. That's it. You do that and everybody wins, understand?"

5

CARNIVÀLE

ere's what West Chelsea is:

West Chelsea—or "Nightmare Square," as I've come to call it—can be defined as the cluster of so-called megaclubs lining the west twenties between Tenth and Eleventh Avenues on Manhattan's West Side. Between the hours of eleven P.M. and five A.M., West Chelsea is also the section of New York most resembling the outer ring of Dante's Seventh Circle of Hell. It's where I propose they build a new Penn Station, so people from Long Island and New Jersey—who flock to West Chelsea in droves virtually every night of the week—wouldn't have to vomit in the backseats of so many taxicabs.

They could set up a new Penn Station right there on Tenth Avenue. They could call it Bizarro Penn Station. And what they also could do is wheel out trash cans and line them up where all the Long Island and Jersey people go to wait for their trains. That way, instead of running loose in the streets after last call, they could drink and fight and puke to their hearts' content in isolation without hassling the rest of us poor souls who've come into Manhattan to make a living.

The open-air free-for-all is hardly unique to New York, though.

You go to New Orleans, or Austin, or West Hollywood, and you'll find the same nightlife logistics in the "club districts." Every other storefront is a lounge or a club, and the streets outside are filled with people fighting, and urinating, and making nuisances of themselves. They come to these places and toss aside the conventions of a civilized society, doing shit you wouldn't see them do anywhere else but there.

It's the demographic, out there in the street, that makes New York different. Sure, you'll see people who could be described as "trash" everywhere, but *our* trash isn't anything like *your* trash. Your trash are generic. Parade your trash in front of me at the club, and I couldn't tell you whether they're Montana trash, California trash, or Alabama trash. Damned if I'd know. Give me three guesses and I probably couldn't even pick a state that *bordered* on your trash's state. Your trash is what we in New York call "the rest of you," because we know how things are in this country. It's *us* and *you,* is what the United States is. Forty-nine-and-one-half states of normal, and then there's *us.*

What we have here is everyone from everywhere making their collective way to the clubs of West Chelsea, looking for a place to park their genitals for a night. They're out here to buy drugs, or to sell them, or simply to amuse themselves for a few hours by making someone else's life miserable. It doesn't matter if that someone they're disturbing happens to be a bouncer, either. I mean, who gives a shit when you've been drinking Grey Goose and Red Bull all night, and you suddenly find yourself falling into a K-hole on your way back from a shared trip to a bathroom stall? Who cares? You're in West Chelsea, where reality is suspended for days on end, and somebody else will take care of the problems you're causing, because that's what you're paying forty-dollar cover charges for in the first place.

Walk down any street in Nightmare Square, and there's a place that'll take your kind. If you can't get into Axis, you move fifty yards down the block and wait in line outside some other club

that's been in business for a few years. Places pass their prime and they'll take anyone with an ID and a twenty-dollar bill. That's where the bridge-and-tunnel crowd come into play. Nobody wants the B&T locals. When you open a club, you're looking to tap into the steady stream of celebrities, socialites, and investment bankers who consistently make their way south from the Upper East Side for the sole purpose of impressing nocturnal New York with their spending habits. If you want to stay afloat, however, you're eventually going to have to accept business from the outer boroughs.

And *that's* when you'll know whether this is really the business for you.

I went back to work the Saturday after my first night thinking I'd accomplished something. I'd landed a solid punch, knocked a guy down and threw him out in front of everyone, and I still had a job to show for my trouble. Arriving early, I went directly to the back of the main room and began setting up the area the way I'd seen Johnny do it when we first met. It wasn't long before one of the veterans showed up, a guy named Ray.

Ray was a fighter once, and by all accounts a good one. You know fighters when you see them, if you know what to look for: the flattened nose, the scar tissue over the eyes, and the clinical detachment with which they approach situations where they'll be called upon to use their hands. For me, it's the nose. When a guy's nose is flattened from being broken repeatedly, either he's had a lot of practice or he can't stop getting hit. If it's the latter, there's a good chance you'll get away with all your teeth, but it's not the best idea to try and find out the reason why his nose looks the way it does through trial and error.

He was a few years older than me, and didn't look like much that your average drunken, coked-up, hyperaggressive twenty-one-year-old from Staten Island wouldn't think he could handle. He was a good half-foot shorter than all the other bouncers in the room, and his thickening torso indicated a mild distaste for the sort of training regimen he'd once followed as a professional. As

was the case with Migs, though, you could simply *tell* he'd been in places and situations with which most people weren't familiar.

———

SCENE: In the rear of the club, the ex-fighter approaches a person of interest—drawn, as it were, by the novelty of a properly thrown straight right in an atmosphere devoid of technique.

RAY: You ever train as a fighter?

ME: Yeah. I did a little bit, years ago, but I never really took it seriously. I wouldn't say I know what the fuck I'm doing, if that's what you mean.

RAY: That was a pretty good right hand you threw last night. Nice and clipped, like somebody taught you how to throw it. You hurt that guy.

ME: I know. I shouldn't have done that.

RAY: Why the fuck not? Who cares about these fuckin' people? You think you gotta hit someone, I say go ahead and do it. What are you supposed to do? Let yourself get hurt? What'd the piece-of-shit Zev say to you?

ME: He gave me the whole speech about being a tough guy, and how tough guys can take all kinds of shit without losing their heads, and how he's worried because if I'm punching people when things are good, he doesn't know how I'm gonna work out here when shit starts getting worse.

RAY: He's got that part right, at least.

ME: Which?

RAY: The part about how the club's gonna start changing.

ME: Why? How bad's it gonna get?

RAY: Oh, it gets bad. It happens to all these clubs in Chelsea. They open up, and everything's great, and they get all these rich fucks and celebrities to come in and spend, but then the

place ain't at the top of the list no more and they gotta start opening the doors to everyone who wants a fuckin' drink.

ME: Celebrities? Anyone big?

RAY: Yeah, we get some big ones from time to time, but you don't even fuckin' see them. They come into the VIP rooms with five of their own security guys and they don't fuckin' do nothin'. You'll see some famous people in here, but it's the same half-dozen of them every week, and they don't do shit. They just sit there. They don't spend shit, either.

ME: So no big incidents?

RAY: Fuck no. That shit only happens in L.A. There's too much nasty shit can happen to you in New York, so they all got security out the ass to make sure there's no problems. It's the shit that's gonna go on in a few months that you gotta worry about.

ME: I guess that's the part I'm trying to understand. How bad does it get? I've never really hung out around here, so I don't know what it's like when these places go downhill.

RAY: Where you from?

ME: Queens. Long Island, too, I guess.

RAY: Queens. Okay, picture all the dumb motherfuckers that hang out in all the bars and clubs in Astoria, or on Bell Boulevard. You ever go there?

ME: Yeah. They're all filled with guidos. That's why I don't fucking go out anymore.

RAY: Bingo.

ME: Jesus. When's that shit gonna start?

RAY: I see it happening already. That line out front ain't what it was a month ago, I'll tell you that. It usually takes a little longer, maybe a year or so, for places to get bad, but this area's got some fucking reputation now. Nobody wants to come down here anymore except these pieces of shit that come in from Jersey and Long Island and everywhere else. These people with money come in here once, and they don't wanna

come back. It's impossible to keep a good crowd in this area anymore with all the shit that's gone on.

ME: What shit?

RAY: You know, the crap you see when we're closing up. All these assholes out in the street acting stupid. Fucking cops all over the place. People with money and any kind of class don't wanna come down here and get hassled like that. They'll go somewhere else. They'll come down and try a new place out, but it ain't worth all the trouble when you gotta mix with all the rest of the retards outside.

———

THE PEOPLE OUTSIDE in the streets of West Chelsea don't look like me. The people inside my club don't look like me, either. They don't dress like me, wear their hair like me, or let their eyebrows grow out like I do. They don't talk like me, or think like me, or value any of the same things I do. They're inconsiderate and they're rude. When they were children, and they walked into the house in January and left the door open, their mothers never said things like, "You weren't raised in a barn, young man." They surely didn't, otherwise their sons and daughters wouldn't act the way they do.

All night, every night, they're into you, standing in your lap, getting into your space and your business. They're constantly within arm's distance of your life. They're not challenging you to tell them to move, though, because they don't even know you're there. A nightclub bouncer is an afterthought in the consciousness of a drunken, drug-addled fool with a limited grasp, even when sober, of how society functions. My mistake, when first starting out, was thinking that wearing a black suit would make people listen.

There were few problems during my first month or so, other than the fight that precipitated the punching incident. I was even given a regular post: the ropes outside the service bar of the VIP

room. The space Axis occupied had originally been designed to house a restaurant, and the service bar was set up just inside what was intended to be a kitchen entrance. The idea was to make sure the VIP waitresses could get in and out of the bar area without having to negotiate an obstacle course, and to keep customers from passing through the ropes into the bar area, where they'd be free to do what they do best: keeping the club from functioning in an efficient and orderly fashion.

Midway through my first night in the VIP, a gentleman talking on a cell phone brushed past me when I wasn't looking and tried to get into the kitchen. I was little more than a piece of furniture to him, placed in this spot solely for aesthetic effect, and he hardly even broke his stride in passing me.

"Hey," I said, gently taking hold of his arm. "You can't go in there."

"But I gotta make a call!"

"You can't go in there. This is for employees only."

He took the phone away from his ear, moved closer, and began to shout. "What the fuck? I gotta make a fuckin' call! Are you fuckin' kidding me?"

"You got a problem you wanna talk about outside?"

We say shit like this because there's nothing else to say. You find yourself in situations where someone's an inch from your face, f-bombing you left and right, and you're occasionally going to sound like James Cagney. This happens, and there's not a whole hell of a lot you can do about it.

"You're throwin' me out?"

"Not yet," I replied, "but if you don't stop cursing at me, you're not gonna be staying too long."

"Are you serious? I spent about a fuckin' G in here tonight."

"Yeah? How's that my fucking problem? I'm not gonna see any of it. This is a fucking business. You can't just go wherever you want because you're spending money, and you can't come over here and start busting my balls because I won't let you do what

my fucking boss told me not to let anyone do. You wanna make a phone call, go the fuck outside and get the fuck away from me."

I waited with my finger on my radio, but nothing happened. He turned and walked away. See, the thing of it is, you can't win in a nightclub if you insist upon doing something we don't want you to do. I'm not alone. I have a radio. I have backup. I'm reasonably confident I can handle most things on my own, but I'm *supposed* to call someone first. You can engage in whatever histrionics make you happy at that moment, but if you can't bring yourself to back down, you're not leaving yourself, or us, a lot of options. All I have to do is make one call and I can have thirty guys come running, and you'll be engulfed in a sea of black within moments. Can you beat up thirty bouncers? If you can, God bless you. Most people can't.

An hour or so later: "Side bar! Side bar! Side bar! Side bar!"

Everyone was already outside by the time I fought my way up the VIP stairs and out to the side bar. One group had been taken out the near side door, into the adjacent alleyway, and the other had been dragged out the front. I fell in line with a group of bouncers who were on their way to help with whatever was happening at the side door. Migs was in the alley, questioning the customer who had apparently thrown the first punch.

"What happened?" he asked.

"Bro, you see this?" the customer said, displaying a prominent wet stain on the side of his pant leg.

"So? You're wet. Why'd you throw a punch?"

"Yo, he pissed on me!"

"Huh?"

"That guy pissed on me! He unzipped his fuckin' pants and pissed on my leg. That's why I hit him. What the fuck would you do if someone pissed on you?"

"Did he do it on purpose?"

"How the fuck would I know? I'm standin' there talkin' to my girlfriend, and the next thing I know, my leg's wet, and he's standin' there pissin' on me. That motherfucker's lucky he ain't dead."

"Did anybody see this?" Migs asked, looking to verify the story with a bouncer before making a decision.

"Yo, nobody *had* to see it. I'm here with my girl, man. I ain't gonna fight with nobody. That motherfucker pissed on me. What would you do?"

Migs considered this. "You know what? I believe this fucking guy. You don't wanna come back in like that, do you?"

"Fuck no. I'm gonna go throw out these fuckin' pants and drive to fuckin' Staten Island in my underwear. Fuckin' two-hundred-dollar pair of jeans."

Migs took out his radio. "Ray, you still got the guy who got hit?"

"Yeah. He says he didn't do nothing."

"Do me a favor. Tell him we got him pissin' on this guy's leg on camera."

After about thirty seconds, Ray came back on. "He said the line was too long, and he couldn't hold it no more."

The thing I was having trouble understanding was the sense of entitlement these people seemed to have, as if it was perfectly acceptable to demand whatever the hell they wanted as loudly and as forcefully as they could. Shit, most of them didn't even go so far as to demand it. The philosophy was this: simply do whatever the fuck you want, whenever you want, and when someone has the audacity to call you on it, you throw a tantrum. You curse. You scream. You piss on people's legs. You turn everything into a goddamned federal case where even the smallest of slights elicits a visceral reaction requiring the intervention of twenty or more angry men with radios and flashlights and frustration to spare.

Why does this happen? What gives them license? They're in an expensive, exclusive club, spending shitloads of money. Where do they get it? Where did the guy on the cell phone find the thousand dollars he claimed he'd blown that night? If he were ever to come to me looking for a job, with his rudeness, and his arrogance, and his disdain for anyone other than himself, I'd tell him to get the

fuck off the property. He wants what he wants, *when* he wants it, but in what parallel universe does a guy like that *ever* get *anything* he wants?

What gives people this impression? What makes them think that unpleasantness is their ticket to anything at all? With their poorly advised choice of hairstyles and clothing, their dearth of rudimentary communication skills, and the complete and total absence of decorum and manners, how could they possibly get by in life on even the most basic of levels? How can they survive?

"How you making out?" asked Ray as we put away our radios at the end of the night. "You like being in the VIP?"

"Dude, those people are *assholes,* every single one of them. You throw up a set of ropes, and it's like these idiots are attracted to them like they got magnets inside. I swear to God, man, you could put a set of ropes in the middle of nowhere, in front of nothing, and you'd have twenty shitheads trying to sneak through them anyway."

"You heard about the guy who pissed on someone's leg?"

"Yeah," I replied. "I was outside with the guy who got pissed on. I heard you on the radio with that other prick. He fucking got this guy good. I don't think he even knew he was getting pissed on until the guy was done pissing."

"Weird fucking crowd tonight. Somebody slipped GHB into one of the bartenders' drinks, too."

"No shit? Which one?"

"The girl who works up top in the middle bar," he said. "I forget her fucking name already. The blonde. The one who don't talk to anybody except when she needs something, the arrogant little cunt."

"She okay?"

"Yeah. She was in the office for a while, and I think they had somebody drive her home."

6

FRINGE

SCENE: Four thirty A.M. *in West Chelsea. Past closing, front of the club, me preparing to leave, thinking about my post-shift bagel and long ride home. Ray nudging me toward the radio cabinet in the back closet of the lobby.*

RAY: You gotta come to the diner with me.

ME: Now?

RAY: Yeah. Right now. I been talking to this Spanish girl all night, and she and her friend wanna go to the diner. They're gonna wait for us.

ME: Are we gonna take them somewhere after?

RAY: Yeah, you dumb fuck. Just put your radio away and hurry up. You got any money on you?

ME: Of course I got money on me. You need me to fucking pay or something?

RAY: No. Just hurry the fuck up before they leave.

ME: How's the friend look?

RAY: Worth it.

———

WE WERE HEADING uptown. *Far* uptown. When you're not *from* uptown, but you know New York and the way the neighborhoods go here, you start getting nervous around 110th Street or so, because that's foreign territory for bridge-and-tunnel people. People from Queens or Long Island simply don't go that far north. I sat in the backseat of Ray's Mercury and peered out the window as the streets of Washington Heights rolled past. Karlita, the "friend," was drunk, her head on my shoulder. She was snoring, and I wasn't pleased with the viewing angle I was being offered. I wondered if my car would still be there when we finished.

"Make a left over here," said Ray's girl, motioning toward the sign for 175th Street. "We're right on the corner of Saint Nick."

They said they were nurses at Columbia Presbyterian. Over breakfast, Karlita told me she worked in the cardiology unit and that surgeons would request her, specifically, for their most difficult jobs. She told me she was *that* good. While we all waited for our eggs, they'd gone to the bathroom and stayed there for almost ten minutes. Karlita's friend's name was Iovanna. They were Dominican, they said, and Karlita, slender and with softer features, was the more attractive of the two. When they came back to the table, their voices were louder than they were before they'd left.

"If you guys want some wine or beer or something," Iovanna said, turning on the lights in the apartment's living room, "just help yourselves. We'll be back in a minute."

"Listen to me," said Ray as soon as they'd left the room. "Just do what you gotta do and get the fuck out. If you fall asleep, I'm fucking leaving you here. I don't wanna be here more than an hour. I gotta be at work at eight."

"Okay."

"If you walk out and I'm not done yet, go sit in the hallway and wait for me. If I'm not done by five thirty, call my phone, okay?"

"Sure."

WHEN IT WAS over, Karlita rolled onto her side and went to sleep. I dressed, hurriedly scrawled my cell number on a pad I'd been keeping in my pocket for just that purpose, and left it on her nightstand. I had enjoyed this. I hadn't counted on sampling the wares much at Axis—the breakup with Kate had induced a rather pronounced valley in the contour of my confidence curve—so a random uptown plug-and-run wasn't entirely unwelcome after a night spent keeping the zoo. At four thirty, I was locking the front door of the club with an Allen key. At five fifteen, I was in Washington Heights, being straddled by a Dominican nurse with breasts I could hang my keys on. Life had been worse.

I closed her bedroom door behind me and made my way, in the dark, back into the living room. Iovanna was asleep, fully clothed, on the couch. Ray was sitting on a recliner in front of a large television, remote in hand, absently flipping through channels.

"You done?" he asked.

"Yeah."

He stood and turned off the TV. "How was it?"

"It was good. I needed that. What the fuck happened in here? She still has her clothes on. You get in a fight or something?"

"Sort of."

"Sort of?" I asked. "I didn't hear anything out here. What happened?"

"I didn't like her feet."

SCENE: *Ray started the car and pulled out onto Broadway, joining the "trade parade" of delivery trucks and taxis that had been in full swing for nearly an hour. In the distance, the sun was rising over the South Bronx.*

ME: You mind if I ask?

RAY: Ask what?

ME: What the problem was with her feet.

RAY: She had bad feet. That's what the problem was. They looked like two loaves of potato bread with bandages on them.

ME (rubbing my eyes and yawning): So you didn't do anything with that girl because she had bad feet? What the fuck does that have to do with anything?

RAY: It's one of my things. I look at feet.

ME: Are you serious?

RAY: Yeah, I'm serious. If a girl doesn't have good feet, it ruins it for me. This one was wearing boots tonight, otherwise I would have noticed. She took her boots off and it almost made me sick.

ME: What the fuck do you get out of looking at feet?

RAY: Hey, say whatever you want, but it's just one more thing I can use. Look at it this way. If you went into the bedroom with that girl, and she took her shirt off and her tits came down to her belly button, would you still bang her?

ME: I don't know.

RAY: No, I mean if they were really, really bad. Like, you've never seen anything that bad in your entire life.

ME: I know what you mean, but it's five in the morning and I'd just want to get it over with, you know? Turn out the lights and it's all the same once it's in. Who gives a fuck about their feet?

RAY: I do.

ME: You take the shit *that* seriously?

RAY: I'm probably one of the world's experts on women's feet. I can look at some broad's feet and tell you where she ranks with all the other broads in the world.

ME: So a girl could be a supermodel, with everything else perfect. Perfect face, perfect ass, and perfect tits, and you wouldn't touch her if her feet were bad.

RAY (opening the window and spitting): Probably not.

ME: How about if she was perfect? Everything about her was perfect, even her feet. Absolutely drop-dead gorgeous, with perfect feet, except she was missing a toe. What about that?

RAY: I don't know if I could do it.

ME: Not even at five in the fucking morning in the middle of Washington Heights, when you're the one who decided to bring us both up here in the first place?

RAY: Only if you let me amputate the fucking things.

———

"ROB, TURN AROUND."

The guido was taunting me. He was standing behind me, wide-legged, with his hand on his crotch, and I'd caught him in the act. Rather, Johnny had caught him in the act and pointed this out. What I would do with the information—whether I would act on it or not—was entirely up to me.

We'd responded to a fight at the back bar. When anything happened back there, I'd have to leave my spot and weave through hundreds of oblivious drunks who had no idea what I or the rest of the black-suited mongoloids running through their section were so upset about. Getting to the back bar always took some work, but I'd been among the first this time.

Things had been moved outside rather smoothly, and the crotch-grabbing guido was the one I'd pulled out the door myself. When you throw a guido out of a club, he'll fight your grasp—he'll fight the concept of being tossed—but he won't fight *you*. He won't turn and square off with you. All he wants to do is get away so he can yell and scream. He doesn't want to rumble.

On the sidewalk, they stay quiet if they know you're physically superior. Guidos don't like pain. They don't like to be embarrassed. It's only when you make a move to go back inside that they'll yell at you. They'll move behind their friends, or another

bouncer they think won't do anything to them, and they'll call you every name in the book. Or they'll wait until you turn around and they'll grab their crotches.

This guido had been nabbed. He'd been seen. He was embarrassed and afraid, and he straightened up and braced for a confrontation. I laughed at him. I laughed at his life. I laughed at *my* life, and I laughed at the notion of collecting a check to stand still for eight hours amidst hordes of frightened guidos, all of whom had made their way over New York's bridges and through New York's tunnels to arrive at this moment with me. They're interchangeable, these guidos. It was simply this one's turn.

"What the fuck was that supposed to be?" I asked, moving toward him.

He backed away. "Yo, you fuckin' threw me out for no reason!"

"Come over here," I said. "Let me talk to you for a minute, then."

"I could come back in?"

"I dunno. Are you tired?"

"No," he replied.

"Then get *bushed*," I said, grabbing him by the shirt and throwing him face-first into the potted shrub next to the door. "And stay the fuck down."

I was doing well for myself that night. Within the course of one fight-call response, I'd accomplished a significant amount in bouncer terms. I'd been among the first to run to the situation and I'd thrown one of the combatants out of the club, then tossed him into a bush. This was a score for any bouncer, and all was seen and processed by the staff, most of whom had come running outside after hearing the urgency of the original radio call. I was earning my respect.

"Rob," called Migs, gesturing at a customer with a cut over his eye. "Go inside and see if they got everyone from the other group. Nobody's picking up the fucking radio in there."

I moved from bouncer to bouncer, looking for answers, but nobody knew anything. Evidently, the customer who'd initiated the entire thing was still roaming around inside, and several bouncers were in the process of looking for him. I went back to the side door.

"The one guy who hit him isn't up front and nobody inside grabbed him yet. They're still looking for him."

I'd violated a cardinal rule of bouncing here: you *never* give one side of an altercation *any* information about where the other side has been taken. This is because you can't ever satisfy someone who's just been in a fight. I could say, "We took the guy who hit you out back, cut his balls off and fed them to him, then stabbed him in both eyes with an icepick," and it *still* wouldn't be enough in the moments immediately after something's been broken up. Hearing what I'd said to Migs infuriated the bleeder anew and he tried to make a run inside. His friend, the guido I'd thrown into the bush, tried to go with him. They were restrained, violently, by the bouncers Migs had told to stay outside. Punches were thrown. The bleeder was covering everyone with his blood.

"What the fuck is wrong with you?" shouted Migs. "Are you a fucking asshole? Is this your first fucking day on the job, you stupid fucking prick? Use your fucking radio next time!"

"Sorry."

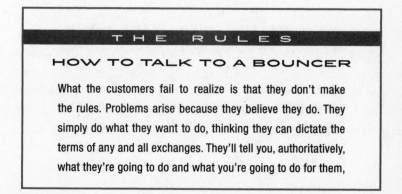

THE RULES

HOW TO TALK TO A BOUNCER

What the customers fail to realize is that they don't make the rules. Problems arise because they believe they do. They simply do what they want to do, thinking they can dictate the terms of any and all exchanges. They'll tell you, authoritatively, what they're going to do and what you're going to do for them,

as if the five-dollar bill they're waving in your face is a signed covenant obligating you to risk your job on their behalf while they're off razoring lines of coke on the toilet seat.

If you want something in a club badly enough, all you really have to do to get a bouncer to look the other way, or to open a locked door, is be polite. Have manners. Throw in some niceties—the conventional ones like "please" and "excuse me." Bouncers appreciate them. Ask permission. Say, "I'll give you twenty dollars *if you allow me to* . . ." Approach us like this:

"HEY, I REALLY FEEL FOR YOU, DUDE. DOING WHAT YOU DO MUST SUCK ASS. I HOPE THEY PAY YOU ENOUGH." This sort of thing disarms us from the start. This person is nice. This person sees me struggling. I will hear this person out and not be an asshole. This person has *a chance.*

"LISTEN, I DON'T WANT TO BE A PAIN IN THE ASS, BECAUSE I KNOW PEOPLE COME UP AND BOTHER YOU ALL NIGHT, BUT CAN I ASK YOU A QUESTION?" Say this, and you're well on your way. You're so refreshingly pleasant that I'll likely "hook you up" without even asking for a payoff, provided you don't blow it later on. Chances are, if you have enough class to phrase things like this, you'll also know there's a payment involved, so I'll not try to shake you down. Starting an exchange in this manner serves to further enhance the power of a cash payment as the swift kick that sends a teetering bouncer over to your side of the request fence.

It's when you don't know what not to say or do that things become complicated, which is a crying shame. What custom-

ers too often overlook is the fact that bouncers know the inner workings of the club better than anyone. Whatever your dilemma, chances are we've dealt with the exact same situation hundreds of times in the course of our work. Any experienced bouncer, if simply asked—as opposed to *told*—could easily suggest a more appropriate place to transact "business" than the ones customers are always so anxious to occupy. They lose us, though. They lose us in their approach, which is, more often than not, all wrong:

DON'T TOUCH US.

A simple tap on the shoulder is perfectly fine if you need my attention, but that's where the contact has to stop. Don't grab my shoulder. Don't digitally manipulate me every thirty seconds with some contrived "street handshake." Above all, do not hook your hand around my head in order to make yourself heard more clearly. This will result in injury.

DON'T TRY TO MAKE INNOCUOUS, INANE SMALL TALK ABOUT THE CLUB.

To any bouncer who's been working in an establishment for more than two weeks, the club is something about which he tries not to think. The last thing we want to do is engage in idle bullshitting about the place with you, especially when your breath has us on the verge of passing out. The following opening lines are to be avoided at all costs:

"YO, MAN, THERE'S SOME HOT BITCHES UP IN HERE TONIGHT!" This is not a bingo parlor. It's a popular nightclub in the middle of New York City on a

Saturday night. A more effective course of action would be to scan the crowd for a particularly "hot bitch," point her out to a bouncer, then attempt to engage in a mutual appreciation of her aesthetic merit.

"YO, THIS CLUB IS FUCKIN' PACKED TONIGHT, KID! IS IT ALWAYS LIKE THIS UP IN HERE?" Yes, it is, and the bouncer you're asking will be forever in your debt when you remind him of how miserable he is as your balls compress against his leg.

"YO, THIS DJ PLAYS SOME DOPE SHIT, YO! HE GOT THE BITCHES MOVIN'!" Well, yes, it's a very nice thing that hundreds of beautiful women are dancing in front of me, but what, in either my appearance or demeanor, would indicate an affinity for this auditorily invasive wall of noise that nightly inflicts permanent damage upon my hearing? Ninety-nine percent of all nightclub bouncers despise house music. Many of us are also sober, and haven't been skating on ecstasy tabs all night. Don't expect us to appreciate it along with you.

"YO, YOU GET A LOT OF FIGHTS UP IN HERE, YO?" No, asshole. The thirty men you see wearing black suits are engaging in a form of performance art. We're part of an interactive interior design package. It's the new wave in nightclub sidewall ambience.

You like?

7

MIRAGES

SCENE: I was tired. Very, very tired. It was mid-shift, back of the club, and I was standing with Johnny, watching the crowded dance floor. A girl caught our eye.

JOHNNY: There's an ass for you, kid.

ME: I'm diggin' the camouflage.

JOHNNY: I wouldn't mind doing a little spackle job on that.

ME: Nice way for a married guy to talk.

JOHNNY: That's all you can hope for, my friend. She's gotta have some of that yellow caution tape around that snatch, otherwise I'm gonna sit here and do this all night.

ME: I couldn't afford it, anyways.

JOHNNY: How about that one? That's affordable, even on *your* salary.

ME: I dunno. I was hoping to do a little better than that, I start going after anything in this place.

JOHNNY: Those are the ones you gotta aim for in your position. Little spackle job on that, and there's no *way* she's gonna spit

it out. Look at that flap under her chin, kid. She's gonna store
it in there like a fuckin' pelican.

ME: I'm so tired that's actually funny.

————

IT'S A BEAT-DOWN, whipped-dog kind of tired, the kind
of tired you get when you bounce on weeknights and try to hold
down a regular day job. You do it on a Thursday night, say, and
you won't be getting any sleep from Thursday morning until Fri-
day night. That's how this thing works. When *you're* home, in
your bedroom, getting ready to settle in after a hard day's work,
I'm feeling the same way you are, only I'm mounting a carpeted
cube, keeping the peace for three thousand people who, evidently,
don't have the same problems as the rest of us.

Try this schedule one day after you think a bouncer's been rude
to you. Do your daily thing. Go to work, or school, or whatever
it is you do, and when you come home, start your normal evening
routine. Eat something, watch some TV, read the paper, study,
and all the rest. Wait it out. You'll get tired around the time you're
done digesting dinner. When this happens, head off into the bed-
room, but only for about twenty minutes, because when you're
just ready to nod off, it's time to go.

Get your ass up. Take a shower, get dressed, and go down to
your local nightclub. Stand in the same place for the next seven
hours and invite as much verbal abuse as the locals are willing to
dole out. Take a few punches. Get yourself good and angry, but
make absolutely sure you don't have anything to eat, because any-
thing that makes you happy—other than the receiving of fellatio
in the bathroom stall, that is—will get you fired. And keep your
damned hands out of your pockets.

When your seven hours are up, you're free to go home and sleep,
but you're still obligated to go about your business the next day,
so you'll only be getting about an hour's nap. Maybe less, if you're

still worked up from something that happened the night before. Of course, "the night before," for bouncers with day jobs, usually means "an hour ago," but it won't make a difference to you when your boss is asking why your eyes are so damned bloodshot.

"Maybe you ought to think about quitting that night job," he'll say. "I can't have you coming in here looking like you just smoked a half ounce."

"I'll quit my night job if you give me a raise," you'll reply.

"We can't do that." And so on.

The experiment's over when you're finished with everything you're required to do the next day, but not before then. And make sure you go through the whole next day with a big, fat, phony grin on your face, lest anyone inquire as to why you're in such a foul mood.

You'll see what I mean. It's not always the customers. They're not entirely at fault here. They'll inhale their lines, they'll drink their Red Bulls with vodka, and they'll ask a sober bouncer, awake for nearly twenty-four hours straight, to share, willingly, in their state of euphoria. I understand this, to be sure, but it's not something in which, given my customary unwillingness to socialize under normal circumstances, I'm always primed to participate.

Still, you try, at least with the people you have to work with every night. There are certain niceties to which one must adapt, and after accruing sufficient experience in the ways of the world, one understands this. You get along. You blend in. Say hello. Talk at length. How's the family? How's the job? Your car running okay?

Paramount in all this is politeness. Getting on well within the framework of a bouncing staff—the assistance of which you may one day desperately need—requires the decency and consideration to participate in the exercise of social graces. The key is to avoid leaving your coworkers with a negative impression. *Rob's okay, isn't he?* You get a drink at the bar? Thank the bartender. Introduce yourself to the new guy on his first night. Another

bouncer covers your post while you take a leak? Thank the guy. Small things, left undone, leave others requiring more, and that's not the way to acceptance. Reciprocating courtesy will take you far in this business. It'll also keep you safe.

What happens, when you work a job for a few months, is you pick up on the social system. At nightclubs especially, there's a well-defined multi-tiered food chain. There are *people who matter,* and as a rank-and-file "inside guy" bouncer, you're not one of them. The *people who matter,* so firmly entrenched within the hierarchy, will assign you your place, and it's decidedly nowhere near the top.

Down here in the lower tiers, it doesn't matter how long you work at a club, because you're expendable. The *people who matter* won't be coming to your wedding or your funeral. They'll never speak to you, and you'll never meet them, because they're the stars. They're the gifted, glamorous few who'll drive their leased Hummers to work and scurry about the club at a thousand miles an hour before the place ever opens, affecting their contrived aura of importance everywhere their magnificence happens to carry them.

I'm too busy to acknowledge your existence, bouncer. I've important work to do here. This is a club, don't you know.

But, you know, there's always that whole sleep-deprivation thing and all, and Jesus do I need a cup of coffee when I get to work. Most nights, I'll have two, taking it with half-and-half and two sugars, sitting alone in what passes for a break room, savoring the last fifteen minutes of relative peace I'll be getting until I'm home.

SHE WAS THE one who worked at the middle bar, I thought—the one who was drugged. I wasn't sure. Sans entourage, for once, she swept regally into the room, a chartered member of the blessed first nightclub tier. The ability to oscillate one's gluteus at an impressively high rate of speed can get you there. I couldn't do that yet, but I had resolved to work on it.

There was no acknowledgment of my presence at all. She perused the offerings on the coffee tray, gave a furtive glance at the clock, pouted dejectedly, and then she was gone. Had I registered?

IT'S NOTHING NEW for us, the ones kept perpetually out of the loop, whatever the loop might be on that given night. You don't know what's going on. You never know. It's not because nobody wants you to know, but because they can't be bothered to *let* you know, so you stand your ground, up on your box, and hope for the best.

The fear, for a bouncer, stems from never knowing exactly who you're dealing with. *What can this guy do?* Is there a weapon? Are the guys up front paying attention? They search, but can they ever be sure? Are we dealing with a lunatic? Will they cross all lines of decency and pick up a bottle?

Can you ever know what you're dealing with? Before I met him, I'd have fought Ray in a heartbeat had he ever crossed me. I'd have unknowingly tangled with a professional who'd ripped through better men than me like an alligator through a sirloin. He's too unassuming to think I'd have done otherwise. He steps on your shoe, maybe, or looks at you the wrong way, and you're mouthing off because you don't know. You simply can't tell, and that's when things get dangerous.

Somebody needed to tell me when the wolves came in, but they didn't think I was important enough to know.

"Middle bar! Middle bar! Middle bar!"

She was in a frenzy now, the one from the break room. A screaming, crying, pointing, accusatory frenzy.

"Him! That asshole right there! Get him the fuck out of here! Now! Throw him out!"

I was last on the scene, as usual, having traversed the entire club from my spot buried deep in the crowded VIP section. A bystander on the fringe of things, waiting for the first spark, that first shove to set the process in motion.

The spark never came. *Nothing.* There was no move from anyone, neither bouncer nor manager, as we all focused on a smiling Migs, who graciously offered handshakes all around and dismissively waved for the staff to return to our posts. *Nothing's happening here, guys.* My bartender girl was still in hysterics in the background. Pretty girl.

A commotion behind me. I ran. One guy, clean-cut, was being bulldozed out the side door.

"What the fuck? You assholes are fucking throwing *me* out? What the fuck? It's them! *They* fucking did it!"

"Listen," said a bouncer named Louis, likely fingering a set of pliers I'd seen him carry, "we're doing you a favor. Them guys'll fuckin' kill you, bro."

"Fuck them! Did you see what they did to her?"

Everything was fragmented. You run from one spot to another, you do the "mad dash," but you never know exactly why. It's impossible to put it all together that way, yet that's how it works. Was he a friend? Her boyfriend? They'd done something to her, she panicked, and he'd retaliated in defense of her honor. Was that it? Did any of this matter to me?

"Was that what I fucking think it was?" I asked Johnny.

"Probably."

"And what? Those guys come in and do whatever they want?"

"Not usually," he replied. "Christian'll have a word with them if they stepped out of line."

"Were those guys friends of his?"

"Everybody's a friend of his, kid. Guy in the black suit's made. Just steer clear of that group. Nobody woulda let you go near 'em even if you tried."

When you bounce, you find out the bartenders call a lot of the shots, because they're bringing in business. If they want someone out, we have to comply, and they're out. Unless, of course, the target turns out to be somebody who isn't ever asked to leave, which is something a bouncer like me won't find out until after the fact.

They come to the club, they have a good time, and we don't think about them. They're not our responsibility unless there's disrespect. Then things turn ugly.

But what *does* happen if they have a problem with a bartender, or a problem with one of us? What the fuck are we supposed to do then? How am I supposed to *know*?

THINGS ARE ALWAYS muddled when bouncers are called upon to take care of situations involving other people's money, yet protecting someone else's investment is the reason we're there in the first place. When a customer has a problem with a bartender, they're not treating it as a business transaction, because in a club, every reaction everyone has to everything is visceral. Hyperemotional, crotch-grabbing, wildly gesticulating displays of cocaine- and methamphetamine-fueled bullshit histrionics. You can't ever get away from it, no matter how calmly you approach these sons of bitches. You ask a patron to move to another bar—you're not even throwing him out—and it's invariably seen as a challenge to his manhood.

"You think you're a fucking big man? Is that what you think? Just because you're a fucking bouncer?"

I've been to my share of nightclubs as a customer. This happens rarely, but it's not something I've never done. When it does, I tend not to have dealings with bouncers. I might strike up a conversation with one, shooting the shit out of a sort of drunken professional curiosity, but they're never a part of my experience, simply because I don't need them to be. I don't ask for special privileges. I don't try to stand where I'm not supposed to stand. I don't duck under ropes, or attempt to force open locked doors. I won't cut in lines for bathrooms, or harass people, or cup peoples' ass cheeks. If I'm displeased with something, my solution to the problem doesn't include shouting obscenities at bouncers, ripping my shirt off and challenging them to fights, or threatening to return later with a gun.

When you're a customer at a Manhattan nightclub, and something goes wrong for you, it's completely unnecessary to engage in childish theatrics. A major nightclub is a multimillion-dollar operation, and it will, for the most part, be run by management personnel with some degree of competence. If you take the time to explain your situation to a manager reasonably and rationally, he or she will, most times, make an honest attempt to set things right for you. At its core, the nightclub industry is all about customer service, and most managers, despite their occasional glaring moral and intellectual shortcomings, pay close attention to this fact. They want your business, and they want you, and everyone you know, to come back and spend your money again.

People think bouncers can solve their problems. We're out on the floor, we're accessible, and you're drunk, so you'll vociferously lodge your profanity-laced complaints in our faces, time after time, thinking we give a shit about whatever it is that's ruining your night. There's no point. We couldn't possibly care less, because we have no financial stake whatsoever in the loss of a few customers. Leave. Go. Get out. There are plenty more under the same rock from under which *you've* emerged, so we hope you go the fuck home and never come back. At worst, there's a good chance you'll piss us off and end your evening sailing headfirst into a Dumpster out back. Management won't do that to you, so I'd advise you to approach them first with any and all complaints.

"Back bar! Back bar! Back bar! Back bar!"

SCENE: You've got nothing for me. You've no rationale for doing what you're doing. By the time we're called over, if there's nobody from management to tell me not to take you out of the club, whatever pile of steaming nonsense you're about to toss in my lap makes no difference whatsoever. You're thirty years old, and you were

just caught engaging in a fruit-fight with a bartender.
You've got nothing for me. I address the customer.

ME: What the fuck are you doing?

CUSTOMER: What?

ME: Dude, you're throwing fruit at the bartender. You can't throw fruit at people.

CUSTOMER: That asshole gave me a bad drink!

ME: What was wrong with it?

CUSTOMER: It didn't taste right! I pay twelve bucks for a Grey Goose and cranberry, and it wasn't fucking right, and that fucker won't make me another one. That's not right!

ME: So you throw fruit at him?

CUSTOMER: It's not right, and *you* know it! What the fuck am I supposed to do?

ME: You ask to speak to a manager. How old are you? Are you a fuckin' adult? You're throwin' *fruit* at people?

CUSTOMER: How am I supposed to find a manager?

ME: Ask a bouncer. We have radios. We'll call one. That's what we're here for.

CUSTOMER: Fuck that! I want my fucking money back.

ME: No. You're leaving first. You want a manager, I'll get one to talk to you outside.

CUSTOMER: Why do I have to leave?

ME: Because you threw your fruit, and now you need a timeout.

———

WHAT WE'RE REALLY concerned with here is *other people's money*—the gold mine on which the club's ownership is sitting. We're there, as security, to protect that investment. It'll eventually occur to you, around two in the morning one night as you stand on your box, how small your stake in that investment actually is. You'll begin to wonder why you've ever cared, and you'll stop.

Try as I might, I've never managed to figure out why some people have the mistaken impression that the safety and sanctity of *their* money, or of *their* capacity to generate it, should concern anyone else, especially those with such a minute stake in the matter. As a bouncer, you're assuming a certain degree of risk in order for other people to have the freedom to procure large quantities of cash that you're never going to see. This assumption rather defies logic, one would think, yet you keep coming back.

It's difficult to care in this regard. It's hard to justify putting yourself out there for people who don't appreciate what you're doing for them in any financially rewarding sense. Bouncing pays fairly well, but when you compare our wages to those of the club's "beautiful people"—our hosts, bartenders, and VIP waitresses—it becomes easier to understand exactly *why* it's almost impossible for us to give a shit about anyone other than ourselves. You're running against your instincts here. To launch yourself into a situation involving people who could potentially change your life for the worse, simply because a female bartender with a perfect ass was offended by something and had to temporarily cease stuffing the registers with bills, is a folly. *Pure folly.* And yet, here we are.

"EXCUSE ME, DO you work here?"

"Yeah," I replied.

"There's a bouncer having a problem with someone in the ladies' room, and everyone just ran out of there."

This left only a bouncer named Juan in the women's bathroom, glaring into an open stall at two male customers and a woman, all three of whom seemed to be suffering from some nasty form of nasal congestion.

"Empty your fuckin' pockets," Juan said. He was a massively built Dominican who, ironically enough, spoke English with a New York accent more pronounced than my own.

"Yo, I told you, I'm not dealing anything! We're just back here getting in the game a little. That's it."

"Listen," Juan said, glancing back at me, "I ain't gonna search you, but I'm tellin' you one time to stay out of the fuckin' bathrooms for the rest of the night. If I see any of you back here again, there's gonna be a major fuckin' problem."

"I swear to God, man. I'm not selling!"

"Whatever. Just get the fuck out."

Three roaches, under the glare of the flashlight, scurrying for the safety of the main room. Why was he letting them stay? Getting caught in the act of snorting coke was acceptable, just as long as you weren't selling it? Do I try to overrule this?

"What the fuck was that?" I asked.

"I thought the guy was back here selling shit."

"And?"

"And what?" he asked.

"And shouldn't we be throwing them out right now?"

"No, 'cause I don't want to hear any bullshit from Don if they bought their shit off him."

"Don?" I asked. "Bartender Don?"

"Yeah. Bartender Don. You see any of them back here again, you just lemme know, okay sunshine?"

———

SCENE: *Rear of the club with Johnny, trying, unsuccessfully, to make sense of what I'd just seen. Trying to stay out of it.*

ME: You know anything about Donnie?

JOHNNY: Donnie from the main bar?

ME: Yeah.

JOHNNY: Yeah, I know him. Why?

ME: I take it he sells coke?

JOHNNY: Probably. Everybody in this place has something to do with that shit, it seems like.

ME: How long has Juan been working here?

JOHNNY: I think he's been here about six months. Actually, I think Donnie's the one who brought him down here for a job.

ME: Fuckin' figures.

JOHNNY: What happened?

ME: I found him back in the bathroom shaking down some kids in one of the stalls. They were gettin' high, and Juan was telling the kid to empty his pockets, and when I went back there and asked him what the fuck was goin' on, he started telling me all this shit about how Donnie doesn't want anyone else sellin' shit in the bathrooms.

JOHNNY: And you can't put two and two together?

ME: I was wondering why I've never seen him make a fight call. The guy just fucking sits there. I don't even think he carries a radio.

JOHNNY: Why should he? Fuck him. Let those fucking guys do what they want. I don't wanna get involved.

ME: You've known about this?

JOHNNY: Of course I know about it, but it has nothing to do with me. Just mind your own business, kid. I seen guys like that come and go. Somebody'll notice what they're doing, and he won't last long. There's plainclothes guys all over the place down here. They pick him up, there'll be another one to take his place.

———

8

SCALE

ttention all security. All security, listen up. Some customer stole Amanda's tip bucket from behind the middle bar. She doesn't know who it was, but look around for anyone carrying a silver tip bucket."

Which, of course, any self-respecting tip thief would have dumped seconds after snatching.

"Amanda?"

"Girl at the middle bar," Johnny replied. "All the way right."

The GHB girl. The one from the break room, who'd had the problem with the crew of "made guys." Busy weekend for Amanda.

What did anyone expect here? What lead were we supposed to be following? *Keep your eyes peeled for a well-dressed man in his twenties, with loads of gel in his hair, who just stuffed a wad of bills in his pocket.* That narrows it down beautifully. *He'll* stand out.

Amanda. As if any of us were supposed to give a shit. We took a lap, went through the motions, and moved right back to our spots, because it wasn't our money that'd gone missing. *Bartenders.* Fuck. Let the superstars fend for themselves. The bouncing

staff stretched its collective legs, walked the requisite walk, then wrote the event off as the momentary distraction it was.

She knew it, too. You could see it in her face, from across the floor, as she screamed at Migs. It wasn't about the money, you could tell. It wasn't the theft itself, but our indifference—the lack of urgency in our half-assed non-attempt to set things right. It was an immediate need for someone simply to *care* about her money. Not to find it, of course, but to care. She was indignant, I assumed, at the serfs' lack of concern for the Lords and Ladies of the Manor.

"Fuck her, bro," Kevin said. "Shit happens. I hate when people fly off the handle like that."

Kevin worked the back of the club adjacent to Johnny's area. With his red hair and signature anomaly—the anvil-hard distension of his beer gut—I'd originally made him for a cop, but he wasn't one. However, this didn't stop him, like most bouncers, from being a miserable prick most nights.

"I don't think anybody deserves to have their pay stolen. That's probably all the money she was gonna make tonight."

"No. Fuck her for actin' like it's our fault. I'm s'posed to give a shit about *her* money? You know what? It's fuckin' gone, and it ain't comin' back. Deal with it. She's more pissed off that nobody cares than she is about losin' the fuckin' cash."

"Hey," I said. "Money's money. I'd be pissed about both."

"You know what? She's gonna put that tip cup back where it was, and she's *still* gonna make more money than you an' me both tonight. Gimme a cut of that shit, and I'll start strip-searchin' motherfuckers."

"What do you do during the day?"

"I'm a high school teacher," he replied.

"See, you *got* a day job, man. You *got* a career."

"So?"

"So," I replied, "I hear what you're saying, but nobody's gonna steal your paycheck. If they do, you just tell your school, and they

cut you another one. That girl worked for free tonight. I feel bad for her is all."

"You think she gives a fuck about you?"

"Probably not."

"Right," he said. "So don't."

KEVIN WAS RIGHT of course. Most times, I can't find it in myself to be sympathetic to any club employee save my fellow bouncers when misfortune strikes, as it *always* will in this business. Bouncers who stand on boxes—inside guys—are the foot soldiers of the nightclub industry. We're the equivalent of your union men. We're rank and file. The money we're paid is a pittance in the grand scheme of a club's cash flow, and so our comings and goings are of little consequence to anyone but us.

Not that we care, mind you. On this job, in this atmosphere, it's always best to fly well clear of the radar to avoid the burdens of significant responsibility. To remain hidden in the dark, back in the far reaches of the club, where nobody will think to ask you to perform any tasks in addition to standing still, thumb in ass, for seven hours. When anything further is assigned, the secret is to have your name as far from management's lips as it can possibly be.

You make their refusal to acknowledge your existence work in your favor. You're part of the untouchable caste, but you're free, standing in a bounded universe of your own design, the limits of which extend only to the tip of your outstretched middle finger. For as long as you're on their dollar—provided you fail to stand out in any way—the sanctity of your motionless anonymity won't be violated by requests to perform the mindless exercises in futility known as "bar tasks."

Do the *people who matter* have favorites among the bouncing staff? Absolutely, but one needs to speak in relative terms when describing the treatment these "favorites" receive. Bouncers are considered a necessary evil in the nightclub business, and the

cultivated narcissism of any nightclub's management types and star bartenders has necessarily created a demarcation line between security and the rest of the club, which neither side ever seems to express a willingness to cross. It's pure stratification, and, as with anything else, it's based upon the financial realities of the scene.

We're menial, sure, but there's a difference here, which may not be apparent: we prefer it that way. The bottom of the ladder is where we'd like to remain, in most cases, because our collective disdain for the entire environment serves to prevent us from ever aspiring to climb it.

I didn't dislike the managers and bartenders at Axis at this point simply because I hadn't met any of them yet. It's entirely possible that some of them could actually have been nice people. We could conceivably have held pleasant conversations on a wide variety of topics. We could've enjoyed each other's company. I mean, why not? Just because I was predisposed to a complete and utter lack of respect for the way they earned their money doesn't mean we couldn't at least have gotten along cordially.

Unlike lower-rung employees in other businesses, bouncers aren't married to the job. The vast majority of us have something else more important going on in our lives, and the existence of that something inevitably leads to a distinct lack of solicitude with regard to the concerns of anyone but ourselves. Barbacks? Dishwashers? Service bartenders? Go ahead, abuse them. Say anything you want. Ram your overtime down all their throats. It's fine, because they're desperate to hang on to their jobs, and they'll take it without complaint. A bouncer? Hell, you're lucky if a wad of spit in your eye is all you get, should you take an abusive tone. He simply doesn't give a shit, because another job is a phone call away.

Bouncer abuse didn't happen at Axis, but it wasn't a matter of management fearing the consequences. See, in order to abuse someone, it helps to have some prior knowledge of their presence in the club, something the *people who matter* rarely seemed to notice. They rarely realized we were even there until they needed us.

Still, we reap the benefits, since there's nothing extra to do. There's nothing extra to say. Instead of calling a bouncer on the radio to ask a question, however simple, upper management will send a member of the floor management or bar staff across the club to take a cursory glance at a situation and give a report. And I'm not referring to anything technical here, either. For example, when *the people upstairs* want to know if the temperature in a specific area of the club is comfortable, they'll uproot a bar manager from whatever he's doing and send the poor bastard over to check things out, despite the fact that the same bouncer has likely been posted in that particular room for the past six months and could undoubtedly do a much better job of informing the questioner whether conditions in his sector differed significantly from the norm.

Simply put, Christian didn't think I was intellectually capable of telling him whether I was hot, cold, or comfortable. I liked it better that way.

"FUCK," AMANDA SAID softly, eyeing the small alleyway parking lot designated for club employees, at least the important ones. I parked in a garage when I drove to work.

"Fuck!"

"You okay?" I asked. She seemed smaller outside.

"Fucking Maria. Fucking coked-up bitch took off."

"Your ride?"

"Yeah," she replied. "Shit!"

"Where do you live?"

"Whitestone." Queens. *Surprise, surprise.*

"You need a ride? I live in Queens."

"No, thanks. It's okay. I don't wanna make you go out of your way. I'll just call a cab."

"Listen, it's fine. You were the one that had the money stolen before, right? And you got drugged the other night, no?"

"Yeah."

"You had a bad night," I said. "Lemme make sure you get home okay."

"You sure?"

"Seriously, it's not a problem. Whitestone's on my way."

"Can we stop at a diner, then? Do you mind? I'll buy you breakfast."

———

SCENE: The Gemini Diner, a little piece of shit on Second Avenue, but an empty little piece of shit, which is exactly what you want after doing what we do. You can't go where the customers go. You simply can't, so we went somewhere I knew they wouldn't be.

AMANDA: I've never seen you before. Did you just start working at Axis?

ME: You always get in cars with guys you've never seen before?

AMANDA: No, really. Are you new?

ME: See, this goes with my theory about everybody at the club who's not a bouncer.

AMANDA: What?

ME: I've been working there almost four months now, and you think I'm new. I've been standing in the same spot, on the same box, the whole time, and *still* nobody even knows my name.

AMANDA: I'm usually really busy behind the bar.

ME: Yeah, I know. And I'm not posted anywhere near you, so I wouldn't figure you'd ever seen me before. I'm kidding. I was talking more about management and the VIP guys.

AMANDA: They're all assholes.

ME: Even to you guys? The bartenders?

AMANDA: *Especially* to us, and especially for the girls.

ME: They try to get you to do shit?

AMANDA: What do you think? Of *course* they do. All night,

every night. Everyone in that place is so fucking lecherous. Be thankful you don't have to put up with it.

ME: Well, I mean, I kinda figured that, but it's just so stereotypical. I figured a place like Axis would be a little more professional with that kind of shit.

AMANDA: Are you serious? I can't *wait* to get the fuck out of that place.

ME: Really? You gotta be making sick money back there, though, right?

AMANDA: Yeah, but who wants to do that for a living? I didn't go to college for a bunch of scumbags to pimp me out every Saturday night. I can't do the shit the rest of these girls do.

ME: Where'd you go to school?

AMANDA: Saint John's, and I was in grad school at NYU, but I stopped when my father got sick.

ME: Oh, shit. Sorry. Is he okay?

AMANDA: Yeah, he's in remission. He had a blood cancer. Multiple myeloma.

ME: That's really rare, isn't it?

AMANDA: Yes. It is. How'd you know that?

ME: I knew someone who had it. So how much longer do you think you'll be doing this?

AMANDA: As soon as I can get up enough money to go back to school, I'm cutting down to like one shift a week, if they let me, and I'm going to finish school and get out of New York as soon as I'm done. I can't stand it here, and working in clubs makes it worse.

ME: What are you taking in grad school?

AMANDA: Educational administration.

ME: You're a teacher?

AMANDA: Well, no, but I will be. I'm certified, but I was making more money doing this so I kind of got caught up in it and never really looked for a teaching job.

ME: I thought about that a little.

AMANDA: What, teaching?

ME: Yeah. I still have to finish school, though. I dropped out a long time ago.

AMANDA: So why don't you go back?

ME: I dunno. I guess I've been kind of unmotivated these last few years. Haven't really thought much about it.

AMANDA: You should! You seem really smart. I can tell just from talking to you. You'd make a great teacher!

ME: Maybe. I got some issues, though, believe me. You wanna get the check?

AMANDA: Hey, thanks for this.

ME: For what?

AMANDA: For just talking. This was a shitty night, and I think maybe I just needed to know that there was one other decent person in that place.

ME: There are, but we're all wearing black suits, so you can't see us in the dark.

AMANDA: Listen. Here's my number. It's on the card . . .

ME: You have a business card? For *bartending*?

AMANDA: They make them for us. It's not like I ever give any of these out. Anyway, that's my cell number written on there. If you ever just wanna talk . . .

ME: This is funny.

AMANDA: What?

ME: The irony.

AMANDA: What irony?

ME: Don't worry about it. It's just ironic that you've got all these assholes throwing money at you all night, and a guy with twenty dollars in his pocket is the one who ends up with your number.

AMANDA: Oh, stop. You're cute. Stop selling yourself short. And don't lose the card, either.

ME: You gonna say hello to me from now on?

9

THE DREAM

"Dance floor! Dance floor! Dance floor! Dance floor!"

Relax, relax, relax. It's bullshit. Guy punched another guy from behind, but the dance-floor security crew had the lid on things before anyone could retaliate. One group was taken to the front, the other to the back. I had arrived late, as usual, so I had my choice of which group to assist. I chose the back, thinking I could avoid the crowd at the door.

"Yo, Rob," said Louis. "Run over to the bar and get some napkins and a bottle of water. One of these kids is bleedin'."

"HERE," I SAID, handing over the towel and napkins to the customer, who was bleeding profusely from a cut over his left eye. "Dip the napkins in the water and keep pressing it over the cut. It'll help stop the bleeding."

"Yo, where's da niggas who hit me?"

"Excuse me?"

"Where's them muthafuckas who hit me?" he clarified.

"Gone," I replied. "They got kicked out. You wanna press charges or anything?"

"No. I jus' wan' dis ting to stop bleedin'. I ain' got health insurance an' shit."

"Just keep pressing the towel on it 'til it stops. That cut's not deep."

"Yo," he said, standing now, "ain'chu got nothin' better than dis?"

"Huh? Dude, sit down."

"Yo, I'm bleedin' muthafucka! What'chu got to say about dat?"

"Say about what?" I said, as his friends and the other bouncers who'd remained outside inched closer. "Just keep the fucking towel on it. You're bleeding so much 'cause you've been drinking and your blood's thinned out. Just calm the fuck down."

"Yo, nigga! You gots to do somethin'!"

"Say that word again, and you're gonna *need* fuckin' stitches, asshole. The fuck's wrong with you?"

"This is bullshit, muthafucka!" he screamed, standing up again. "What would you do if a nigga dropped dead right here? You can't do nothin' bout dat, right?"

"Holy shit. Okay, listen close." Enunciating. "What the fuck do you want me to do for you?"

"Yo, can't you see I'm bleedin', muthafucka?"

"Enough," I said. "Fuck this. Guys," I said to his group of friends, "I don't know what this fucking idiot wants us to do, but he's got a towel, and he's got water, and he's got Band-Aids. You got in a fight, and it's three thirty in the fuckin' morning, and if your friend here wants to stop bleeding, he should go to a fucking emergency room and see a fucking doctor, instead of standing out here and yelling at me like a fucking retard."

"Is the guy that hit him still in there?"

"Honestly, dude? I couldn't give two shits. Your buddy here's not getting any more help from us. Take the fucking Band-Aids and the water and go to a goddamned hospital if it's that bad. Have a nice night."

"WHAT IN THE hell was *that*?"

"I told you, man," said Ray. "It's gonna start gettin' bad in here."

"*That* bad? That kid was a straight-up piece of trash. No wonder somebody fucking tuned him up. You believe that shit?"

"Hey, listen. Things in this business don't stay good forever, man. Get used to it, 'cause you're gonna be seein' more and more shit like that from now on."

"What *was* that fucking kid?" I asked. "I mean, I couldn't understand a word he was saying. He wasn't black, but he was talking like a damned rap video. Nigga this and nigga that. What the fuck?"

"Guidos, son. Word to your moms, yo."

"Guidos talk in fucking Ebonics now? Man, I been outta this loop way too long."

"Get ready, son," he said. "They comin'. You just got a little taste of how things are gonna be."

"Word?"

I THOUGHT ABOUT Amanda, and how good it feels when you meet someone new, and about how bad it feels when the someone new you've met is someone from a club—the one pool in which I didn't want to dip a toe. Whether they worked there or not, I associated every girl I met *at* Axis *with* Axis, and the association wasn't a positive one to my line of thinking.

Two weeks before I met Amanda, I had handled a situation on the side of the club, which essentially formed my opinion of club-related women, at least of the ones with whom I'd be coming in contact. I was standing in my spot in front of the VIP kitchen, when Migs called me on the radio.

"Rob," he said, "go out the VIP door and take a walk down the alley. Juan said he saw some girls go in there a couple of minutes ago, and they haven't come out yet."

I went out the door and took a left, walking toward the set of Dumpsters outside the barbacks' area. I heard laughter—female voices—coming from behind the fence surrounding the trash compactor.

"Excuse me! Ladies! What are we doing back here?"

"One minute!" came the group reply.

"No! No minutes! Get the fuck out here now! All of you!"

One obviously inebriated girl staggered out, saying, "Everything's okay. We're not doing anything."

"It doesn't matter what you're doing. You can't be back here. The rest of you gotta come out here now!" A liquid trail came flowing out from under the Dumpster nearest the gate, which was supposed to be locked but wasn't. "Get the fuck out here before you get locked up. You're fucking trespassing!"

A second girl waddled out, holding a glass. "Jesus, we're leaving already! Calm down!"

"Honey, do me a favor and throw the glass in the Dumpster. There's a shitload of cops outside, and you're gonna get us both in trouble walking around with an open container."

"I'm not finished yet!" she replied. "Hey, baby, are you having a bad night? You're cute. You should smile more. I bet women would like you better if you smiled more."

"Wow. You're pretty fucked up." I smiled. "Listen, tell your friend back there to finish up quick. You guys gotta get out of here."

"One minute!" came from behind the Dumpster.

"What the fuck?" I asked. "Is she taking a dump back there or something?"

"For your information," said the final girl, making her way around the gate, "I was changing my tampon. You wanna see?" she asked, proceeding to thrust the bloodied vaginal implement in my direction.

"Jesus Christ," I said. "Have some fuckin' class, will you please?"

"Caitlin, stop!" cried the first girl. "She doesn't mean it. She's having her period. She's really nice."

"I'm sure she is," I said, backing toward the gate. "Listen, you think I want to be back here yelling at you guys like this? I could give two shits if you wanna be back here doing that."

"He's so sweet," said Caitlin. "Like a big teddy bear. We're sorry, big teddy bear. We're leaving now. But Brittany's right. You *should* smile more."

"Not much to smile about tonight," I replied, thinking of something. "Hey, are you guys Polish by any chance?"

"No," they replied, almost in unison. "Why?"

How many Polish girls does it take to screw in a tampon?

"No reason. You ladies need a cab?"

I'VE ALWAYS BEEN attracted to women who wear glasses. It's a look I like to stare at. Sure it's clichéd and all, but I think it makes them look intelligent, and that works for me somehow. At the club, however, it's always possible to be fooled by the packaging, assuming, mistakenly, that women wearing glasses are all potential Nobel laureates out for an evening's sojourn at the club. Sometimes when I'm at work, I'm so tired that I quietly slip into this fantasyland, where all the pretty girls are virgins, and the ones wearing glasses do so because their eyes are out of focus from reading so much.

One bespectacled beauty in particular enjoyed dancing in my area for hours on end. I would stand at my post and watch, envisioning her in a laboratory somewhere, feverishly working on some radical cure for cancer, or as a tough-as-nails investigative reporter, shaking out the scandals of Tammany Hall, toiling deep into the night pounding out copy for the next morning's editions. I was digging her, or at least my delusional version of her, which was about as close to reality as the artificial environs of the nightclub industry itself.

She'd set me to daydreaming, imagining a world where she

and I could sit, sipping strong coffee from Navajo pottery mugs, wearing hipster glasses, listening to jazz and discussing books. We were young and hip in these dreams. Maybe we'd have our laptops in a wi-fi hub, reading the latest *Wired* and blogging. On the way home to our loft in DUMBO—with its exposed brick walls, cathedral ceiling, and mountain bikes hanging on the wall—we'd trade "world music" MP3s to listen to on our iPods, and stop to sculpt and tone our shiny vegetarian bodies in yoga class. Late at night, she'd throw on a symphony and paint—in a style she'd call "experimental abstract"—on the numerous easels dotting our postwar brownstone, which she'd lovingly refer to as our "space." In those dreams, I loved her for her quirks.

"Look at that fucking slut," said Johnny, gesturing at the center of the VIP room, where the "glasses girl" was clearly enjoying a thorough groping from a trio of strangers. "You believe what goes on in this fuckin' place?"

"Whatever, man. I'm used to it by now."

"Why, you don't like this shit?"

"Ha."

"You know, me and my wife do this shit all the time. We come to the club and dance and act all undignified, and then I turn her around and make her dry-hump five other guys. We love that."

"I bet."

"What, you and your girl don't do that? Oh wait, you said you didn't have a girl. Sorry, I forgot you swung that way. Anyways, I even have DJ Charisma make tapes of this music and I play it in the car. I got the baby doin' 'Shake Your Ass' all the way down the street."

"Yeah, I'm gay, John. I don't wanna go in the bathroom and get herpes, and that makes me fucking gay. And you're a forty-five-year-old man workin' in a nightclub. I should take a night off and go over and bang your wife. You know, get into the spirit of things."

"Yeah. You should. And then you know what we could do? We

could stand outside the club cursing at each other while all the bouncers stand there watching us 'til five in the morning."

"Sounds like a great night out."

"Without a doubt. You don't know what you're missing."

————

SCENE: *The Bayside Diner on Northern Boulevard, a vast upgrade from the Gemini. Amanda, smiling, sitting sideways in a booth, her feet dangling over the edge. Her eyes, this early in the morning, were crescents with only a touch of blue available to indicate my progress.*

AMANDA: So what's your story? You don't seem like you're too into this job.

ME: I'm not. I really can't stand it, quite frankly.

AMANDA: Quite frankly? I think you're the only bouncer I've ever heard say "quite frankly" about anything.

ME: Something tells me you don't talk to a lot of bouncers, so you really don't have a large enough statistical sampling to work with if you're gonna generalize like that.

AMANDA: Yeah, you're probably right, but you still speak more eloquently than any of the ones *I've* met.

ME: And you just said "eloquently," so I could say the same thing about you. I don't think I've ever met a hot female bartender who could use the word "eloquently" in a sentence.

AMANDA: You think I'm hot?

ME: Don't flirt. Eat your damned bacon, 'cause I gotta go home and sleep.

AMANDA: Okay, fine. You're all business. I can work with that, so I'll just come right out and ask you.

ME: Ask me what?

AMANDA: Well, from what I can tell, you're a really nice guy. I mean, you're driving me home all the time, you haven't hit

on me once, and you won't take any money for gas, no matter how hard I try to give it to you. And you don't talk like a bouncer, either. I like talking to you. I can have a *conversation* with you.

ME: So?

AMANDA: So, I want to know what you're doing here.

ME: Here? At the diner? I'm tryin' to eat my goddamned omelet. That's what I'm doin' here.

AMANDA: You know what I mean. You seem like an intelligent, decent guy. Not the kind who ends up as a bouncer.

ME: Yeah, well, shit happens. And in case you've never met any of us, there's a lot of intelligent, decent guys right under your nose.

AMANDA: Shit like what?

ME: Just shit, you know? I gotta make a living, just like you do. What's wrong with bouncing?

AMANDA: There's nothing *wrong* with it, per se, but I think I'd feel the same way about bouncing that I do about bartending.

ME: And what's wrong with bartending? You make a damned killing back there, and it's not like anyone's trying to punch you in the face all night.

AMANDA: It's not the job. It's this whole atmosphere. The people. The customers. The drugs. There's nothing healthy about any of this.

ME: Who gives a shit if it's healthy or not? You come in, you do your job, you get paid, and you go home. If you don't get caught up in any of that other bullshit, who cares what you're doing to make your money?

AMANDA: Don't even try to tell me you're satisfied with that.

ME: I never said I was, but at this point in my life, I'm happy to have a roof over my head and my bills paid on time.

AMANDA: And you don't want more than that?

ME: Well, yeah. Sure I do. But this is the situation I'm in. I made

this bed, so now I gotta lay in it for a while. It doesn't bother me all that much either. I'll always get by.

AMANDA: But is that all you want to do? Just "get by"? This is a means for me. Not an end. If you have half a brain, which you obviously do, you don't do this as your livelihood. You do this while you're doing something else that's gonna *get* you to your livelihood.

ME: You know, there's a lot you don't know, so you probably shouldn't go around making judgments on why I ended up here. You think I'm doing this 'cause I want to? Or that I plan on making a career out of it?

AMANDA: That's what I'm trying to figure out.

ME: Well, the answer to that is no. I don't want to be doing this. I fucked up college, fucked up being an athlete, fucked up this, fucked up that, and now here's where we find ourselves. In a fucking diner in Queens at five in the morning getting a motivational speech from someone I know for two weeks.

AMANDA: Don't get mad, Rob. I'm not trying to pry.

ME: Listen. I'm not mad. You can ask me anything you want. It's just that I get this shit from my family twenty-four hours a day, seven days a week, and the only thing I can tell anyone, all the people that act like they're all disappointed in me all the time, is that I'm tryin'. It's hard to be successful. It really is, and I know that, because I tried it, and I failed. But you know what? It ain't easy being a goddamned disgrace all the time, either.

AMANDA: I didn't say you were a disgrace. I don't know you well enough to say that. All I think is that if it gets you so mad that you are where you are, that you should take some of that negative energy and turn it into something good. If you're so down all the time about where you are in life, you have to turn that around and *do* something about it, don't you think?

ME: And what's that supposed to be? I got more bills to pay than

I know what to do with. I gotta keep payin' my rent, my car, my insurance, and everything else. I can't think about anything else but that right now. And what happens? I get a job workin' at Axis, and the money's good, and the people like me. And now I'm in a pretty good spot, and I'm gonna be makin' even more money if Migs moves me over to the front of the ropes. That's okay with me for now. I'm not thinking past that.

AMANDA: I think you're making a mistake if you think Axis is the answer.

ME: Hey, maybe it's not the answer for *you.* Congratulations. You've got shit going on right now. Me? I don't. It's what I've got right now, and I'm gonna make the most of it before I can think of anything else, okay?

AMANDA: That girl really threw a *tampon* at you?

ME: No, she didn't throw it at me. She just kinda held it out so I could inspect it.

AMANDA: And did it pass?

ME: Did it pass for what? By the way, all these guidos are staring at you. I feel like a fucking pimp in here.

AMANDA: I'm so glad you approve. I mean, did you do some kind of professional bouncer visual blood test or something?

ME: Well, I mean it had a couple of crabs stuck to it, but other than that it looked pretty clean.

AMANDA: Lovely.

ME: I'm serious. It looked pretty clean. All you gotta do is shake off the STDs, and . . .

AMANDA: Seriously, though. What kind of a trashy whore lifts her skirt behind a Dumpster? Did they get kicked out or something?

ME: No. One of them was even carrying a full drink. You mean to tell me you've never done that in public?

AMANDA: What, have I ever taken a leak in public? Of course not.

ME: You've never done that? Ever?

AMANDA: Well, I've been camping and stuff, but I'd never do that outside of a club. In Manhattan? That's so trashy.

ME: And you're hardly trashy.

AMANDA: No. I'm not.

ME: Even with that slut top on at a diner at five in the morning.

AMANDA: Fuck you.

ME: We're getting there.

————

10

LUXE

I f you had the available cash or credit, and you wanted the best of what Axis had to offer—there were no limits on what we could provide, mind you, as long as you were willing to spend enough—your best bet was to reserve a table in one of our three VIP rooms. This was easier said than done, at least when the club was still "happening," because you needed to know whom to call, and the privileged few who had that knowledge were usually insiders who'd done business with the club's owners or management in the past.

If you played for the Yankees, and were looking for a big night at Axis—one complete with all the trimmings—you'd have someone call ahead and reserve your place. As a Yankee, you had the name—and with it, the cachet—to move the ropes, and management, cognizant as they seemed to be of *everyone's* bottom line, knew you were a proven commodity who had sufficient scratch to cover the "minimum"—the amount you'd have to spend in order to keep your table for the night.

In return, you'd be given the best seat in the house for a show that vigorously renewed itself, with a fresh set of horseflesh for your enjoyment, every single night. Everything was private in the

VIP rooms—even, in the case of one particular section, the simple fact that it existed in the first place. You'd be contained in a roped-off area with high rollers just like you, granted all your wishes, whatever the fuck they may be, fulfilled by waitresses who had to audition for their jobs, and you'd have your own private security force—us—to make sure you wouldn't be made to mingle with any of the great unwashed who were stupid—or short-moneyed—enough to have to wait in line outside to get in. Fuck them.

The minimum was the thing. At Axis, tables weren't cheap—$2,000 was the figure I'd hear quoted most often by the waitresses and hosts. To cover this, you'd be required to purchase wildly marked-up bottles of champagne or top-shelf liquor all night, until your tab exceeded the magic number, at which point you'd be encouraged to continue spending, preferably until closing time.

For my first few months, the VIP rooms at Axis were filled with the sort of people you'd expect to find there: celebrities, athletes, and corporate types entertaining some of the more adventurous segments of their clientele. These people don't fight. They bitch, they irrationally gripe, and they say and do things the rest of us wouldn't, but they won't attack. Most times, just as Ray had initially told me, they'd come in with their own security, so we'd simply leave them alone and let them drink in peace. All we did, as bouncers, was make sure nobody from the club's *general population* made it through the ropes.

When the custom was of such high quality, the room ran smoothly, and Axis's VIP manager, Vince Manzone, seemed to be the single most vital, highly respected member of the entire hierarchy. A "friend of Vince's" was a friend of Axis, and Vince was given free reign—and a separate entrance—to conduct his rooms as he saw fit. With his Armani suits, his bought-outright Hummer, and his Rolex, Vince was fluent in the language of the higher end, and could be seen, nightly, knocking back flutes of Dom Pérignon with a veritable who's who of New York nightclub society.

I couldn't place Vince's age, exactly. He seemed caught in a

rather awkward in-between stage—a touch too old to cavort with Axis's general population, but not yet prepared to be weighed down by the considerable burdens of becoming, as they say in the business, a *distinguished gentleman.* His suits conjured images of sit-down meetings and ordered "whackings," but his slicked black hair and sideburns hinted at a desire to keep hold of something more innocent. He was, above all things, a man who tried hard to satisfy his *real* constituency: the bouncers who ran his rooms.

"How long you been here?" he asked early one night, as I set up the ropes outside the service bar.

"About six months."

"You ever missed a night? I see you here every fucking night. You ever call in sick?"

"No," I replied. "I need the money too bad."

"Yeah? Why, you got kids or something?"

"No. I'm just used to the extra grand or so a month I've been making since I started doin' this shit."

"How'd you like to make a little more money here?" he asked.

"That'd be nice."

"You wanna work the VIP door? We're moving Ray out of there and putting him up front, and I think you'd be a good fit for the job."

"Really?"

"Yeah, really. It's not that important of a spot, other than just letting people in and out, but I need the same guy up there every single night, so he can have relationships with the people coming in. They need to feel comfortable down here, like they know everybody. You don't even gotta talk to them. Ray's only here every other night, and I want the same guy to be standing up at that door all the time."

"What'd you mean about more money?" I asked. "Do I get a raise for that or something?"

"These are VIP rooms, my man. These people have needs. They're gonna ask you to do shit for them, and I want you to get

them whatever they need. And when you do the right thing by them, they'll do the right thing by you. That's what I'm talking about."

I was thrilled to finally get the opportunity to see the actual forest instead of concentrating all my efforts on keeping the trees from pissing in the kitchen. Posted in front of the service bar, I spent entire nights in a struggle to keep individual customers from doing things they weren't supposed to be doing. Now I'd have an overview of the room where the other half would be playing, and with the confidence I'd gained in my abilities over the six months I'd been at Axis, I'd finally be called upon to take the lead on some things. If something broke out, I'd no longer be pinned in the back of a crowded section, unable to make it out in time to be anything other than a bystander.

It didn't take long to see what Vince was talking about.

"Hey buddy," said a man wearing a black blazer and slacks. He looked like one of us—a bouncer—only he hadn't bought his suit at Burlington Coat Factory. "What's your name?"

"Rob."

"Okay, Rob. My name's Lior. You need anything? You want something to drink?" He extended his hand, slipping a folded bill into mine as I shook it.

"No, thanks," I said. "I'm good. Do *you* need anything?"

The bill was a fifty—a third of my shift pay. When Vince came down the stairs, I called him over.

"Who the fuck is *that* guy?"

"He owns two clubs in the East Village," he replied. "Why? Did he hit you up already?"

"Yeah. He gave me fifty as soon as he walked in the door."

"Okay, two things we gotta talk about here. First, I get twenty for every hundred you make. If it wasn't for me, you wouldn't be at this door, so you gotta kick something back. I gotta kick what I make back upstairs, so you guys gotta hit me up at the end of the night. I'm gonna trust you to be honest with what you got, so don't try to fuck around with it. Twenty for every hundred, and I know you're gonna do good tonight with him here."

"What's number two?" I asked.

"You do whatever that guy asks, no matter how fucking stupid it sounds. If he asks you to walk up to the bar and get him a napkin, I don't give a fuck if you get insulted 'cause you're not a waitress. You go up and get the guy a fucking napkin."

AXIS HAD TWO sets of bathrooms—one for regular customers and one intended only for the use of employees and people in the VIP rooms. As a high roller in the VIP, a folded twenty would afford you the privilege of lining up at a urinal next to the likes of me, which, at two in the morning, is hardly as thrilling as the price tag would indicate. Of course, if you wanted to avoid the lines and the hassles that came with a trip to the general-population bathrooms, you were always free to try your luck at greasing the nearest bouncer to see if he'd let you piss alongside the well-heeled, but most off-the-street customers didn't even know an alternate set of stalls existed.

Later in the night, Lior, a spender with every right to use any bathroom he liked, would nonetheless take this concept to a level I hadn't yet seen.

"Hey, I need a favor."

"Sure," I said.

"Can you walk me to the bathroom?"

"It's right over there," I said, pointing across the room.

"Yeah, I know. I need you to walk me over there."

Walking directly in front of him, I cleared Lior a path to the facilities. After I'd opened the door and let him slide through, he gave me another handshake with a bill inside, and made his way in. I pushed the door shut behind him and snaked back through the crowd to my spot at the door. A few minutes later he returned, visibly agitated.

"Why'd you leave me there?"

I stared at him blankly, hoping against hope that he didn't mean what I thought he did.

"Listen, I need someone to walk me there and back. Can you do that next time, please?"

I kept staring.

"In other words, when you walk me over there, I need you to wait until I come out, and then you walk me back. Can you do that?"

"Yeah," I said. "Sure, man. Sorry about that. I didn't know if I was supposed to be leaving the door."

A hundred dollars for essentially doing nothing was fine by me, but it was the concept of what that nothing was, exactly, that I couldn't get out of my mind. What grown man asks another grown man to walk him to and from a public bathroom? The entire thing—any and all protocol involved with the act of doing this—was completely foreign to me. I had never, and *would* never, ask another man to escort me to a bathroom, of all places. There would be a certain surrender of something—my manhood, per-haps?—involved, which made the scene all the more distasteful.

"I gotta ask you something," I said to Vince.

"What?"

"That guy Lior asked me to walk him to the bathroom, but he wants me to stay over there on that side until he's done, so I can walk him back. You want me doing that?"

"Yeah," he said. "For that guy, I want you doing that. It's fine."

"Should I hold his hand, too?"

I finished that night with over three hundred dollars in my pocket, even after throwing Vince the sixty I owed him as a vig. I had made twice as much from customer handouts as I'd made in shift pay, and was ecstatic about having potentially tripled my sal-ary overnight. New York's struggling post–9/11 economy seemed to have no bearing on how quickly people were willing to part from their money at the club, and Vince, having spoken to me a grand total of three times in six months, had put me in a position to take full advantage of the largesse of some of the loosest wal-lets in the house.

THE CELEBRITIES, HOWEVER, had mostly gone elsewhere. We'd get a few here and there, but the majority of these were people who were paid to be there. They were either performing on the stage or making scheduled, announced appearances in last-ditch attempts by management to continue drawing the same sort of crowd the club had been attracting since we'd opened.

As I was looking out on the main floor six months later, however, there was no mistaking the fact that the demographic had changed. The weeknight crowd seemed much younger and more aggressive, and they dressed in a way I'd never before seen, especially the men. They spiked their hair and shaped their eyebrows into fine points. They all wore similarly striped French-cuffed dress shirts with no cufflinks, allowing their sleeve-ends to dangle uselessly about their wrists. And they *posed*. Every step was a challenge to move out of the way, and quickly. Every sip of a drink was an excuse to flex.

The worst of the bridge-and-tunnel set had arrived. The guidos had taken control.

FOR GUIDOS, "THE CLUB" is assigned a measure of importance entirely disproportionate to what they're given in return. Let's say, for argument's sake, that you're a guido. You pick up your paycheck on Friday morning and you know damned well where the whole thing's going, and there's not a force in the world that can stop it from going there. Come Saturday night, you call up Carmine, Louie, Anthony, and the rest of the boys, and there's only one place you'd ever be going: West Chelsea. You're on your way to 10th Avenue in the 20s, the capital of the known world—the world known to you, at least—where the quality of the "bitches" is something few would ever question.

When nine o'clock rolls around, it's time to break out the new shirt—the tacky one with the stripes "like you seen on the guy at

Crobar"—and start your preparations. Slather your head with hair glue, do that last little bit of fine-tuning on your brows, and head out into the South Ozone Park night, because you're Chelsea-bound—off to drink and drug yourself into a stupor, irritating countless bystanders along the way and ending up, more often than not, either beaten senseless or locked in a cell.

It's Saturday night, folks—clubbin' time in New York Fucking City—and guidos from all five boroughs, Long Island, and the swamps of Jersey, are simply *orgasmic* at the thought of getting out on the dance floor and showing you what they've got.

"Them niggas better have my fuckin' table," you shout to Mario over the throaty growl of his Mustang GT—a vintage 1989 five-liter convertible—as you and "your boys" make your way over the 59th Street Bridge for the third time this week. No toll booths for you, right, guido? Or have you chosen the "free bridge" because Mario doesn't have an E-ZPass—couldn't get a credit card, the fuck—and would prefer to avoid the inevitable discussion about why the fuck he's in da fuckin' cash lane?

None of this matters right now, because the crew is rolling five-deep this time around, clustered all warm and safe in Mario's cinna-berry-tree-scented cocoon—"niggas for life," off on another bitch-procuring mission in the wilds of Manhattan.

Over the bridge, Mario's GT parked smartly in a bus stop, you're on the street and ready to roll. "My boy," you blurt out, "used to bounce up in dis muthafuckin' spot, but he gave too many muthafuckas beatdowns, you know what I'm sayin'?" Clubs don't want that sort of reputation, you explain. They don't want bouncers from Howard Beach and South Ozone Park and the like, because they're not ready to take that step into *the real*.

"They don't unnerstand the way we are. All's they got there now is some college-lookin' muthafuckas workin' the door, especially dat fuckin' kid dat choked Artie last week. Fuck that nigga. You think the car's gonna get towed?"

"Nah," says Mario. "My uncle's on da job. They try any towin'

bullshit, he's gonna have 'em directin' traffic in East New York, da fuckin' rat bastids."

It's the bouncers that create the problems, making you—*you!*—wait on that muthafuckin' line and pay their insulting cover charges. Nobody has any respect anymore. They don't know who you know, and they don't know where you're from, but you're making a note of everything and everyone, remembering their ugly fucking faces for that day, that one glorious day of guido retribution, when you'll come back and show them all what big, fat fucking mistakes they've been making all these years.

"Yo, it's freezin' out here, muthafucka! Fuck savin' a dollar on da fuckin' coat check. I'm goin' back to da car to get my fuckin' coat!"

If you walk in the club, though, and the right song is playing—the soundtrack to your world, if you will—everything changes. The order you've chosen—the extra half hour on the hair, the forty-ounce bottles from 7-Eleven, and saving the eight-ball for the bathroom stall—is validated when they make you feel like the *king you are* walking in. Sometimes you come through the lobby and it's as though we've been expecting you, and only you.

> *I work in a warehouse, I live with my mom*
> *I carry my bank account in my wallet*
> *Me and my niggas is solid*
> *If I run out of money, I'll ask my boy Dom*

Once you're in, however, you're hopelessly caught in the grand nightclub illusion and there's no way out. You're in the web. You've been fleeced, and you'll be finding that out the hard way by the end of the night, only you'll be too drunk and coked-up from your five Michelob Ultras and three trips to the bathroom stall to notice the tangles. You'll be too fucked up to do bumps with Anthony's cousin, which is a goddamned shame, because, as everyone knows, he always brings the good shit to the city, and the good shit is why you're all here.

"Yo, where's my muthafuckin' Newports, yo?"

By the end of the night, the guidos are holding up the walls, nodding, forming a receiving line outside the ladies' bathrooms. The best way to score the premium bitches, as every guido knows, is to take hold of their elbow after they've taken a leak.

"Hey, man," your friends will say. "Your girlfriend is beautiful! Where'd you meet her?"

"At the club," you'll reply. "The place was about to close, so I waited outside the bathroom and I grabbed her ass when she came out. The rest was true romance . . ."

Every Saturday night becomes a Sunday morning, though, especially for the Cinderella guido, who, in those early hours, must slink back to Queens, clinging for dear life to whatever shards of remaining dignity his shouting will let him retain. So much dancing and drinking and bumping makes a man hungry, and as long as Mario's GT didn't get towed, and as long as those Greek-diner muthafuckas don't fuck around again, there's a Western omelet somewhere on Hempstead Turnpike with your name written all over it.

Fuck it, though. Mario stopped drinking at two, and he doesn't play where the Mustang's concerned, so he only went back to the stalls once—just that one bump, him and Carmine, right when you first came in. Any scumbag cops pull him over, he's got a stack of his uncle's PBA cards the size of your house, right? *That* will straighten out Five-O, and once it does, all that's left to do is kill a plate of cheese fries and start the countdown to Monday.

"HOW DO YOU like working Vince's door?" asked Migs, sipping the coffee I'd bought him from the deli next door. "You getting along with those jerkoffs down there?"

"It's not that bad now that I'm not pinned in the fucking corner. At least I can see what's going on at the door."

"That's a money spot, that door. You figured that out yet?"

"Yeah," I replied. "I'm doing okay, actually."

"They tip you coming in, they hand you money for standing there, and you walk people to the bathroom. Easiest fucking money *you'll* ever make. I know the whole deal with that door. How much is Vince asking you for?"

"He told me he wants twenty for every hundred I make."

Migs nodded. "That's generous. That's less than what I take out of my door guys. It's less than what Zev and Christian take out of me. Fifty percent is what everybody takes out of everybody's ass around here."

"I got no problem with it. If it wasn't for Vince, I wouldn't be in that spot."

"That's true, but I got a question for you, and I wanna see if you can answer it the right way. I wanna know if you know who you work for, so tell me that. Who do you work for here?"

"You," I replied. "I'm a bouncer, and you're the head of security, so I work for you."

"That's the right answer. You still work for me. You're at that door because Vince put you there . . ."

I cut him off. "But I have this job in the first place because *you* hired me. I get it, Migs. You want a cut of it, too?"

"No. That's your money. I don't want nothing to do with the VIP money. You keep as much of that as you can get your hands on. All I want you to do is remember who you work for. You don't work for Vince. You still work for me. When shit happens in here, and people start giving orders, Vince might come over and tell you something different from what I tell you, but you gotta listen to me, because I'm your boss. Not him. You understand what I'm saying?"

"ONE DAY I'LL have a fucking driveway, out on Long Island somewhere, and I won't have to constantly worry about driving around and finding a spot and parallel-parking on these goddamned streets with all these assholes coming through here like they've never seen anyone park a car before."

"Do you ever stop cursing?" Amanda asked, rolling up the passenger-side window.

"Fuck, no. You started it, anyway. I never cursed in front of you until you started doing it around me."

I walked up the steps first, opened the door, and turned on the light.

"So this is it?" she asked, looking around. "This place is the reason you became a bouncer?"

"Why? Something wrong with it?"

"No! It's actually a lot nicer than I expected it to be."

I went into the bathroom, washed my hands, and ripped open a new box of Trojans as quickly as I could. I pocketed two, brushed my teeth, and came back out. "What the hell did you expect? The bathroom's all yours, by the way."

"I don't know. It just doesn't look like a *guy's* apartment."

"Well," I said, "you have to remember two things. First, I drive a furniture truck for a living, and sometimes shit falls off the back."

"Nice. What's the second thing?"

"I wasn't the only one living here for the past two years. She didn't move out *that* long ago."

I sat on the sofa and waited for her to come out of the bathroom. Five in the morning wasn't exactly the ideal time to put a *move* on someone, but this *was* the club business, so I figured I'd have to acclimate myself to this sort of thing eventually. After all, we *were* club people, weren't we?

The bathroom door opened. "I look like shit, so don't expect much. If my customers ever saw me without makeup, they wouldn't give me a fucking cent."

"What's with the sweatpants?"

"Why? You thought you were getting some tonight?"

I kicked off my shoes and took a sip of water. "You know, you should go to work without makeup more often."

"Why?"

"Dude, you're absolutely fucking beautiful. I'm so far over my head right now I have no idea what to even do."

"Good line," she said.

"It's totally not a line. You want to know something?"

"What?"

"When I went into the bathroom before, I had a box of condoms, *unopened*, in the medicine cabinet, and I slipped a couple in my pocket to be slick."

"A couple?" she asked. "That's pretty ambitious."

"Yeah, well, I did that because you were still in your stupid club outfit and that's how I'm used to you. I've never seen you not all dressed up, even when we've gone out and I've dropped you off. I can deal with you wearing normal clothes, but now you're wearing some sloppy-ass outfit at five in the morning, and your makeup's off, and you look a thousand times better."

"You're fucked up."

"I'm serious. It's making me all nervous, almost like I didn't know you looked like that."

She put her knee on the sofa between mine and sat on my left leg. I brushed her hair back behind her ear, and we kissed. The inside of her mouth felt bottomless, as if I were trying to reach something and couldn't. It always felt that way.

"Easy," she said, touching my face. "Like this."

I lay back on the cushions with her on top of me. She rested her head on my chest and scratched a spot on the back of my head that, until right then, I had no idea was erogenous. I buried my face in her hair, undeterred by the lingering smell of smoke from the club.

"Can we go in the bedroom?"

"Yeah," I said. "It's clean. I knew you were coming."

She hadn't been wearing anything on under her sweatshirt, and the feel of her skin against mine was something I couldn't get enough of. She was there, and I couldn't get close enough. I was prone, my head against a pillow, with my hands on her shoulder blades, and I pulled her into me as I burrowed beneath her hair and kissed a spot on her neck just below her earlobe. I hadn't slept with anyone I'd given a shit about since Kate left, so being with Amanda was quickly becoming cathartic.

I reached under her waistband, and, with my middle finger, found what I was looking for. Amanda bit down gently on my lower lip, and her entire body began to tremble.

"Put one of those condoms on."

"Now?"

"*Now.*"

I've always hated the idea of using condoms. You stop what you're doing, take the time to rip open the package and unroll the stupid little thing, and if you're as ham-handed as I was with the entire process, it can end up killing whatever mood you'd managed to create. Not this time, though. With Amanda, I was as aroused as a fifteen-year-old high school sophomore whose fresh-out-of-college English teacher had just sat on a desk and crossed her legs. I unrolled the condom and gently pushed her knees apart.

"Shit."

"What?" she asked, exhaling deeply.

"Fuck."

"You're done?"

"Sorry," I said, lowering myself onto her and resting my head on the pillow next to hers. "It's been a while."

"Don't be sorry. It's fine."

"No it's not! Jesus, I feel like I'm in junior high." I rolled off of her and lay on my back.

"This isn't gonna happen every time, is it?"

"Fuck no. It's just that I haven't done that in so long that it's a little *sensitive,* you know? I guess you should probably be flattered."

"I am," she said. "Sort of. At least I know you're telling me the truth about not being with anyone."

"Wait. Every time? You said 'every time.'"

"Well, yeah."

"Then that means it wasn't so bad and I get another shot at it?" I asked.

"Yeah. Wake me up when you think you can last more than ten seconds, okay?"

INTERNECINE

They don't like each other," said Johnny. "Never have, since day one."

"Why not?"

"They have two completely different goals when they come to work, those two. Think about it. Vince is here to bring in as much business as he possibly can. His job is to sell as many tables and as many bottles as he can move, every single night. That's all he gives a shit about: selling tables and bottles, and pocketing as much commission and tip money as he can get his hands on. That's why the guy drives a fucking Hummer and lives in a palace in Bergen County, 'cause he's great at selling shit, and great at skimming money off the people he sells it to."

"What about Migs?" I asked.

"Well, Migs's job is to make sure nothing happens inside the club. That's pretty cut-and-dried. He's the head bouncer. He makes decent shift pay, from what I understand, and he hustles the shit out of people at the door, so he's making a nice chunk off of that, too. The thing is, Vince makes his life difficult by not giving a shit who he's letting in the VIP, just as long as they're spending money."

"I haven't seen any real problems in the VIP rooms yet."

Johnny laughed. "Don't worry, you will. This happens every fucking time, trust me. You can see it already. Vince isn't getting anyone good down there anymore, so he's falling back on taking anyone with a pulse to buy his tables, and that's gonna mean problems for us, and for Migs. Drug dealers, mob guys, you fucking name it—they're all gonna be down there doing stupid shit. And Migs's hands are gonna be tied when he wants to crack down on the assholes Vince is bringing in there, because Vince is gonna justify it by telling Christian how much money he's bringing in."

"And Vince doesn't have to do anything, because he's not the guy that has to throw anyone out."

"No, he doesn't. Vince never looks like the bad guy to anyone. He makes Migs do that, because Migs is the one who's calling the bouncers on them. All Vince does is take their phone calls the next day and apologizes and convinces them to come back and act like assholes again next week. It's a vicious fucking cycle, and I can see it starting up again, just like it did the last time they were trying to run a club."

"Can't they have a meeting about this shit?" I asked. "If it happened before, you'd think they could sit down and figure out some way to make everybody happy."

"It's too late for that. Vince already got Ray moved off the VIP door, and he managed to get you in there, which is something I can't figure out in a million fucking years."

"Why not?"

"Because," he said, "you've only been here for half a year, and Christian couldn't pick you out of a fucking lineup. He must be drinking Kool-Aid out of Vince's asshole, because that's usually not the way things work. Vince got rid of Ray 'cause he knows Ray is Migs's guy, and he knew Ray would eventually cause problems down there by not doing whatever Vince wanted him to do. He's got you at that door because he thinks you're a clean slate,

and you'll just do whatever the fuck he says. And if he throws you a little extra money, he figures you'll listen to that when the time comes, instead of doing what Migs wants you to do."

"Which is why Migs was talking to me like that."

"Listen, man. Migs is a good guy. I don't know if he's the best guy to have as head of security for this place, because he's a fucking hothead sometimes with the customers, but he's a good guy, and he'll always stand up for you if you stand up for him. I think the best thing you could do for yourself would be to stay on his good side."

"I haven't done anything to get on his bad side," I said.

"I'm not saying you have. What I'm telling you is to remember which side your bread gets buttered on, and I'm not talking about whatever little kickbacks you get working for Vince. I know both guys a long time. I'll take Migs over Vince in a heartbeat, and so should you if we ever get to that point."

I'M WHITE TRASH, whether I'm ever willing to admit it or not. Not the middle-America version of white trash, mind you, living in that trailer park I told you about, with my chips and my satellite dish and my Marlboro Reds. No, I'm the New York version of white trash, which is a different breed of cat altogether.

We're the sort that are able to overcome our backgrounds long enough to afford to be able to live here. I could give you the entire litany if you wanted to sit and listen—the crappy childhood, the relative(s) in prison, and the knuckleheaded parents who never seemed to want kids in the first place. I could sit here and blame all the flotsam of my youth for the position I was in back then, but I won't, because I'm New York trash—the kind that's too busy *working* to dwell on shit like that.

What I'm saying is that life as a working-class schlub bouncer becomes a matter of proportion when it comes to money. I'd spent so much time without having it, in fact, that my tendency was to overvalue what *was* flowing into my pockets at the club.

These people had corrupted my sense of *what* was worth *what*, and anyone not meeting my set price—no matter how badly I could've used a simple twenty at the time—wasn't getting my services.

"Yo, could you move that rope out the way?"

"How many you got?" I asked.

"Just us four," said the customer, indicating his friend and their female companions.

Letting four people into the VIP should have cost, at a minimum, a hundred dollars in a handshake—which I always made sure to receive before moving the ropes for anyone.

"No problem," I said, extending my hand. "You're all set."

"Thanks man," he said, accepting my handshake with his thumb tucked in the universal cash-transfer position.

"What the fuck is this?" I asked, holding up a ten-dollar bill. I'd learned from Vince how to subtly check the denominations of the bills I was handed. Vince never put money in his pocket without counting it first.

"What?"

"Ten bucks? You have to be fucking kidding me." I handed him back the bill.

"You need *more*?"

"You see these tables in here? There's a thousand-dollar minimum in here, and you're trying to hustle your way in for ten bucks? For four people? Are you serious?"

"Yo," he said, taking out his wallet, "I'll give you more."

"It's cool, man. Have a nice night."

"Seriously!" He whipped out two twenties and waved them in my face. "I got more!"

"Listen, man. It looks like you need those more than I do. Do yourself a favor. Put those bills back in your wallet, go home, and when you wake up tomorrow morning, go over to Wal-Mart and buy yourself some class."

"You mother*fucker*. Yo, fuck you, motherfucker!"

LIKE I SAID, the clientele in the VIP rooms had changed significantly in the six months I'd been posted there. The models, investment bankers, and "club kids" had been replaced by another group—this one seemingly of more dubious origins. I'd be making money with this new group for certain, but a tension hung in the VIP's rarefied air whenever they came in—a tension fueled by my knowledge that while I was at this particular door, I wouldn't have *any* choice in the matter when Johnny's "moment of truth" finally came about.

"Castigliano was in here da udda night, pissin' about alla dem guys comin' in on dis side," said Old Vito, his South Ozone Park inflection growing with each syllable when talkin' 'bout the Eyetalians. Old Vito, the way I had heard it, had once been a higher-up in the Fire Marshals, and was being paid a nice little sum by Christian to help head off occupancy and smoking violations and fines if the FDNY ever came by for spot inspections. He was in his mid-seventies, at least, and used every muscle in his face to blink his eyes. The effort of having to do this annoyed him, so he drank.

"Yeah?"

"Yeah. He don' wan' all dem guys comin' in like dat. Two, tree, dat's okay. Twenny? No dice."

"Which one is he?" I asked.

"Aw, he's a real nice guy. Hits us up over here whenever he comes down. You seen him."

"These guys have a thing about coming in the front door?"

"Nah," said Old Vito, sipping Johnnie Blue from a Styrofoam coffee cup. "Dey jus' come and see who dey know. You got your guys, I got mine."

"I don't have any guys yet."

I wasn't a cop. I had no specific knowledge of how powerful the Mob was in New York, how much influence they still had, or whether the "Five Families" were even still around. It simply

wasn't a part of my world, nor did I want it to be. I knew that Rudy Giuliani was considered a hero in certain circles for cleaning up the traditional rackets—carting, concrete and waste management, among others—but I wasn't about to concern myself with how they went about the business of paying for tables at Axis. What I wanted to know and what common sense told me were two different things, though.

Carlo Gambino left New York in 1976, and that's what I'm talking about here. Some would say all the honor went along with him. You'll certainly not find it anywhere near a West Chelsea nightclub, what with the small-time shit most of our yahoo customers seemed to be working—at least the ones I got to see in action down on the couches of the VIP. Do you honestly think you'd ever see the Old Man jumping around in a nightclub like some kind of, well, *mulignane*? Would you find that kind of money prancing through a sea of eggplants like this?

It's said the Old Man never stepped out of Brooklyn, except to spend time at his summer house out on the South Shore of Nassau County. He had a place down on the water in Massapequa. My uncle Frank used to point it out to me when we passed by on his boat, on the way out to Fire Island to angle for blackfish.

We went that way because there were scads of shipwrecks off the coast of Long Island. Blackfish like confined chaos, sticking to the rocks and the wrecks. They'll hit your line like lightning, then snake it in and out of those goddamned wrecks until something snags. You think you're got something—you feel the son of a bitch bite—and then it just snaps. Your tip comes up and you're done, and all you can do is just retie and rebait.

"Rob," said Vince, standing next to a young, immaculately groomed man wearing a black gabardine suit, "this is my friend Angelo. I want you to always take good care of Angelo and anyone he brings in. Angie, this is one of my best guys. You need anything? He gets it for you. He can't get it? He calls me, and I'll come over right away."

"What's your name again?" asked Angelo, offering his hand and kissing me on the cheek. He was overweight, a fact hidden by the expert tailoring of his suit. I would beat him in a fight, though I'd not be trying anytime soon.

"Rob," I replied, slipping my first-ever laundered bill in a pocket. "Pleasure to meet you."

With that, I was bought.

———

SCENE: *Amanda lay back, her feet resting atop the padded arm of my sofa—her presence in my apartment an accessory much too fine for this room—as I dressed myself in the clothes I'd been wearing prior to our initial engagement. I handed her a bottle of water.*

ME: I hate to break it to you, but people at work know about this.

AMANDA: Who?

ME: Johnny, for one.

AMANDA: What'd he say?

ME: Do you ever wear glasses?

AMANDA: Yeah, when I read. You gonna tell me what he said?

ME: He told me to be careful. That "club relationships" are doomed from the start, and that everything we're doing is gonna end in disaster. I fucking hate condoms, incidentally.

AMANDA: Asshole, come on.

ME: He just told me he figured it out. I mean, shit, we show up to work together all the time, and we leave together every night. Who the fuck's not gonna be able to figure that out?

AMANDA: That's not good.

ME: Well, I don't think I'm gonna have a problem with anyone over it. The only bouncer I met that seems a little shady is the one I caught shaking some cokeheads down for their shit in

the bathrooms. Other than that, I don't think anyone will give a shit what I do.

AMANDA: It's a lot worse for me if anyone finds out.

ME: Why?

AMANDA: Don't you know what kind of a prick Christian is to the girls who work for him? It's like I told you. I think the only reason I'm still working here is because he's still holding out hope that I'm gonna go up into his office one of these nights and snort a bunch of coke and have sex with him. I think if he found out I was dating a bouncer, he'd be insulted.

ME: Insulted?

AMANDA: Yes, insulted, because he's tried. Believe me, he's tried. And he's failed. And a scumbag like that won't take getting beaten in a competition with a bouncer very lightly, believe me. He likes you guys, and he trusts you to do your jobs, at least. Me? And all the rest of the girls who work there? We're only there for his gratification. Sure, it's partly because we make him a lot of money, but female bartenders are a dime a dozen. He finds out you're not going to put out for him because your boyfriend is one of his bouncers? Forget it. You won't be working there much longer.

ME: How the fuck's he even gonna notice? Believe me, I'm barely even on the guy's radar screen. The one time I ever saw him talk to anyone, he was so fucking coked up he kept calling Migs "Billy." I don't think he notices that kind of shit.

AMANDA: You're right. He doesn't. He'll keep *you* around, and get rid of *me,* but you still have to be careful. There's more sketchy shit going on in that place than either one of us knows about, and the less they know about our personal lives, the better.

ME: Sketchy shit like what?

AMANDA: Oh, please. Are you really that naive? Or have you not been watching the people going back and forth into the VIP room every night? You honestly think they're there to have

a good time? Or has it ever occurred to you, in your infinite wisdom, that they might just be in the club to supervise their business operations?

ME: And how does this have any bearing on the way I do my job? Or on how we have to keep everything so secret? I mean, I understand it, obviously, and I feel the same way, because it's none of anyone's fucking business, but what's the deal with the Mob guys? They tie into this somehow?

AMANDA: Jesus, you're slow. You really don't get it, do you?

ME: What's to get?

AMANDA: You work at Axis, stupid. You might as well be *in* the fucking Mob.

————

ANGELO AND HIS crew, having become regulars, would come into my VIP room en masse, occupying the corner sectional next to the door where I stood. As soon as they'd arrive, I'd set up a forest of stanchions and rope them off, giving them their own private little domain where they'd be free to do whatever it was they'd come to Axis to do. I was happy with this arrangement. The more I could segregate Angelo and his group from the rest of the room, the less likely it was that anything requiring my intercession could happen.

"Do me a favor, Rob?" he asked late one night, toward closing, pressing another bill into my palm. "I need to take my girl somewhere else for a little while, away from the rest of these fucks."

"The bathroom, you mean?"

He laughed, thank God. "No, but I see you and me think along the same lines. That's good, but no. What I mean is, I wanna take her to another part of the club, if I can, 'cause we need to work some shit out. You think you could walk us somewhere where it's a little less crowded?"

I guided them to the rearmost bar in the club, all the way in the

back, adjacent to the bathrooms. With the club emptying out rapidly, my presence wouldn't be needed in the VIP room and I was free to milk the situation—and Angelo—for as much trickle-down cash as I could. The bartenders in back had already begun breaking down their stations, and any customers who'd been drinking there had made their way up front after last call had been announced.

Angelo's crew knew where we had gone. You don't work for someone like Angelo and let him out of your sight for long. I could see them hovering a short distance away, talking among themselves, trying to look inconspicuous to the boss amid the exodus of drunken leftovers drifting toward the front door. Occasionally, one would approach, exchanging a word or two with the *capo* until he disgustedly waved them off.

One of these, told by Angelo that it would be a few more minutes before they'd be leaving, turned into a corner and proceeded to unzip his pants. This left me in a rather uncomfortable position. If I was caught on camera watching someone piss on the floor and not doing anything to stop it, I'd undoubtedly be going home without a job. The unattractive alternative entailed informing a drunken Mob henchman—with nobody else around, save his boss—that I objected to something he was doing. For the first time since I'd started working at Axis, I was legitimately frightened, and with no real solution coming to mind, I appealed to Angelo.

"Uh, Angelo, your friend is gonna piss on the carpet."

"Oh, fuck! Nicky! What the fuck are you doin'? Get the fuck over here!"

Nicky stopped, arranged himself and his pants, and sheepishly walked over. Angelo slapped him across the face.

"What are you, a fuckin' animal?" he screamed. "This guy's doin' me a fuckin' favor, and I gotta sit here and watch you disrespect people by pissin' on the rug? In front of my fuckin' *girl*, for chrissakes? You apologize to this man, and go use the fuckin' toilet."

"I'm sorry," said Nicky, who was so drunk he could barely focus on me. He wouldn't remember this.

"Don't worry about it," I said, as nervous with Nicky as I was around Angelo. "It's not my carpet."

"Listen, Rob," said Angelo, handing me another bill. "I'm sorry about that. We don't come in here to disrespect your place. We come in here to have fun. What you did back there? Coming to me first? That showed respect, and I appreciate that. You respect me like that? I'll respect you."

12

FLEXION

Respect is critical in the magical world of night-club narcissism. If I'm a mobster, or especially if I'm a garden-variety Staten Island guido, I desperately need for you to respect me, because respect is what makes the world go round in row-house New York. When the coke you've been snorting compels you to cup the ass cheek of a guido's sister, you don't do that because the ass cheek in question is so attractive that it somehow commands your hand to cup it. You take this action because your intent is to show disrespect to the guido himself. This is how the guido thought process operates, and it's why you'll so frequently see them throwing their fists at people. To violate the guido respect/disrespect code is to strike a blow at the very heart of guido culture, and any guido worth a shit will justify his actions—whether right or wrong—in terms of the amount of respect or disrespect he was receiving at the time of the offense.

How do guidos go about getting this respect? What does it take to make one's peacock strut even remotely believable when one insists upon spiking one's hair and waxing one's eyebrows? For most, it starts at the gym. Walk into any commercial gym in the

New York area, and you'll see countless guidos lined up along the wall—where gyms typically place their dumbbell racks—doing inordinate sets and repetitions of bicep curls and forearm exercises. The remainder—those guidos who aren't preparing for the "gun show"—will be clustered four- and five-deep around whichever guido is performing his thrice-weekly bench-press workout. The squat rack, and any other apparatus in the "leg area," for that matter, will consistently be devoid of guidos, because guidos tend toward the "lightbulb"—entirely top-heavy—look when sculpting the image they'll be presenting that weekend at the club.

"At least," you may be thinking, "they're doing *something* healthy."

I'll give you that. A guido *does* need something to counterbalance the drinking and the drugs and the smoking and the STDs to which he's exposed on weekends. They go down to the gym and pay the price with some hard-assed upper-body training for a few hours a day, and it goes a long way toward rationalizing the abuse they put their minds and bodies through on Saturday nights, right? I mean, if a guido is hard at work hitting the weights all week, who gives a shit if he's taking in a little Grey Goose—and the obligatory eight-ball in the bathroom—once in a while?

It's not as innocent as all that, though. To the guido, getting his coveted respect isn't about how he *feels,* nor has it anything to do with his cholesterol count or his resting heart rate—unless, of course, he's doing some cardio to condition his ticker to withstand the effects of the coke and the six Red Bulls he'll drink on club nights. It can't be. For him, respect is all about how he *looks,* no matter how cosmetic and useless all the muscle he's packed on happens to be. He may not even like lifting weights, but he has to, because being a guido is the life he's chosen. And part of that life—a huge part, for many—includes jamming a needle in your ass and shooting yourself full of anabolic steroids.

Don't ask me how I know about steroids, but I know almost everything there is to know about them, and they work like crazy.

They'll make you big and strong. They'll make you huge. They'll rip you to shreds, as it were, and the nightclubs of New York—the ones the guidos have occupied, at least—are filled with people who use them. Step on any dance floor in West Chelsea, and you'll see what I mean: dozens of freakishly built men, clad in skin-tight stretch T-shirts, strutting about the place all peacocklike, their lat spreads aflare.

I'm not a dancer. I can't cut a rug, so please don't make me try. I'll step all over your feet and knock you down and make you wish you'd never asked me onto the floor in the first place. But I know about steroids, and I know what they can do, and I'll tell you this: they didn't make me dance.

Guidos love to dance, and guidos love steroids. And somewhere, deeply rooted in the innermost reaches of the guido endocrine system, is a supersecret, genetically unalterable compound that forms a bond with the steroids they inject. The steroids swim through the guido bloodstream, and one morning the guido wakes up and thinks it's Christmas, because the veins in his biceps aren't hiding anymore. Once this happens—and the biceps are most definitely a main guido priority, as opposed to the elusive "Guido Leg Day" that I defy you to find at any gym in New York—the steroids find their way to that compound, and an irreversible chain of events is set in motion.

The process is violent. The guido is shaken to his core. He begins to shudder and twitch. His heart rate elevates to dangerous levels. Some guidos lose the ability to govern their speech, mouthing random idiocies like "Yo, nigga! Dis my song!" when the reaction begins to take hold. Others clap, seemingly mistaking a prerecorded mélange of electronic nonsense, played by a DJ, for the playing of a live band.

They can't sit down. You look over, and they're up, en masse. They're jumping and pointing at the DJ to congratulate him for his skillful manipulation of their inner mechanisms. They hug one another and pump their fists in the air. The chemicals have taken

hold, the guido is no longer in control, and what happens next is a scene replayed at virtually every Manhattan nightclub on any night of the week: the juicehead dance.

The best way—the only way, I think—to understand how the juicehead dance really works is to try it for yourself. Of course, you can't possibly hope to nail it down the first time you try, because it takes a great deal of practice—and massive quantities of Grey Goose, Red Bull, and hallucinogenics, preferably taken together on an empty stomach—to maintain any sort of juicehead flow. It's difficult to learn from a book things that require such timing and grace, so be patient, and it'll come to you eventually.

The best place to start is with your footwork. Any juicehead dance begins with a precise placement of the feet. What you'll need to do is practice skipping in place. The way to do this is to imagine you're skipping forward—much like a fairy or pixie—yet remain "in a barrel." You'll be doing what I call the "double tap," with each foot, in time with the music. As you begin to master the double tap, try to add some spring to your step, getting higher off the ground with each successive repetition.

Now, make fists with both of your hands. Touch your fists— they should be approximately an inch apart—to your forehead and keep them there. Your palms should be facing, and your thumbs and forefingers will be in contact with your head, the little-finger side of your fists facing outward. This is the touchstone for your initial juicehead hand position.

With your fists still touching your forehead, flare your elbows directly out to the side, as if you're striking the classic guido double-bicep pose so often seen in group photos of guidos at play. Once your elbows are properly flared in true guido fashion—as far upward as you can possibly extend them—it's time to introduce the correct guido arm action.

Tilt your head back so your line of sight is directed at a 45-degree angle upward. In other words, if you were to draw a straight line from ceiling to floor—through your body, that is—your line of vi-

sion would form a 45-degree angle to the segment of the line from your head upward, and a 135-degree angle to the segment extending down to your feet. A useful verbal cue here is to imagine you're staring at the goal on a regulation basketball backboard.

Extend—or "pump," to use the vernacular—your arms in time to the music, aligning this extension precisely with the line of vision you've established. This is accomplished by alternating the "pump" arm as follows: left, right, left, right, left, and so on. At this point, since you'll just be starting out, it's advisable to continue holding your hands in the aforementioned "fisted" position. Advanced guidos often choose to execute this pumping action with their hands forming the universal "hang loose" gesture, or by extending their middle fingers, but this is a matter of preference best left to those more experienced at executing the more essential parts of the juicehead dance.

Remaining "on beat" is crucial to the success of the movement. A good rule of thumb to remember is that the total number of fist pumps must never exceed the number of double taps with the feet at any point during the dance. If you keep the two on a one-for-one basis, the proper rhythm should be fairly simple to maintain.

Another important consideration is the concept of rigidity. Juicehead guidos strive to remain in a rigid, flexed position at all times—even when sleeping or eating—and if you want to make your juicehead dance look as authentic as possible, you should make every effort to do the same. When you raise your arms, make absolutely certain to flex them as hard and as forcefully as you possibly can. Take care to maintain this rigidity throughout the movement, keeping in mind the age-old, time-tested axiom to which guidos the world over adhere still today: *elasticity eradicates credibility.*

Keeping your head cocked upward, purse your lips, narrow your eyes, and give the world your best "hard" face. It's an aura of arrogance you're after here, so, as in other parts of this process, the appropriate facial expressions will take some time to perfect.

All that's left to do now is to put it all together and take it to the club: the "double tap" skip, the head tilt, the facial posturing, and the alternating pumping and flexing of the arms. Hold this all in place until a visible sweat stain forms on the back of your hideous faux-silk shirt, and you've done yeoman's work in presenting your juicehead guido dance to the world. Don't forget to grope someone's wife outside the bathrooms, get in a fight, say all sorts of stupid shit and get kicked in the ribs by bouncers, and eventually get arrested, and you, too, can be a dyed-in-the-wool New York juicehead guido.

THE DEATH OF Axis as a Manhattan "destination" was a painful thing to observe from within, but the place *was* dying, and it was obvious to everyone involved. The arrival of the guidos and the Mob, along with the mass evacuation of anyone with anything *Manhattanish* going on, solidified, for us, the fact that the run had come to an end. We'd been *overrun*.

Christian knew this, of course, but he wasn't about to let the place go down without a fight. We'd entered the second phase of the "club cycle"—the part where maintaining an acceptable profit margin matters more than image—and management was determined to bleed the place dry before everyone stopped coming in altogether.

Did Christian have to answer to some combination of external forces that compelled him to shift his priorities so drastically? Was it some sense of professional pride that led him to believe he could make the same money every night no matter who was coming in our doors? Not being in anyone's loop, I had no way to be sure. All I knew was that I'd seen Axis at its peak, and the depths to which it seemed to be sinking were a far cry from what it once had been.

In the beginning, at inception, every bouncer in the city wants to work at a place like Axis. The owners throw millions and millions of dollars into remodeling a space, the media get wind of

what's going on, and a buzz is created. You'll see spreads in *New York* magazine, the *New York Times,* and Page Six of the *Post,* and even though you *know* from experience that the job's a losing proposition, there's a period when you're almost proud to be working at a place that's on somebody's radar. You're a performer at an A-list attraction in the nightlife capital of the world, and you're at the top of your "profession." And even though that profession is one of which you don't really want to be a part, it's always nice to be at the top of *something.*

Axis didn't all go wrong at once. When the beautiful people moved down the block, they were replaced by curiosity-seekers—tourists and those without the patience for the lines at the door in the opening months—who acted as a sort of buffer zone between the departure of the moneyed and the onset of the B&T crowd. The tourists would see us listed in *Time Out New York.* They'd come down, get the Manhattan nightclub experience crammed down their throats for a few hours, and buy the T-shirt. Before long, Axiswear was haute couture on the streets of Billings *and* Helena.

Guidos knew not to attempt the line when Axis boasted a line one would "attempt." The doormen would spot them a hundred yards down the sidewalk, know exactly what they were and where they'd come from, and deny them admission every time.

Overmatched, they knew to stay away early on. If one *would* show up for whatever reason, the door staff would pull him aside and offer a friendly word of advice: "Don't even waste your time, buddy. Go next door."

Eight months down the road, however, the vibe was gone. The shiny folk had moved on and Christian was feeling the pinch. The B&T crowd became our standard, and the only people being turned away, it seemed, were the mentally ill, the gang affiliated, and the homeless.

By the time I noticed the Mob up my ass, it was too late. They had us—they had *me* bought and sold in the VIP room—and there

was no way on God's green earth that Axis would ever be going back to the way things were.

Angelo and his crew were decidedly low-level henchman types, whose connections to the top of the organized-crime hierarchy were tenuous at best. They had little in common with the stereotypical Five Family associates, who've traditionally run heavy industry and mozzarella supply here in New York for the past century or so. Still, in the insular, guido-infested environs of selected neighborhoods in Staten Island and Queens, Angelo and his "boys" were celebrities who were to be afforded treatment as deferential as we could make it.

The Mob waited on Axis until the more glamorous herd had moved on to graze in greener pastures. Like vultures, they only descended on us when they figured there was money to be made: dealers to be muscled, guidos to be hustled, and sluts to be coked and K'd into offering fellatio in a stall when the crew needed a break. Prior to the disintegration of a club's aura, nobody's impressed with Bruno the Vending Machine King of Ozone Park. Once the slide begins, however, everything changes.

You wouldn't have believed the quality of the women at Axis in the beginning. The VIP rooms were teeming with actresses, models, debutantes, and any other brand-name sort of beautiful girl your imagination could conjure. The one thing they all had in common, however, was a complete and total lack of regard for anything smacking of tactless, bridge-and-tunnel barbarity. The two worlds—Manhattan sophistication and outerborough tackiness—were so far removed from one another that the very thought of any interaction between the two was enough to make me cringe. I'd never seen it, but I could imagine the resultant conversations. Angelo wouldn't stand a chance in that environment, and he knew it.

"What up, baby? My name's Rocco. You wanna Red Bull? What's your name?"

"Um . . . Ashley?"

"Whattaya do, doll?"

"I model, I paint, and I summer on the Riviera. What do you do?"

"I skim off cigarette machines, rob quarters outta parking meters, and hijack trucks. I also own half a titty bar on Queens Boulevard."

"Oh, how *exciting*! Can I blow you?"

Angelo wasn't trendy. He wasn't hot. He and the rest of the people throwing money around in Vince's VIP rooms didn't come anywhere close to making *that* map. They can't uphold their end of any bargain with anything other than their power to earn, so they choose to congregate with the type—the fawn-all-over-your-Lexus sort of girl—from whom they can elicit the right reaction. The guidette. Who really gives a shit if she still lives at home in Howard Beach and does nails for a living? It's not like she has to talk, right?

In eight months, I'd progressed from gawking at the shiny people to minding a mid-level mafioso, providing him with six square feet from which he could negotiate blow jobs with girls from Bayonne. The fortunes of Axis paralleled my own: from flavor of the month to a place where anybody with one iota of taste or decorum wouldn't be caught dead. And that, my friends, is when it stops being any fun at all.

———

SCENE: *Mid-shift, at the sink of the employee bathroom, making a show of hand-washing just to be sure. Ray, leaning against a marbled wall, ruminating.*

RAY: I keep my distance. I don't go anywhere near those guys. I don't want their money, I don't wanna be friends, and I don't want nothing to do with them.

ME: Neither do I, but they pay.

RAY: Sure they pay. What the fuck do they care? That's all they can do. They throw money around. They don't do nothing for the world except sell drugs and beat up old ladies, and the only way they can get any respect from anyone is to fucking buy 'em off. You really think any of them guys is worth a shit?

ME: Of course not.

RAY: Vince thinks they are.

ME: Yeah, because they're spending a fortune on bottles and tables every night.

RAY: It's not just that. I think he actually fucking *likes* these guys. I see him down there every night drinking with these motherfuckers, and it makes me fucking sick. He should know better, man. I would *never* do that.

ME: The guy brings in money. You can't argue with that.

RAY: Listen. Some shit breaks out down there? Somebody gets in the way of those fucking guys doing business? The same son of a bitch who kissed you on the cheek an hour ago is gonna be the guy that breaks a bottle over your face. You want my advice? Talk to Migs, and get yourself moved out of there. You don't wanna be taking money from them guys for too long.

———

WHAT HAPPENS IS this: night after night, hour after hour, the customers insist upon heaving bouncers, kicking and screaming, into their steaming cauldrons of bullshit. Even if you're completely "on point," leaving no stone unturned, you'll constantly find yourself in the most untenable of positions, put there by some irrational prick to whom the concept of moderation is entirely alien. You're fucked if you do, and you're fucked if you don't, and there's not a thing you can do to take care of things peacefully, short of simply calling for help and throwing people out of the club. You can do everything in your power to

make sure your area runs smoothly, and they'll still ceaselessly toss their problems into the wind, obliviously expecting someone else—anyone else—to clean up their damned messes for them.

Let them fight, I say. You get tired of the babysitting. You burn the fuck out on keeping people from doing harm to themselves and everyone around them. It's tiresome and unnecessary, and I was beginning to think, after a few months of playing bouncer-to-the-mob, that I'd be disposed one night to simply let the fuse burn to the wick and see how many people the explosion would take out once we actually let it happen.

When I was younger, and my judgment was somewhat less than sound, I had a friend named Ed. Back then, I'd fight you at the drop of a hat, no matter the time, the place, nor the situation precipitating the dropping of the hat. Ed would *not* fight you at the drop of a hat—he didn't want to, because he couldn't—but he knew I would, and he took full advantage of the situation by smart-mouthing everyone within a half-mile radius. He'd step up to anyone, regardless of whether or not he'd actually been wronged, then scurry back behind me, knowing it wouldn't take much for me to want to insert myself, full-throttle, into whatever situation he'd created for us.

I eventually soured on his game, figuring out for myself that I no longer wanted to be led by the nose into someone else's bullshit tough-guy delusions. I didn't need to be subjected to the threats, the shit-talking, and the inevitable scraps that followed his theatrics. This process wasn't advancing my life in any way. I had adopted his fights as my own, taking the side of someone whose mission in life seemed, primarily, to consist of antagonizing me by proxy. Things, as things do, had gotten completely out of hand, and they had to stop.

I ended it on a golf course, walking up a par three, wondering why I was prepared to butcher someone with a seven-iron because he didn't appreciate how Ed had told him he was taking too long on the green. "Come on, motherfucker," Ed had shouted from

the tee box. "It ain't the fucking British Open out here." Which is funny if you play golf, but not so much when grown men are waiting, clubs in hand, for you to back it up.

"Where's this gonna get us?" I asked, stopping halfway to the green.

"What?"

"I think maybe you should handle this on your own if you got such a problem with the guy. I'm too old to be fighting some guy on a golf course because he took too much time to line up a putt."

"You're scared of those guys?" he asked.

"No, but *you* are."

It happens with other people, too. I once had a friend named Anthony. Anthony had some friends-of-friends staying with him, and we took the Long Island Rail Road into the city to drink. One of these friends-of-friends, a kid named Buck—they were from Maryland, of all places—talked too much. About everything. He worked as a sales rep for a major drill manufacturer, and we ended up in a drunken, white-trash-worthy argument about the merits of various drills, which eventually led to him challenging me to a rather phallic "chuck-to-chuck" duel. This, evidently, entails fixing one drill bit between the chucks of two drills and giving it a go to see which is more powerful.

Outside one bar somewhere in the West Village, Buck decided that the thing to do at the time was to slap some random girl on the ass. The girl's boyfriend didn't like this much, and went after his own "chuck to chuck" with Buck. I didn't blame him a bit. In fact, I didn't even get involved. I saw what the jackass had done, and just kept walking down the sidewalk. The way I saw things, I didn't know the guy from a hole in the wall, but if he'd slapped *my* girlfriend's ass, he might've had worse trouble on his plate than a simple punch-up on the sidewalk. Fuck that.

"Your friend's a fuckin' pussy," Buck drawled to Anthony when it was over. "Fuckin' pussy just walked away."

"You think so?"

"Yeah. He should've helped me."

"You're lucky," Anthony said, "he didn't hit you, too."

What happens at the club, like I said, is that people look for their respect. It's the wrong place to do it, but every single night, they're searching for the respect that's eluded them everywhere else in their lives. They're looking for a reputation. We were at a point at Axis, inundated as we were with guidos, where people would peacock their way into the VIP rooms and break out their South Ozone Park shit-talk to people who'd spent the money to be there. They'd do this because Angelo's "boys" would hit on their girlfriends, offering drinks and a seat on the couch. They'd do it because you can't ever let disrespect slide, imaginary though it may be, and it doesn't matter "who da fuck" the offender thinks he is. Mostly, they do it because *we're* there.

Think about it, though. You walk into a room, looking to fuck with a bunch of Mob guys, you may as well jump into an alligator pit for all the luck you'll have. The funny thing is, they'll give you a chance. If you're not "in the business," you'll have that split second of leeway, because they know *you don't know.* Angelo would give me a minute to clear the room, knowing he was already holding the aces in this deck. Still, they'd keep up the talking, the guidos would, despite the odds. You *can't* back down in their world. You can't show weakness, even for a second, or you're nothing.

Occasionally, someone would spark up a joint in the room. When this happens, it's difficult, if not impossible, to catch them in the act. An expert pot-smoker—and I've known my share, believe me—can sit right next to you puffing on a roach and you'll never know he's the one who's holding the thing. I've had friends who've smoked at baseball games. In movie theaters. *At Burger King.* For this reason, it was hard to finger anyone doing it in the dark, crowded VIP rooms at Axis, so I stopped bothering to try after a while. Unless it wouldn't stop—the thing stayed lit, or the fumes filled the room more than once per hour—I'd rarely make any move to stop people from smoking.

Until, that is, the wrong guy complained. The wrong *set of guys*.

"Can you do somethin' about that shit?" asked Angelo. "I'm fuckin' gettin' sick of breathin' it in."

Angelo did the right thing by coming to me first. Angelo *always* did the right thing at the club—by me, by Vince, and by the waitresses and bartenders. He wasn't about to start tossing out threats at some random pack of pot-smoking guidos with me and Vince on his payroll. "You're with us, now," he'd said one night after our obligatory exchange of cheek-kissing, so I was with them, like it or not, for as long as Migs wanted to leave me in the VIP room. And being "with us" entailed making sure Angelo's air was as clean as he wanted it to be.

By this time, I was well known to the VIP regulars as Angelo's personal bouncer. The non-connected spenders in the room didn't like this much, but when they asked around and found out who it was that I was roping off and walking to the bathroom every night, they rarely complained. They didn't ask for much, because they knew they weren't getting anything from me. Being told what *not* to do, however, was something they weren't prepared for, especially when the directive came from a bouncer who earned his money catering to a pack of known criminals.

"You gotta put that out and keep it out," I said to the customer I suspected of smoking, "otherwise I'll have to ask you to leave."

"I ain't the one smokin'." He'd seen things developing, and was getting angry.

"Yeah you are. I saw the joint in your hand. You can't do that in here, so do me a favor and wait until you get outside."

"Why?" he said, standing and pointing at Angelo. "'Cause that motherfucker over there don't like it?"

"Listen, the best thing you can do right now is to sit down and stop pointing over there."

The smoker was shouting at me, but wasn't making eye contact. Instead, he was looking over my shoulder, saying everything

directly to Angelo. "Fuck that! I ain't gonna stop doin' shit. Fuck that guy. He don't like somethin', he can come over an' fuckin' tell me himself."

Angelo had been watching. He stood up, as did several of the men sitting with him in the corner, and undid the clasp of one of the velvet ropes that penned him in, dropping it to the floor. The situation was about to become something I wasn't capable of handling without help, so I called Vince on channel 2, which was our dedicated VIP radio frequency. Vince insisted on using a separate channel—security calls typically went through channel 1—because he didn't want Migs overhearing any of his conversations. "Vince, it's Rob. Get the fuck down to my door. *Now.*"

Vince, who was taking care of something at the service bar, immediately ran over to me to find out what was happening. I was still facing the smoker, but was gesturing with one hand to placate Angelo, trying anything I could to keep him back behind the ropes.

"This guy here," I said in Vince's ear, "was smoking weed. I went over to tell him to put it out, and he stood up and started yelling at Angelo."

Vince looked at Angelo and his crew. "Fuck. Okay, I'll take care of Angelo. Call somebody and get these fucking guys out."

I switched my radio to channel 1. "All security near the middle bar VIP room, come down here. I need all security working near the middle bar VIP to come down here. *Don't run.*" I didn't need to further inflame the situation by triggering a bouncer stampede.

Whenever a bouncer says "Don't run," or "No emergency," in a club, it's invariably assumed by every other bouncer in the place that an emergency is in progress, and that it's time to make an all-out sprint to the scene of the problem. It doesn't matter if he's been cautioned to take it easy on his way to the situation—no bouncer wants to be last to arrive. Within seconds, the VIP room had more bouncers in it than customers.

"These four," I said to Migs, who'd come in through the side

entrance, "have to go. The guy on the left was smoking weed all night, and then he tried to start a fight with Angelo."

"Your night's over, guys," Migs said, addressing the smoker and his friends. "Get your shit and let's go."

The smoker squared off with Migs. "I ain't fuckin' goin' no-where. I didn't do nothin'."

Migs looked down at the floor, then back at the smoker. "We can do this three ways. You can leave now, and you're welcome to come back next week. Or the twenty bouncers standing behind me can throw you out. *Or,* we can throw you out and have your ass locked up for bringing drugs into the club. Your choice."

"Why ain't *he* leavin'?" asked the smoker, pointing at Angelo, who knew exactly what was happening. The smoker knew it, too. "Yeah? Fuck you, motherfucker! Laugh it up, motherfucker! Come outside! Come outside with all your boys, you're so fuckin' tough!"

The pack of bouncers moved in and wrestled the four out the door to the sidewalk. Twenty on four doesn't leave much of a chance for the four, especially when the twenty know what they're doing, so the smoker didn't try to go down swinging. He knew the odds, so instead of fighting with us, he kept screaming at Angelo.

"Fuck you, bitch! Yeah, that's right. I know who you are, motherfucker! You think I fuckin' care? I done five years 'cause of motherfuckers like that! Fuck all you motherfuckers!"

As if, unrestrained, he'd have been willing to take his chances against a table filled with Mob guys. The bravado came out because we were there. It always does. Every single "fuck" and "bitch" and "motherfucker" was uttered solely because twenty large men were standing between the smoker and an unpleasant end to his evening—and, quite possibly, his respiration.

These scenes are about respect. They're about not backing down, and not being anyone's "bitch." They're about having your ego stroked by a team of bouncers, even if the stroking consists of getting dropped on your head out on the sidewalk. The aver-

age guido would rather have it happen *that* way—no matter how painful the experience—because he'll then be able to go home to Howard Beach and tell everyone that Angelo needed the intervention of two dozen bouncers in order to avoid a "beatdown," which is what the guido will tell everyone on the block would've happened, had "those motherfuckers" in the black suits not stepped in to "save his pussy ass." The lost irony here would be the fact that I had saved the *guido's* pussy ass from someone who was paying me the majority of my take-home.

There but for the grace of God go you, you stupid guido bastard. It gets old quickly, is what it does. You get sick of people throwing their garbage out the car window, thinking everything's settled once the garbage is gone. You tire of protecting dumb fucks like that weed-smoker from themselves three nights a week for a damned pittance, in a place where none of the antagonism stems from anything real.

When you grow up here, you eventually come to realize that New York City is the major leagues. You see things happen to people—both on the news and right in your own damned neighborhood—and it becomes apparent that you never, ever know whom you're fucking with here. People are murdered in New York because they wake up in the morning feeling they're armorplated—with nothing to justify feeling that way—and they roll with that feeling until they cross the wrong street and find out, the only way you *can* find out, that they were wrong.

CARLO GAMBINO DIED at his summer house out on the Island, right before the 1976 World Series. 1976. *Christ*. The Yankees hadn't started their run yet, and the boss of bosses, the capo di tutti capi, passed quietly the day before Game 1. They say he died watching the game, but there *was* no game that day. I looked it up. Still, you think the old man knew from spiked hair? You think he knew from guidos?

New York's different now, the field widened and narrowed all

at once. It's the same pie, but with more slices to go around. More pies, maybe, some of them impossible to cut. There are more bad guys with more knives, in any event, some of them invading my world, weekly. Nightly. You work in a club like mine, here in New York, it's hard to know whom you can touch, and whom you can't. They're everywhere. Our place was thick with them now, every single weekend night. They're bad with women, bad with booze, and bad with their hands, but they wouldn't think twice about coming back and tapping a trigger in frustration.

This wasn't what I wanted.

13

GRANTED

SCENE: Pre-shift, nine o'clock, a flurry of activity around us. A synchronized cutting of limes. People looking important. This was like a damned soap opera already. It doesn't take long to realize that at any given moment, someone, somewhere, is talking about you.

MIGS: Ray told me you were gonna want to talk.

ME: He did?

MIGS: Yeah. You been here almost a year already. Fucking took you long enough.

ME: What took me long enough?

MIGS: I figured you'd be done with Vince by the first week. Surprises the shit out of me that you're still in there six months later. Ray wanted out of that spot the first night.

ME: So did I, but the money's too good.

MIGS: So what do you wanna ask me?

ME: I don't know what I'm doing in that room. I kind of don't want to be in there anymore. I want to just go back to being a regular bouncer, outside in the club with everyone else. I feel like I'm not even part of the staff working in there. All I do is

watch the same ten fucking guys every night, and they think I fucking work for *them*.

MIGS: You want the front door?

ME: What?

MIGS: You heard me. You want to work up front?

ME: Are you serious? Why the fuck would you put *me* up front? I've been here less than a year, and there's guys inside who've been working for you for way longer.

MIGS: You know you haven't missed a day of work since I hired you?

ME: Yeah, but that's only 'cause I can't afford to stay home. Don't think that has anything to do with having discipline or any of that shit. Believe me, if I could stay home, I would.

MIGS: The other thing I like about you is how quick you got your legs around here. You're an asshole, like I want you to be. Plus I know you, and I know you're not gonna steal. You're smart, you're honest, and you're gonna show up every night. There's some guys here who don't even have one of those things, and you got all three.

ME: You never wanted me working Vince's door in the first place.

MIGS: You're wrong about that. I did want you there, because I wanted to see if you'd turn into a piece of shit like him because he's getting you paid off. You didn't do that, and don't think I wasn't watching for it. I figured if he got you all turned around and doing the wrong thing, it could happen to anyone.

ME: What the fuck did you think I was gonna do? I don't know Vince from a hole in the wall, and there was no fucking way I was gonna sell out to the kind of people he's got coming in down there. The whole thing made me not even want to come to work most nights. I don't give a shit about the money. It's nice, but if it means I got a shit reputation with you, I'm happy with my shift pay, believe me.

MIGS: You want the door or not?
ME: Yeah. I want the door.

————

I WANTED THE door. I wanted the door so badly I could taste the damned door. I could taste the damned door almost as well as some of the people whose faces we'd used to open it on their way to getting tossed. The door was my ticket out of the VIP rooms, away from Vince and the Mob guys, and back into Migs's good graces, which was where I felt I needed to be.

The months spent working directly for Vince had alienated me from the rest of the staff. During a typical shift in the VIP, I wouldn't interact with anyone other than Vince and the people I was babysitting, unless something happened and I had to get on the radio and call for help. Even then, when bouncers came running, it was as though nobody gave a shit what I had to say about anything. They'd come into the room, take care of the problem, and then leave without a word. And there was no mistaking the fact that this was, above all else, a money issue.

All bouncers are not created equal. You see a bunch of guys in suits standing around in a club, and you'd think they're all being paid the same amount of money for what they do, but they're not. Some make significantly more than others, because, for whatever reason, they've been placed in "money spots." This breeds jealousy, as it would in any other profession. If you've been working somewhere for five years, and some guy who was hired less than a year ago is making double—even triple—what you're bringing home, you're bound to resent it eventually.

Among bouncers, this disparity isn't something that manifests itself overtly. If I ran to a fight and found myself in any sort of trouble, the money issue went out the window and the backup I needed was there. Everyone "had my back." It was during down-times that I realized something was going on. There were snide

comments from some of the other guys—not often, mind you, but things were said—about the "favors" I must have been doing to justify Vince's placing me in a position to make money over and above my shift pay, especially since the majority of the bouncers on staff were "Migs's guys," meaning they were automatically skeptical of Vince's motives from the start.

What nobody understood was that I was never thrilled with the situation in the first place. Nobody had ever mistaken me for a team player before, but at least I was trying. I was making a concerted effort at Axis to get past all of the immaturity and self-ishness that had sabotaged everything I'd ever tried to accomplish in my life, and it seemed to be working—if what Vince and Migs had said about my work was any indication.

Being assigned to the front door would be a way for me to get myself back into the mainstream. I'd be out in the open, dealing with everyone on the staff—and their friends that I'd be letting in, if past experience was anything to go by—instead of lurking in the shadows of the VIP rooms, removed from the action, making my living walking Angelo and Nicky to the bathroom. And it didn't hurt that I'd potentially be making more money up front than I ever had working for Vince.

"AND YOU SAID yes?" Amanda asked. "Is that what you're telling me? You took his offer?"

"Sure I did. Why the fuck not?"

"If you had called me before giving him an answer, I would've told you why the fuck not."

"I didn't know we were at the point where I'm consulting you on career decisions," I said.

"For this, you should. You don't know these people like I do."

"Give me a fucking break. I've known Migs for almost ten years. He's not gonna put me in a spot where I'm gonna get fucked, although I *do* want to hear how you think he is."

"I'm not talking about him. He's your friend. I mean the man-

agement. Christian and the rest of them. How well do you know them?"

"Why do I have to know them? It's a fucking door job. I check IDs, I act like a dick, and I go home. What's the problem? How is this any worse than babysitting for a bunch of fucking Mob guys? If you ask me, the door is a step *up* on the getting-myself-in-trouble ladder."

"You don't know as much about this shit as you think you do," she said. "I think you're just looking at the short-term money you'll be making, and you're not thinking about where this is gonna be going in the long run."

"Where it's going? It's going in my fucking bank account is where it's going."

"Look . . ."

"You're right," I said. "I'm not looking past the money here. What the fuck do you think I'm doing this for? You think I want to be friends with any of these motherfuckers? You think I give a shit if they trust me or if I can trust them? I think what you fail to realize here is that I don't give a fuck about anything but going home with money in my pocket."

"What I was going to say, before you decided that shouting over me would make me stop talking, which it won't, was that you should just be careful. That's all. I've been working for Christian for over two years, and I see where this business can lead. I'm too good for that. So are you, and I don't want to see that happen to you."

"See *what* happen to me?" I asked.

"I don't want you to start thinking the club business is something you can do for a living, because you'll start forgetting that it's beneath you. You're gonna be making a lot of money at the door, just like bartenders make behind the bar, and you'll start believing you can just keep doing it forever. That it's always gonna go on, just like that. But it doesn't."

"No?"

"No," she said. "It doesn't. You can get fired for anything in

the club industry. *Anything.* You even look at someone the wrong way, you're out on your ass, and if you don't have a backup plan, you're pretty much fucked."

"So how'd you last this long?"

"Don't even try that."

"What?" I asked. "I'm totally not intimating anything."

"Don't be an asshole. And they've tried. They've never succeeded, but they've tried."

"Tried what?" I asked, feigning innocence this time around.

"Have you seen the girl Christian brings up to his office every night?"

"I've seen one, I think."

"Tall Spanish-looking girl?" she asked. "Long black hair?"

"Yeah."

"That's Maria, the one that left here without me the night you first gave me a ride home. That's how she got her job, and that's how she keeps her job. She can't bartend for shit. Honestly? I don't know this for sure, but it wouldn't surprise me if I found out they were pimping her out to the VIP customers."

"That's when she's not upstairs blowing Christian, right?" I added.

"Or whatever the fuck else they do up there."

"So what's in it for them having you around, if you're not gonna play their game?"

"Think about it," she replied. "They *are* running a business here, so it makes sense to have at least one bartender in each room who's gonna stay sober and not try and rob them blind."

"True."

"And Christian's a guy, you know? Sometimes men would rather get their hands on some girl they haven't touched than keep their hands on the one who's letting them get away with it. I think in my case, he keeps me around 'cause I *won't* put my head in his lap."

"Can you do me a favor, then?" I asked.

"What?"

"Can you make sure it stays that way, please?"

"Why?" she asked. "What difference does it make if all you give a shit about is money?"

"The difference is that I know what you're saying. I know this fucking place is filthy, and that these people are the scum of the fucking earth. I know that, okay? I just think I have a little better ability to keep all this shit separate than you do. I'm just a damned bouncer, and I think you're telling me to watch out for all this shit a hot little female bartender has to watch out for, and it doesn't apply. Nobody's pimping me out, nobody's pulling me into closets, and nobody's trying to threaten me into blowing them. This shit's just a job, and that's all it ever will be."

"Axis is shit. You know that, right? It's just shit. I can't wait to get out of here."

"Yeah," I said. "I know, but like I said, it's just a fucking job. It's not your whole life, and as soon as you learn to separate the two, you're gonna be a lot better off."

ENVELOPE

Amanda's warnings meant little to me at the time. On my scorecard, our relationship hadn't yet reached a level where I'd be taking her advice on subjects involving anything other than the clothes I wore and the positions she preferred. Whatever reservations she may have had about my accepting a higher degree of responsibility at Axis were her problem—I certainly didn't share them—and I had no idea why she was so vehemently warning me off the door. What I *did* know was that *I'd* be a lot better off up front, away from Angelo and Vince and all the shit that went on in the VIP rooms.

No bouncer would turn down the front door of a Manhattan club unless he didn't want the entire fucking world to know he worked there. The only guys who'd ever say no are bouncers who work during the day as police officers, or bouncers who are being pursued by them. The rest would do exactly as I did. They'd take Migs's offer without a moment's hesitation. It would have been pointless not to. The front door is a club's most lucrative money spot, where you're likely to earn a minimum of three to five times the amount of cash you'd be making as an inside guy.

You don't get the door at a club unless you're a known quan-

tity—known by management, by owners, and by the head of security. Most managers at Axis had no idea who I was, and I'd never even been introduced to Christian, so I was assuming that Migs was given free reign to assign bouncer postings however he chose to do so, without Christian's notorious micromanagement habit getting in the way.

"So I have you to thank for this?" I asked Ray, sipping deli-bought coffee and leaning against the podium I'd wheeled onto the sidewalk at his direction.

"Migs likes you, but yeah, I talked to him about it. He'd rather have you up here than have you quit."

"Who said anything about quitting?"

"Nobody," he replied, "but that's what happens when you put a guy in a bad situation like we were in with those fucking Mob guys. You get so wrapped up in that shit, the only thing you can do sometimes is quit. That shit's dangerous, man. Don't kid yourself."

"I know it's dangerous, but why didn't he just put me back inside standing on a box? I doubt he's got me up here, doing a job that everyone here wants, because he thought I was such an important cog in the fucking wheel. That's bullshit."

"Of course it's bullshit. You're up here 'cause you're not exactly what I'd call an *independent operator.* Migs knows you're so scared to death to lose your fucking job that you wouldn't think of stealing from him."

"I wouldn't anyway," I said. "Even if I wasn't so hard up to keep this fucking job, I wouldn't steal from anyone."

"You remember Freddie? The guy that was up here for the first part of last year?"

"Yeah, I do. Real tall guy with a ponytail, right?"

"Right," he said. "Freddie was a good guy, and he was good at making money up here, but he got greedy. All you gotta do at this door is collect cash and put it in your pocket. At the end of the night, you count it up, and you hand half of whatever you have to

Migs. That's it. Just cut the stack in half and hand it over. The rest is yours. Freddie couldn't figure that part out."

"Which part?"

"The part about not taking more than you deserve. That motherfucker worked on the sixty-forty plan. Better yet, he worked on the eighty-fucking-twenty plan. He'd pull in a grand up here, shaking these assholes down in the line, and when we closed he'd walk up to Migs and hand him two hundred. That's what I'm talking about. He got greedy, and Migs got tired of it."

"How long was that going on?" I asked.

"Not long. See, the thing in this business is, nobody gives a shit if you make money, just as long as *everyone's* making money. So if there's a guy who's responsible for putting you in a spot where you're earning, you gotta kick something back. You can't turn around like Freddie did and slap the guy in the face by lying to him about how much you're bringing in. Migs puts this asshole at the door, and he's gotta sit there and watch the guy take home more than he does? And the dumb motherfucker thought Migs didn't know what was going on, the stupid fuck."

"So Freddie got fired, then?"

"Yeah, he got fucking fired," Ray replied. "He got fired, and he's lucky he didn't end up in the fucking river. I'll tell you the one guy nobody likes. The one guy nobody likes is the greedy son of a bitch who thinks he deserves more than everyone else. And Migs has to kick some of everything *he* pulls in up to Christian. That's what nobody gets. Migs has people he's gotta answer to. You think he's gonna put up with some asshole lowballing him every night? No matter what happens out here, he's still gotta come up with his share."

"So he looked at all his options and figured I was the best one to put up here?"

"Hey, no offense, but you're a clean slate. You're here long enough to have a general idea of what's going on, but you have a reputation of a guy who does what he's told because he needs the

job. He's right, too. I agreed with him that you should be up here. You just can't get greedy, you know?"

"I'm not planning on it," I said. "This is the way I look at it. I could stand there at Vince's door, or up here, and pull in a couple of really big jackpots, but then I'll get fired and cut off the whole source of income for good. Fuck that, man. If I had a choice, I'd rather just sit inside and make a buck-fifty a night and not have to worry. That way, I'll always have a job and the cash will keep coming in. You get too greedy and you get caught, eventually you'll have nothing."

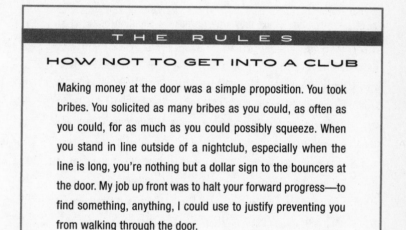

THE RULES

HOW NOT TO GET INTO A CLUB

Making money at the door was a simple proposition. You took bribes. You solicited as many bribes as you could, as often as you could, for as much as you could possibly squeeze. When you stand in line outside of a nightclub, especially when the line is long, you're nothing but a dollar sign to the bouncers at the door. My job up front was to halt your forward progress—to find something, anything, I could use to justify preventing you from walking through the door.

One false step on your part—a minor dress-code violation, or a problem with your ID—and you were shut down. You weren't going past us, and the only way you'd have a prayer of getting in was to "take care of the problem."

"Yo, that guy ain't wearin' a collared shirt! How'd he get in?"

"He took care of the problem."

That's how it works. If you find yourself stuck at the front of a club, and you really want to get in—if getting in actually means something to you—the only way it's going to happen is

if you bite the bullet and fork over some cash. That's it. That's the definition of "taking care of the problem," because the problem invariably entails a certain disconnect between the hand of a bouncer and a bill that stubbornly insists on remaining in your wallet. Drop all the names you want, but we're the final authority unless the manager you know is actually standing on the sidewalk waiting for you, and the chances of that happening are slim. The only thing that'll get a doorman's attention is money. Anything but cash up front, as we say in the business, "ain't right."

Most times, the only way to make a situation better is to avoid telling people all the things they need to do. If you give them a to-do list, nothing will ever get done. Instead, if you take the time to explain to people what they're *not* to do, and you attach a stigma to the doing of these things, they'll tend to listen a little more carefully to what you're telling them. There are lines of bullshit—several of them, in fact—that door bouncers hear every single night. Maybe you've tried one of them out at some point, working your magic on some incredulous stooge of a doorman who, unbeknown to you, has heard the identical song-and-dance three times in the preceding five minutes.

None of the following lines work. None of the following crocks-of-shit have ever worked, at any door, in the history of nightclubs. In fact, if you do decide to use any of these, be aware that you're putting yourself "on the clock" as soon as you open your mouth. This means that the doorman will quickly lose his patience with you, and your wisest course of action—if you still want in—will be to take out your wallet and show him some cash. Otherwise, you'll be told, in no uncertain terms, to take a walk.

"BUT THIS IS MY ID!"

Yes, okay, good, but it still doesn't make this *thing* you're showing me valid. This is the last refuge of someone without sufficient intelligence to concoct a good cover story, but with too much pride to beg for entry. Claiming, however, that some dog-eared, expired piece of crap is your sole form of identification hardly obligates the doorman to accept it as such. The only thing this insistence will do is affirm what we already know to be the case: that you're someone we don't want inside.

"THE GUY SAID IT WAS OKAY!"

What "guy" are we talking about here? Where is this ubiquitous "guy," and why are his policies on letting everyone do whatever the fuck they want so goddamned liberal all the time? Whenever you catch anyone doing anything wrong at a club, there's always a "guy" who, according to them, signed off on whatever it is they're doing. The "guy," of course, never has a name. He's always just "the guy," so nobody's ever able to call him to confirm your claims. If "the guy" exists, do yourselves a favor and ask for his name.

"WE DROVE A LONG WAY TO GET HERE!"

Telling the doorman how trying an ordeal it was to get to the club from Staten Island won't exactly tug at his heartstrings. At the door of any Manhattan club, doormen see IDs from all over the world—the vast majority of them valid. Make sure everything's in order before you leave the house, because the length of the trip you've taken to be denied at the door is *your* problem, not mine.

"I USE THIS ID HERE EVERY WEEK, AND I'VE NEVER HAD A PROBLEM BEFORE!"

This confronts the doorman with the "face value" dilemma—the same one he has to deal with when informed of some mysterious dispensation from "the guy." The thing is, you can't expect anyone working a door to take anything you say at face value, because they won't do it. We've never seen you, and we don't know you from a hole in the wall, but you're expecting us to take you at your word that you're a regular customer despite showing me a license that expired in 2001? People lie to doormen all night. With a bad ID, you're not the one we're likely to believe.

"I CALLED ON THE PHONE, AND THEY SAID IT WAS OKAY!"

No, they didn't. Call any nightclub and ask them a question about their door policy, and they'll tell you everything that happens up front is at the discretion of the security staff. Then they'll hang up on you. And did you get the name of the person you spoke to, by any chance? Of course you didn't.

"ALL MY FRIENDS ARE INSIDE!"

So? You're not. Now what? All you're telling me here is that you're the idiot of the group, because you're the only one who, for whatever reason, couldn't manage to square your life away and get in. Why, out of fifteen people you're claiming are inside, are you the only one with a problematic ID? Your friends' IDs have no bearing on yours. You don't get a clean driving record and a valid ID by osmosis.

"EVERYONE I'M HERE WITH IS OVER TWENTY-ONE!"

Again, there's no runoff from your friends when it comes to your license. Each ID is checked individually—judged on its own merit, or lack thereof—and if one can't pass muster, its bearer can't come in. It's that simple. The fact that your twenty-three-year-old boyfriend and his sister are both of age doesn't trickle any points down to you.

"I WOULD NEVER BRING MY REAL ID TO A CLUB! I MIGHT LOSE IT!"

Men *never* say this. Women *always* do. The premise is this: they'll try to convince us that it's common practice to use an old, expired license when club-hopping, because it's too risky to carry such an important piece of documentation—one's current license—in a place where it could easily be lost or stolen. This is nonsense, because clubs are required, by law, to ensure that customers provide a valid, non-expired form of identification before purchasing or consuming alcohol on their premises.

"I'M A FRIEND OF CARMINE'S!"

If you're a friend of anyone who means anything to the club, you'll be on his or her guest list. Don't drop the name of someone you don't know. Don't mention someone who won't recognize you if we take the time to call them outside for a look. In fact, if you're not on the damned list, stay the fuck home.

"CAN'T YOU JUST DO ME A FAVOR?"

Sure, I can do you a "favor," but I'm going to need something in return. It's only fair, right? You ask a favor of me, I get one back. Isn't that how it works?

"What do you need?" you'll ask.

"Listen. I'm moving out of my apartment tomorrow morning, and I need to carry a heavy sofa bed down five flights of stairs, 'cause it won't fit in the elevator. You wanna come over and give me a hand?"

"Huh?"

"You can't make it? That's okay. I have something else you can do for me, since you're so big on favors. My car needs an oil change. It's out back, and I've got a filter wrench and a pan in the trunk. You take care of that for me and I'll let you in. Favor for favor, right?"

SCENE: *Front door, in a perpetually evolving crowd that, despite turning over every three minutes, never seems to move away from me—the primary theme being one of unwanted, unsolicited interaction.*

GIRL: I had stitches on my hand once. You wanna see?

ME: What, your scar?

GIRL: That's the thing! I don't even have a scar!

ME: Okay, I'll bite. How'd you manage to get stitches without having a scar?

GIRL: It's a great story. I was sitting in the emergency room, hysterical crying . . .

ME: What do you mean by that?

GIRL: By what?

ME: "Hysterical crying." Don't you mean you were "crying hysterically?" Why does everyone from New York insist upon saying they were "hysterical crying"?

GIRL: Huh?

ME: Go ahead with your story. I'm riveted.

GIRL: Oh. Well, so I was in the emergency room hysterical crying, when this, like, guy comes up, and he's like, "What's the matter?" And I'm like, y'know, still all crying and shit, so he tells the nurse he wants to take me in back.

ME: In back for what?

GIRL: Oh, like he was a doctor and shit.

ME: I've heard you could find those in an emergency room on occasion.

GIRL: So lis-sen. The story gets better.

ME: You're kidding. Is that even possible?

GIRL: No, for real. It turns out that the guy who was talkin' to me was the best hand-and-face doctor in Manhattan.

ME: What the hell is a hand-and-face doctor? Like, a plastic surgeon, like?

GIRL: Yeah! And, like, he wanted to work on my hand, 'cause I was all crying and shit.

ME: Hysterical crying?

GIRL: I was scared! My hand was all bloody and shit.

ME: And so the best plastic surgeon in New York put stitches in your hand?

GIRL: Yes! How lucky was I that he was there?

ME: Sounds like it.

GIRL: He was so great. It didn't even hurt, and it didn't leave a scar!

ME: Wow. The best plastic surgeon in New York. That's awesome. Why didn't you have him do some other work while you had him?

GIRL: Excuse me?

———

I KNEW NOTHING about anything, really. When you bounce, you're operating on a need-to-know basis, and I was nothing but

a blank chalkboard most nights at Axis, because nobody ever thought I needed to know anything. All night, every night, question upon question would fly my way and I never had anything to offer in response. Wherever I was posted, I'd make like a wooden Indian, so people would know to pack it in and take their questions elsewhere.

The only two things I was ever truly certain of were the location of the bathrooms and the time. That was it. Most times, it was a crapshoot as to whether I'd remember either quickly enough to let the customers know before they scurried away. All I really knew at any given point during the evening was that I didn't want to be there, and didn't want to be fielding questions from anyone.

"Yo, it's kinda dead in there. Where else around here's happening tonight?"

How the fuck was I supposed to know? I didn't live in Manhattan. I didn't ever come to Manhattan for any other purpose but to work—there, at Axis. In fact, I had begun to despise Manhattan and everything that went along with it, but this fact didn't stop every guido coming down the pike from thinking, for reasons known only to them, that I was privy to some gilt-paved inside track to Manhattan nightlife glory.

"Yo, lots of ladies in there, or what?"

"I dunno. We're outside. Let me just throw on my X-ray glasses and have a look."

"You're the doorman, muthafucka! You should know who been comin' in!"

"Touché. Score one for Howard Beach."

The questions came all night, in flurries and volleys and salvos, and there wasn't a damned thing I could do to stop the process but to tell them all I didn't know. I pled ignorance, meatheadedness, indifference, and hostility, but it simply never stopped. Sometimes, fights would start because customers mistook my inability to answer their questions for "attitude," and the obvious solution to that was to remove their shirts and challenge me to a fight.

"Yo, you got the best job in the world, yo!"

"I do?"

"Yeah, man! You get to stand here all night and watch beautiful women walk by!"

"Well, sure, there's that."

"Yo, you must get *tons* of pussy up in this muthafucka, right?"

Well, no. I didn't. I didn't get "tons of pussy" as a direct result of standing on the sidewalk in a cheap suit, carrying a flashlight. Fact is, my station in life was what I thought *precluded* me from getting the "tons of pussy" I thought I so richly deserved. Standing outside in my hundred-fifty-dollar suit and the cheap-ass boots I'd bought at an Army surplus? Glowering at the line of drunks stumbling out the door and waiting to split someone's head open with my big black Maglite? The *bitches* weren't exactly *swarming*.

If you took a look at us on our way out, if you looked really hard and close, you'd see most of us leaving alone. Working the door—or any spot—at a nightclub doesn't guarantee a man a monopoly on smooth. I was about as suave as a limp dishrag and approximately half as charming most nights. I knew neither "where the bitches was at" nor what to do with them once I found them, so you needn't have bothered to ask.

The questions persisted, lobbed by the trolls. Tossed at me nonstop by the no-shame brigade—those desperate little fuckers who'd come into the club and ask me questions about everything from workout tips to real estate to auto repair. To them, we were bouncer-kings, with access to all the secret things that "guys like us" had always kept hidden from the patently uncool.

"Hey, bouncer! What up?"

"Hey."

"Yo, is the party in here?"

"Why'd you wait in line for an hour," I would ask, "if you don't know what's going on in here?"

"I'm just messin' with you. Yo, there's bitches in there?"

"Sure," I'd reply. "Bitches upon bitches."

"And girls is dancin' up in this shit?"

"Yeah, man," I'd say. "They're dancing everywhere."

"Hey," said one swarthy little man one night at the door. "Let me ask you somethin'."

"Sure."

"I just got divorced and I don't go to clubs a lot. Is it okay to just go up to a girl and start dancing with her? Do you have to ask them first?"

"I don't see why you can't just go dance with them," I replied. "When you're out on the floor, I think everyone just dances together."

"All these clubs I been goin' to," he said, "all I see is guys grinding on girls."

"Yeah, that's the style."

"And all you gotta do is walk up to 'em?"

"Sure," I replied. "That's all it is. They don't give a fuck."

"So, what do you think I should do?"

"About what?"

"Like, how can a guy like me get girls to start grinding on me like that?"

"How would I do it if I were you, you mean?" I asked.

"Yeah."

"I'd pull a knife on 'em and hold it to their throat. That always works."

SOMETIMES, LATE IN a shift, when the lines had wound down, I'd go inside and watch Amanda work. I had some issues with her personality—her penchant for constantly doling out unsolicited advice would grate on me periodically—but I was thrilled with the time we'd been spending together, and I was still impressed with myself, perhaps overly so at times, that I had landed the one girl in the club that everyone wanted to get their hands on. Despite the contentious nature of our relationship, there was no

real way around the fact that I thought she was absolutely beautiful. She knew this about me, too.

I saw what the customers did on those trips inside. There's something about a pretty girl at work behind a bar. Any garden-variety drunk could tell you exactly what that something is—leering at her as the hours go by—and it's the reason clubs hire beautiful women to do the job. Places in New York—and elsewhere, I'm sure—hire their female bartenders through "open call"–style auditions, and I was certain, staring at her from the edge of the lobby, that whoever interviewed her had felt the same thing I was feeling when she'd walked in the room for the first time.

It's a certain vulnerability in female bartenders that makes them so painfully attractive to the lonely men drinking at the bar. They're all alone back there, but you know in the back of your mind that they're someone you'll never get the chance to touch. Amanda was perfect where they'd placed her—at the central bar in the main room—because that untouchable vulnerability was what she gave the crowd. You'd throw your money at her because you wanted her to have it. She was stunning, yet approachable. And I knew the whole damned thing was nothing but an act.

"How's your father doing?" I asked as we made our way over the 59th Street Bridge. "You haven't mentioned him in a while."

"He's doing better. He's back at work now, anyway."

"You do okay tonight?"

"Yeah," she replied. "It wasn't bad."

"What's the matter?"

"Nothing. Why?"

"You haven't said shit to me since we got in the car," I said. "Are you pissed at me or something?"

"No, just tired. Why'd you come inside at the end of the night?"

"You saw me?"

"Of course I saw you, asshole," she said. "Wouldn't you see me if I was standing across from you for a half hour?"

I cracked a window. "Yeah, I'd see you. I just didn't think you

saw me. I was watching you the entire time, and I didn't see you make eye contact once. Can you at least fucking wave if you know I'm there?"

"Why were you watching me?"

"Because I was sick of standing outside watching Ray smoke, and I wanted to come in and think about something pleasant for a while. I think I'm allowed to do that, no?"

"I want to get a real job," she said, tucking her hair behind an ear. "I think I'm gonna just take my bachelor's degree and see if I can get a teaching job at a private school so I can go back and finish my master's."

"You can do that?"

"Yes, I can do that. I'm a certified teacher. That's why I went to *college*. It's just hard to get a job at one of the better-paying schools without a master's or a lot of experience, which is why I was going to NYU."

"Well," I said, "without trying to sound like some kind of jerk-off, I think you know that every night you spend working at the club is another day you're no closer to getting a teaching job."

"I know that better than you do."

"And I think you also know that this fucking club is about as far removed from the reality you want to make for yourself as anything could possibly be."

"Why do you say this kind of shit if you don't really believe it for yourself?" she asked.

"What the fuck are you talking about?"

"I'm talking about you. Where do you get off trying to give me advice like that, when it looks like the club is your *only* reality right now? When are *you* ever gonna get off *your* ass and do something with *your* life?"

I took my eyes off the expressway for a moment and looked at Amanda in disbelief. "What the fuck? It's pretty obvious to anyone who knows you that you can't stand working in that fucking place, and that you'd rather be working on your career, but I'm

a hypocrite for pointing it out and telling you that I think you'd be doing the right thing by doing what you want to do with your life? I don't get it. Why does this have anything to do with me?"

"It has everything to do with you because you don't listen to yourself. You're giving me advice that you won't take yourself. What have *you* done to improve *your* life lately? Anything? And don't give me the lines you're always feeding me about *surviving,* and *making money,* and *paying your bills,* and all that shit, because there's only so much of that I can take before I feel like throwing up. You should have violins playing behind you when you fucking talk sometimes."

"Jesus. Tell me how you *really* feel."

"I don't mean to piss you off," she said, "but look at yourself. You're driving a piece of shit, and you're living in this apartment in Queens Village, of all places, and it's all you can do to keep your head above water. How much money do you have left over at the end of the week? Do you have health insurance? How much longer do you think you can go on living like that?"

"What the fuck am I supposed to do, then?"

"Anything but what you're doing. Something to take a step in a positive direction. All you do is work, and you're working in two jobs that give you absolutely no hope for any kind of future, unless you're planning on making a career out of checking IDs at bars and clubs for the rest of your life. I think you should look into going back to school and finishing your degree."

"And who's gonna pay for *that*?" I asked.

"*You're* gonna pay for it. Move back in with your mom if you have to, for God's sake."

"I think *that* ship left port about five years ago."

"Then rent a room or something," she said. "And get rid of the car, and the car insurance, and take the damned bus to school. When you're trying to get out of a rut, you have to do everything you can to get yourself out of it. And you're *in* a rut, whether you know it or not."

"This whole conversation is a fucking rut, if you ask me."

SCRATCH

Surviving in New York is a bitch. The way things are set up here, we're living in a place where the only way to get anywhere is to keep stacking money on top of money, and the only chance you have to make the world understand you're somebody is to make sure everyone knows you've got some. You need the white Escalade with the gold rims. A house isn't a home until you've installed double doors in front, Belgian block on the driveway, and Italian marble on the steps. That way, when you have the big white truck and the fancy bricks, you'll always have something completely ostentatious on hand to show the world you're willing to spend.

It works the same way in the club. All the things people do in order to make names for themselves—the handshakes, the hugging, the tattoos and the steroids—won't make a damned bit of difference if you're not in the VIP room buying bottles. I'm not talking one-shot deals here, either. Vince wanted people coming back every week. He needed you to blow five thousand dollars in his rooms, then come back the next week and do the same, and the only way to get him, and everyone else at Axis, to treat you

like you were somebody was to give us all the impression that *that* was exactly what you intended to do.

In New York, what you *do* doesn't matter. It's what you *make* that's important, and the only reason anyone will ever ask you what you *do* is because they're trying to figure out what you *make*. It's not important how you make it, just as long as you have it around to spend. You can rape old ladies for a living here, but if you're earning a healthy wage to do the raping—and you're driving a Benz—you'll have your respect. Once you've got the requisite scratch, the respect, for whatever it's worth, comes easy.

The celebrities, the investment bankers, and the rank-and-file people with disposable cash had fled Vince's VIP rooms as soon as Axis went cold. A VIP host can sit you on the most comfortable leather sofa in the world, pour Cristal down your throat, and have supermodels hand-feed you stuffed grapes, but when you look around and see nothing but these obnoxious, porcupine-headed local kids dancing like they're having seizures and comparing eyebrow-tips, the smart thing to do is to take your business elsewhere.

This influx, of course, cut into Vince's personal profit stream in a major way. Vince, as I understood it, was paid a flat percentage of the VIP's revenue—the majority of which came through bottle sales—every night. That was his salary, so it was in his best interest to make absolutely certain he could keep the rooms filled—and the bottles moving—from the beginning of a shift until the end. If Vince had his way, last call wouldn't be made until six in the morning or later, which is why we always had such difficulty clearing the VIP rooms at closing time. Last call for Vince meant "last call for bottles."

Axis was no longer on Manhattan sophisticates' radar, but Vince still had to make a living. With constant pressure from Christian to keep the numbers up, it didn't matter to him *who* was in there, or what they were doing, so long as they were spending. There are a thousand VIP promoters in New York City, each

with a list of contacts as long as Vince's was—each of them more than willing to come to work for one of Christian's clubs if Vince's tally ever showed signs of lessening.

Vince was doing what he had to do to stay in business. It no longer mattered whether you had anything to "offer the vibe." Nobody gives a shit about providing guidos with ambience. If you had enough money to spend, you were in, and treated to the premium version of Vince's hallmark pseudo-hospitality. And when the rich and the famous were out of the picture—at least the ones who'd gotten that way through outwardly *legitimate* means—we were dealing with a cross-section of New York that, to the bouncing staff's line of thinking, was probably best left under the rocks from which they came.

After the "crash," the only people with enough money left to reserve tables in the VIP rooms on weekdays—I was already assuming they didn't have to go to work in the morning—were able to do so because they'd come to the club to sell drugs. This was apparent to everyone but me, but even *I* managed to figure things out with a little help. If you're new to the process, like I was, and you don't know what the fuck's going on around you, you'll eventually come to find out you're surrounded by drug dealers. I wasn't naive enough to think *all* the people I was watching were on the level, but I had no idea that the vast majority of them were involved in "the trade" until someone pointed out the obvious.

"How the fuck can three thousand people possibly afford to be out on a fucking Wednesday night?" I asked Johnny one night before going up front. "Don't these motherfuckers have to go to work in the morning?"

"What are you, stupid or something?"

"Why?"

"Why does everyone here always ask the same question all the time?" he asked. "Of *course* they don't have to go to work in the morning. People like this don't have to work. They just come here and sell shit to each other."

"All of them?"

"No, not all of them, but a hell of a lot, I'll tell you that."

I nodded. "It makes sense. I can't understand how most of these jerk-offs in the VIP rooms can make a living, period. I suppose you don't really need manners to sell coke."

"Look at it this way. You got like, what, ten million people in New York? Plus a lot more in Jersey and Long Island, right? You're gonna have more drug dealers around here than anywhere else, and this is an easy environment to do that shit and get away with it. It's dark, and everyone's fucked up anyway, so why not come down here and make money?"

I'd look around the VIP room, watching them all have a blast ordering bottle after bottle, and think the club was the place they'd come to spend their off-hours. A little Dom Pérignon for their downtime. It's where they'd come to unwind after a hard day's work selling bags. The fact that they were there doing business, combined with the disproportionate number of security problems that *started* in the VIP, made me wonder how I'd worked the rooms for so long without noticing all the commerce going on around me. The VIP was bursting at the seams with criminals, and Vince was letting them in because the money they were spending for bottles was his vig.

The entire time I was at that door, right under my nose, they were working. I'd spent months minding that door with Vince, watching it all unfold in front of my eyes, and never pieced together what, exactly, was going on. Even though Johnny had explained it all to me in detail, I didn't completely understand what was happening—and how it connected to the bigger picture—until Vince came to the door to have a word with me about a week after I was moved.

"You like it better up here?"

"It's not bad," I said. "The money's about the same, plus I don't mind standing outside away from that fucking music."

"Did Migs say anything to you about handling the VIP list?"

"No. I don't touch the list." I knew where the conversation was heading, and I wasn't about to go there. The thing I had always tried to do with Vince, at least until we both knew I no longer wanted the VIP door, was to make it perfectly clear to him that I was aligned with Migs. He knew—whether he cared or not was a different story—that I didn't want to be put in situations where I'd have to be in conflict with the guy who'd hired me. Now, in his desperation, Vince was doing some figuring, and I didn't want to be involved.

"Who does it, then? Ray?"

"Yeah, Ray always has the list."

Vince spit. "You know that was bullshit what Migs pulled putting a guy outside that door, right?"

Everyone coming into Axis through the VIP entrance, by order of Migs, now had to come directly to the front door first. Technically, this had always been the case, but with no bouncer— nobody who reported directly to Migs—keeping track, Vince could bring anyone he wanted into the club. There were at least a few dozen people Migs wanted to keep out permanently, but they knew they could circumvent the process by calling Vince. With a hand-picked watchdog posted outside the VIP doors, Migs would have full control over every part of Axis.

"I knew you wouldn't like it, Vince. Whether it's bullshit or not is between you guys. I got nothing to do with keeping anyone out."

Migs liked to ban people. He especially liked to ban anyone thrown out of the VIP rooms, because, having spent more money than anyone else in the club, they tended to give us the most problems on their way to the sidewalk. Whether they stayed out long-term or not was apparently the issue, because the customers, according to Migs, needed to know they couldn't get away with anything at Axis.

One night—I was still working in the VIP section when this happened—a customer who'd been thrown out had told Migs he

was going to his car to retrieve a gun, and that everyone at the front door was going to take a bullet when he came back. Migs, unwilling to wait for anyone to carry out a threat like that, tackled the guy from behind, and the entire door staff proceeded to brutally beat him in the middle of the street. When Vince went back inside, I brought the incident up to Ray.

"Someone pulls that shit," he said, "and everything goes out the window. You gotta lump him up."

"You gotta beat up a guy *that* bad? I mean, I don't blame Migs for not wanting to see if the guy meant what he said, but that stupid fuck ended up in seriously bad shape because of that."

"Hey, listen. People gotta know they can't get away with that shit here, especially the way things are going now. They gotta know we ain't targets. If some guy comes in and says something like that, and we don't do anything about it, that shit gets around."

"Gets around with who?" I asked. "People talk about this shit with each other outside the club? Why is what goes on at a club important to any of these people when they're not here?"

"When it fucks around with their business, they'll talk about it. You think people don't know? Look what happened with that motherfucker. You know the guy who got beat, right?"

"Yeah. I know who he was. He got thrown out the back door, but he was in the VIP with Vince all night that night. He was a regular."

"You should've seen the way he acted around me when I was down at the VIP door. He didn't do shit when I was around, 'cause he knew not to. Guys like that ask around. When he walks in the door, he knows who he can fuck with and who he can't, and he thought he could fuck around with Migs."

I WAS UNDER no illusions as to why I'd been posted at the front door. This was strictly Migs's handiwork, and it was being done because he wanted more money than he'd been pulling in

with his previous group of doormen—all of whom had been there since before I was hired. I would essentially be his puppet. I'd be reporting to Migs, watching other employees for Migs, and, most important, handing Migs a significant sum of money at the end of the night.

At Axis, I'd never been regarded as one of the club's prized "show ponies." As an inside guy, I had earned the respect of everyone who'd seen me work, but I wasn't moved up front because anyone wanted me to be the "face" we'd show the people coming up the line. I was a solid bouncer to have around in the event of a fight, but that was about the extent of things. Women weren't exactly lining up to ask me to pose for pictures. I wasn't leaving work with a half-dozen phone numbers every night. To me, the important thing was the job. I was the guy who paid attention, who listened to his radio, and who did exactly as he was told. My shtick was being there—always being *there*.

As a result of lying low for a year, I was rarely the recipient of any of the quasi-legitimate offers customers often make to higher-profile bouncers. I'd never been offered a modeling contract or an acting job, and VIP invitations to other clubs hadn't yet come my way. I'd get the occasional invite—"Come to my place! I'll hook you up!"—but it seemed as though I was destined never to be "that guy." Where these customers' "places" were, and what, exactly, I'd be "hooked up" with—an STD, perhaps?—I had no idea, nor was I ever inclined to find out.

Once I had the door, though, everything changed. I finally had something to offer the world other than the competent and consistent performance of my job, and when that happens to you, you'll quickly find yourself in the company of more new friends than you can count. People who hadn't so much as looked at me for the better part of a year were asking how I was doing. They asked how my *family* was doing. The compliments—"Damn, nigga! You lookin' huge! What you takin'?"—started coming my way as soon as the line began to form.

Not that any of this mattered, mind you. I wasn't authorized to do a damned thing for these people other than check their IDs and direct them to the cashier. The door layout was configured in a checks-and-balances sort of way, so no single bouncer would be able to let anyone inside for free. Someone was *always* watching. Ironically enough, I had more authority inside, where I could at least escort people to the private bathrooms and score them drink tickets. Outside, I wasn't shit, a concept nobody in line seemed willing to grasp.

Reality, however, failed to stop the customers from grouping the entire bouncing staff together as some favor-granting unit of benevolence whose sole purpose for coming to work was to dole out free shit to guidos-in-need. They viewed us as a collective. A favor done for one particular bouncer was a favor for the entire group, to be redeemed at any time, from any individual bouncer, however the favorer saw fit.

"Hey," muttered one in my ear, "could I talk to you for a minute?" He'd come from behind the barricades lining the sidewalk and leaned in beside me.

"What do you need?"

He moved closer. We were speaking in profile. "Listen, I got five people back in line. You can slide us in through the side door, right?"

"No."

"Come on, man. I own Siciliano's. I'm Siciliano!"

"I'm sorry," I said, "but I have no idea what that is. Is that supposed to mean something to me?"

I usually didn't eat at any of the local places, either before or after work. When I'd take Amanda out after a shift, we'd go to a diner in Queens, because I didn't trust anything I was getting in West Chelsea and didn't want to deal with the runoff from all the clubs. In Queens, it'd be a different sort of runoff. There'd be guidos, certainly, but they'd be newer, fresher guidos. If I had to eat a bacon cheeseburger in a crowd of them, at least they wouldn't

be the same guidos with whom I'd been haggling at the door three hours earlier. I had honestly never heard of his restaurant—which, of course, didn't mean that I couldn't at least try to take advantage of the situation.

"It's the restaurant down the block! I bring pizza and sandwiches to Freddie all the time, and he sends us right through the side."

"Freddie doesn't work here anymore."

Siciliano raised his eyebrows. "*Really?* What happened?"

"I don't know what happened, but he's not here anymore, and I've never met you before, so I can't do anything for you."

"Fuck. Come on. I been bringin' Freddie food since you guys opened!"

"And that obligates *me* to risk my job for you?" I had to laugh at this. I'd spent an entire year watching everyone else in the club get "hooked up" with every favor under the sun, and now I was being asked to reciprocate for something done for somebody else.

"I used to take care of him every night, man. Can't you do nothin' for me?"

"Look, I'm totally not trying to bust your balls here, but you doing shit for Freddie has absolutely nothing to do with me. You keep telling me about all the food you brought for Freddie, but *I'm not Freddie*. It's like you bought a Hummer, and you're trying to take it to a Cadillac dealer for an oil change. It doesn't work that way."

His shoulders slumped at this. "Please? I got three girls with me."

"Have you ever seen me coming into your place asking for free food? What would *you* say if I walked into your restaurant and started asking for shit? I don't even know if I'm allowed, but you gotta actually start bringing food down for *me* before I can do anything."

"What do you like?"

I smiled. "A couple of slices and a chicken parm hero could probably get you in most nights."

"YO!" SCREAMED THE guido who had just been wrestled out the door. "Fuck you, muthafucka! You a fat bitch! You a big fat *bitch*! Come out here, muthafucka! I'm a beat all yo' muthafucking asses, dog!"

"Put your shirt on, asshole," said Kevin, the bouncer that had thrown him out. "You're not big."

You can't argue with Patrick Swayze when it comes to bouncing, because he's our valedictorian. Swayze made *Roadhouse,* which compelled an entire generation of meatheads to become bouncers when they grew up. Swayze is what you'd call *influential* in this business. Fuck around with Swayze and you're asking for a beatdown. The next thing you know, he'll have his shirt off and you'll have a set of hyperextended knees, and the whole scene's an embarrassment to you and your entire family because when you're facedown on the floor, with your knees hyperextended and blood all over your face, Swayze's going to dance, and nobody wants to see *that* happen after a fight.

Swayze said it best, though: *You have to be nice, at least sometimes.* The way conventional wisdom tells it, bouncers are supposed to be able to solve more problems with their mouths than with their hands. Even people who've never worked as bouncers can tell you this. In fact, it's one of the first things they *will* tell you to make you think they're "in the know." It's counterintuitive to think you're better served stopping a fight with your words, so people think they're filling you in on some big trade secret when they tell you this.

It's not as simple as that.

What I'd found after a while was that I was a highly proficient bouncer-talker, but only at certain points within a situation. I was at my best at the very beginnings of incidents, when punches had yet to be thrown, because I could defuse things by whispering. I whispered the guidos off the ledge. I was the Guido

Whisperer—the bouncer who could insert himself into the middle of a problem and make at least one of the involved parties see my side of things. I'd learned this from Vince, taking care of things in-house down in the VIP so as not to involve Migs in our "family" affairs.

Swayze occasionally wasn't so nice, and neither was I. Most times, I wasn't nice. I'd always been equipped to handle the physical parts of the job, because I could hold my own in most fighting situations and had been in enough scraps to know I wouldn't freeze. I couldn't dance over your body like Swayze—hell, I couldn't roundhouse-kick you like Swayze, either—but if you needed to go, I could usually get you out.

The one thing I found I couldn't do, once hostilities were underway, was *talk shit*. The moment I'd lay my hands on some unsuspecting guido, I'd clam right up and not utter a word until it was done. When someone would goad me into saying something, it more often than not came out as a stuttered mélange of nonsensical profanities that few, myself included, could even come close to understanding.

"Go fuck y-y-yourself!" I'd shout, wiping my mouth. "I'll, I'll fucking . . . I'll fucking *kill* you, you m-m-motherfucker! I'll kill you!"

Once I started fighting, the key was not to listen to a word I'd say. If you wanted something memorable—some line you could repeat to all your friends for the next week—there were dozens of better bouncers you could've listened to. I could only prey on the obvious—appearance, size, or a lack of intelligence—and most of my attempts at "verbal judo" were too straightforward to elicit laughter in the retelling. All I wanted to do, once things turned physical, was get my job done. I was a rank-and-file dickhead whom nobody knew anyway, and all management really wanted for me to do was to get the better of people and get them out. I sure as hell wasn't winning any battles of wits once my adrenaline started flowing.

"Come on, muthafuckas!" shouted the guido. "What! What! It takes ten of you bitches?"

"You look like a hundred pounds of chewed bubblegum, kid," said Kevin. "Shut the fuck up."

The guido, considering this, paced back and forth. He offered no reply.

"Hey," said Kevin, smiling broadly, "how about I whip my cock out and choke you with it?"

"Yo, you whip . . . you w-w-whip . . . yo' cock . . ." The guido was drowning in a sea in which he had no chance of learning to swim.

"Go home, you fucking pussy. I take shits bigger than you."

"YO, WHAT THE fuck?" asked one guido who'd been unceremoniously shoved out the door by two bouncers. "What the fuck did I do?"

They've never done anything. Nobody has. It's the same way outside clubs as it is in jail—everyone's innocent and they've been railroaded in some way or another. I knew a guy from my neighborhood who'd killed someone back when I was in high school. Everyone knew he did it, but he denied this fact with every fiber of his being. He was still denying it when they hauled him out of the courtroom to spend the rest of his life in a cell upstate. He said he couldn't possibly have done it because it took the police over a year to catch him. To him, this made sense.

"Listen," I said, sticking to the script. "You're not coming back in."

"Yo, why not?"

"You know what, man? I have no fucking idea why not. I'm the guy who stands at the front door and checks IDs. Do I look like the guy who threw you out?"

"Yo," he shouted, "this is bullshit! What'd I do? What the fuck did I do for your boy to choke me out like that?"

"Honestly? I really don't know. All I know is that you're not

allowed back in, and that you should go home because it makes no sense for you to stand out on the sidewalk yelling at two guys who weren't even inside when it happened."

"Yo, fuck you!"

As I pointed out before, to the customers the bouncing staff is a collective. They seem to think that every single bouncer knows what every other bouncer is thinking at all times. If someone throws some guido out the back door, the guido in question always believes he can plead his case to the bouncers up front. He thinks we're going to listen to him and let him back in because we know exactly what happened and we'll decide—having seen nothing—he's not at fault. None of them ever are, of course. It's a mystery why clubs need bouncers at all.

"Hey," said Ray. "You got really nice eyebrows, man. Somebody did a really nice job waxing those things."

"Yo, they ain't waxed, muthafucka. These niggas is threaded."

I tried very hard not to laugh. "Threaded? What the fuck is that?"

"Why you wanna know, muthafucka? You'd need a chainsaw for your shits."

I stroked my right eyebrow with my forefinger, vaguely insulted. "How much do you have to pay to get your eyebrows threaded?"

"Same price you pay to suck my dick, muthafucka."

"Come on, man. Why do you have to be like that? You're asking us to let you back in, we're trying to talk to you, and all you keep doing is cursing at us and saying shit like that. What the fuck should I let you back in for?"

"Yo," he said. "My boys is in there. Could I just go back in and get them?"

"Where are they?" Ray asked. "Why aren't they out here with you? If I ever got thrown out of a club, my friends would be outside with me as it was happening. You sure these guys are really your friends?"

"What the fuck am I supposed to do?"

I shrugged. "How about not doing whatever you did to get thrown out?"

"Yo, you think your place is special, muthafucka? Fuck this club!"

"Maybe," said Ray, "we can work something out."

"You want money?" asked the guido. "I got money. I got more money in my pocket than you make in a year. How much you need?"

"No, no money. We're on camera up here. I got something else in mind. I'll tell you what. You tell me where you had your eyebrows done, and maybe I'll think about letting you back in."

"For real?"

"Yeah," Ray replied, "for real. I see all you guys coming in here with your eyebrows all done up like that, and I feel like I'm doing something wrong."

"I get my shits done at the Staten Island Mall, dog. They do all that shit. Could I go back in now?"

"Are you *all* this fucking stupid?"

———

SCENE: *The long line on the sidewalk finally wound down to nothing, we're savoring our first break of the night. Ray offers me a cigarette. I'm leaning on a barricade, my chin resting against the back of my hand. NYPD activity up and down the block. We're caught in a front-door time-loss vortex. Time is irrelevant up front. You get so wrapped in what you're doing that you move into a zone, failing to notice its passage. Inside, you can check your watch, then check it two hours later to find that only ten minutes had gone by.*

ME: I'll tell you this much. I have a newfound respect for what you guys have to do up here. These people are idiots, every single one of them.

RAY: You know what the good thing about this is?

ME: What?

RAY: Look at your watch. It's almost three.

ME: Shit. I didn't even think about what time it was until now. Time fucking *flies* up here.

RAY: You're handling this pretty well. Nice job with all the shake-downs. You picked that up fast.

ME: It's not easy up here.

RAY: It used to be. Years ago, when I worked at places like Lime-light and some of the nicer places Christian was part of, we didn't let *anyone* in. Fuck, people would walk down the street and they wouldn't even look over at us. When it's like that, you don't have all these problems.

ME: I just can't believe how stupid these fucking people are. They're just as stupid coming in as they are coming out.

RAY: What, you think they're serving retard juice in there? These fucking morons were born like that. *Now you know.*

———

16

SHACKLES

What do you do for a living, young lady? Where do you work? What do you do during the day, or during the night, that affords you your weekly visits to this club? And you, dear guido, what avocation pays the bills on your end? Surely you're accountable to some poor soul, somewhere in the industrial wilds of Union County, who's counting on you to punch the clock on time each morning, are you not?

I have to find out. I *need* to find out. I'm bound and determined to find out where all of these people work, especially the ones who won't leave the bouncers the fuck alone. Where do you work, honey? I'm dying to know. Are you a cashier in Paramus? A nail technician in Bayside? This is important, so you've got to tell me.

Why do I want to know so badly? What could possibly be in it for me? I want to know because I *need* to see if it'll be appropriate for me to toss aside the conventions of polite, civilized society when *I* visit *your* workplace. I *need* to know if you'll tolerate me telling everyone in a fifty-foot radius to fuck the hell off. That's what I'd like to find out for myself. Believe you me, I'm coming. You say you answer phones at a dentist's office in Sunnyside? I'm

on my way, sweetie. Me and Ray, the other poor bastard you terrorized the other night. We're both coming down.

We have a plan, too, and it's a good one. This won't be just any old visit to the dentist. No fucking way. We're stopping at the bar first, me and Ray, with the idea of getting good and liquored up before we deal with the likes of you. What's the sense in going anywhere or doing anything sober? There's no challenge in sobriety. No, we're going to the bar, and we're gonna drink our asses off until we're goddamned good and ready. Ray's picking up a big bag of coke and some meth, and in between the pints and the carbombs we're gonna head into the bathroom and bump ourselves up but good before we walk out into the light of day. Hell, why not? We'll be visiting one of our newfound club pals, and people from that world *have* to feel good before they go *anywhere,* right? Why not *us,* then?

So now we're out in the street, Ray and I, lurching down Jamaica Avenue in the heart of shitty Queens, one step at a time, ready for anything. Where's the fucking car? Where the *fuck* is the fucking car?

"Man, I feel great," I'll say. "This fucking coke has me on top of the motherfucking world!"

"You got that right," Ray will say in reply. "These guidos are really onto something! Let's go for a drive!"

Here we come, honey. We're all coked up and drunk and fucked out of our minds, and we're coming your way. The plan is to walk right in the front door of the dentist's office and do our thing. What, you're asking, is our thing? Our thing is the same as your thing, baby! We're coming in, and the first thing I'll do once we're there is walk right up to your desk, light myself a cigarette, and shout at you incoherently. You won't understand a goddamned word I'm saying, but that's okay, because everybody's feeling good in West Chelsea tonight, right?

Then, we're gonna stand there, a foot in front of your face, and shout at *each other* incoherently. And then we're gonna dance!

And wrestle! And spill shit all over the floor you've just vacu-umed, then vomit on it! Doesn't that sound grand?

It doesn't? Well, why not? We're inappropriate, you say? Boy, I'll reply, *that's* the pot calling the kettle black. Oh, and here comes the dentist. The boss. Big fucking deal. Look at the little big man trying to take charge in the fucking office. What are you gonna do, Doctor Goldstein, fill my cavities? Cap my crowns? Why don't you put the hygienist in the chair and drill *her*, you stupid little fuck?

Fuck you! Fuck you! I'll fight everyone in this office! Watch out! Watch out! I'm taking off my shirt! Go ahead you little pussies—call the police. See if I fucking care. You think I'm scared of Five-O? Fuck that. My cousin Vito's in the seven-five. Them niggas can't touch me, yo!

That's right, honey. *You're* the asshole. It's not me. It's you. You know why? Because *I* should be able to do what *I* want, wherever *I* want, and whenever *I* want, because it's the rest of the world that doesn't understand. You think I'm bothering you? You think I'm disturbing your peace and violating your personal space? Fuck you! You have no say in the matter. *You're* here solely to cater to *my* needs! I'll just continue to stand here smoking ciga-rettes, yelling, spitting, spilling shit, and dancing, and there's not a goddamned thing you can do about it.

Yo! This place is *dead*! What? It's a *dentist's office*? My questions are stupid? You all have *got* to have some drugs here then, no?

What's the matter, honey? You really don't like the way we're act-ing? You still think it's inappropriate? We're *bothering* you? Tell me something, then. Does your boss, Dr. Goldstein, DDS, know what a fucking idiot you make of yourself on weekends? Do you shout at him and blow cigarette smoke in his face, then call him an asshole when he tells you to stop? Do you not enjoy it when total strangers come, uninvited, into your workplace and hover around you saying stupid shit and calling you names? Do you honestly think *you* have the right to tell *me* to get lost when *I* do it in *your* office?

Would you at least agree that you have the right, during your quiet moments at work, to peacefully chat with your coworkers without having some drug-addled root-canal patient come up from behind you and grab your head for no apparent reason? Does that ever happen at the dentist's office? Would you *let* it happen?

Why can't Ray and I stand outside and have a cigarette without being harassed by you? *We* didn't bother *you*, did we? Did we chase you down the sidewalk and mercilessly hassle you up and down the street? Why linger, then? Why stay in a place where you're so obviously not wanted? We ask you people nicely. We even give you reasons.

"Ladies," I'll say, "I'm fucking exhausted. I worked all day today, I'm having a rough night, and I've got a splitting headache. Can you please just go away?"

I know, honey. It's terrible. How dare I try to keep the peace in the twenty-four inches in front of my face? What sort of nasty son of a bitch craves peace and quiet at three in the morning? Who could possibly be so rude as to express such displeasure at having drinks spilled on his jacket? I still don't know what gets into me sometimes. Who the fuck wants peace? Who the fuck wants privacy? Who, in this city of God-only-knows-how-many-millions, could ever expect any measure of either?

The way I see things, the bouncers in this city can't possibly win. And if you can't ever seem to beat something, you may as well join it, so that's what I think I'll do. I'll call it the Bouncer-Customer Work Exchange. Do you have a job? Are you planning on coming to the club and acting like a complete jackass at my expense? Well, you can expect the same from me, only worse, because I'm big and I'm hostile, and I'm bringing backup.

If you're wondering whether you've ever observed me at work, see if this exchange sounds familiar:

"Hi, you got ID?"

"Here."

"Thanks," I'll say, as I copy your name and address into my

book. "Now give me your work address and your schedule for next week."

"YO, WE COULD get in now?"

He was asking for the tenth time in the past five minutes, reversing "could" and "we" in a way that guaranteed I wasn't doing shit for him or anyone in his party.

"Not yet, man," I said. "It's gonna be a while."

I looked into the lobby and saw that the line for the coat check was still too long to be manageable if anyone else was permitted inside. I checked the time on my cell phone, as I would every ten minutes, and did everything else I could think of to make myself look too busy to field questions.

"Why?"

"Because it's not up to me, is why. I can't let anyone in until they call me on the radio and tell me I can, so you can stop asking and just wait like I asked you to."

"Yo, do I look like I can't pay? Is you not lettin' me in because I look like I can't pay? I got a G in my pocket, dog. A *G*."

This is what guidos do. Apropos of nothing, they'll try to solve all their problems by announcing, to everyone within earshot, how much cash they're carrying in their pockets. This is *not* a safe thing to do in New York. Here, it makes sense to convince people that you're carrying much less than you actually are, because you don't want to set yourself up as the target of a robbery. Guidos don't think in these terms. And it's not like they're planning on giving *you* any, either. There's no reason for any of it.

"Whatever, man," I said. "Just fucking wait. You see anyone else going in?"

"Yo, fo' real?"

"Yes, for real. Just fucking stand over there and leave me alone. You'll be inside in five minutes."

The guido considered this for a while. "Yo, my girl got a pass from last Saturday. We could use that?"

I looked directly at his girlfriend's Adam's apple. "No," I replied. "Dude's got to pay."

"What?"

"I said," I gestured at his transsexual friend, "that the dude has to pay. Those passes are no good tonight anyway."

"What the fuck you mean by that?"

"I mean that the line is too long, so the manager decided that we're not honoring last week's passes because we don't need to."

"No, what you . . ."

"God almighty," I interrupted. "Will you please shut the fuck up?"

"Yo," he said, opening his coat. "You see this shit? This shit's chinchilla, dog. This a chinchilla coat. You know what a chinchilla coat is? This shit cost more that your car, dog."

"Actually it doesn't. I just bought a new one with the money I made off idiots like you."

"Yo, what you buy?"

"I bought a none-of-your-fucking-business-mobile," I replied. "That's what I bought."

"Come on, man. On the real, it's cold out here, dog. Any way we could take care of this piece?"

"Fifty apiece gets you in right now."

"Serious?"

"You heard me," I said.

"Yo, you know this shit ain't real chinchilla, right?"

WORKING UP FRONT isn't quite as simple as those who've never done it appear to believe. It's sure as hell not as easy as most "inside guy" bouncers tend to think. Most of *them* are convinced that a door spot is the pinnacle of the "profession," and that once you're moved to the front, the hard part of your "career" is behind you. We check IDs, we bullshit with people all night, and we have first crack at all the beautiful women coming into the club. For this, the doormen are paid more than anyone

else on the staff. This is all some people know about the job, and it makes them jealous.

To inside guys, it's especially troubling that bouncers up front generally won't leave the door to run to fight calls. This isn't because we don't want to. We're simply not permitted to abandon the door. Regardless, the fact that we rarely show our faces inside rather segregates us from the rest of the staff, and it's why guys who work the front are commonly referred to as "doormen" instead of bouncers.

I had spent my share of time "in the trenches," working inside on a box, responding to fights and getting my hands dirty—and, on more than a few occasions, bloody. Standing up front, when the radio sounded a fight call, it was all I could do to keep from running inside and throwing myself into the middle of whatever was going on. Bounce long enough and sprinting to situations becomes instinct. After a while, there's no more fear. You hear a location and you run to it, figuring you'll know what to do once you get there. There won't be any hesitation, because it's the same thing you've done hundreds of times before. There were moments at the door, when my radio went off, that I would take several steps in the direction of a fight inside—only to turn around and come back, remembering where I was.

You hear the urgency—"Back bar! Back bar! Back bar! Back bar!"—and whatever neural patterns being an inside guy had wired you with kick in before you can actually think about what you're doing. This pathway that's been created carries you inside, and it sometimes takes a few steps before you remember that what's going on in there is no longer your responsibility. What *is* your responsibility, though, is what happens once a fight moves outside, and this is usually what your fellow bouncers fail to realize when they think you're living a life of leisure at the door.

What happens when a group of angry juicehead Staten Island guidos is thrown out of a club for fighting? Or sexually assaulting someone? Or inciting a riot? They usually want one of three

things. They want to know where their "opponents" are, so they can continue the action that the bouncers had so rudely interrupted inside. Then, when they realize that security has numbers on them and they'll not be able to overpower or intimidate anyone, they focus their efforts on trying to get back inside. Finally, when their end-of-the-night reality settles in, they blame the bouncers for their troubles and they come after *us*.

That's where the *doormen* step in. The bouncers inside are the ones who're charged with breaking up the initial fight and hauling everyone outside, but the doormen are the poor bastards who end up stuck on the sidewalk with these idiots when they spend the next half hour telling us how tough they are, and how their "boys" are coming from God knows where to "bust a cap" in us, and how we're all losers for being bouncers and wearing cheap shoes. If you work inside, all you have to do is get the cocksuckers out the door. The longer you stay outside with them, giving them an audience, the longer they're bound to stand there and yell at you. So you go back inside, get back on your box, and move on to the next thing.

Not so for us. We *can't* go back inside. When situations move outside, there's nowhere for us to go, because we're required to stand out there and listen to all the garbage, and it's up to us to stop these people when they try to rush the door and get back in.

Doormen are also responsible for maintaining some kind of control over the mass exodus of jerk-offs that happens at closing time. Ideally, what clubs like to do is have the patrons trickle out little by little, so a giant conglomeration of people doesn't end up developing in front of the door. The way this trickle-out is supposed to happen is through a gradual slowing down of the music selection. This, of course, never happens, and most DJs—ignorant of what bouncers will be dealing with outside—insist on playing loud, intense house music until the very end, pulling the plug at four o'clock on the nose and causing a slew of problems for the security staff.

For the customers, the evening is far from over at closing time.

A night doesn't officially end until you, the patrons, walk out the front door and run the meathead gauntlet through to the early Manhattan morning. How you manage to get this done has a huge bearing on the overall quality of your experience, because nothing positive ever happens on the way out of a club. Trust me on this. The five minutes between taking your first steps off the dance floor and calling a cab to take you home can be the most trying period of your night, and it's critically important to make sure you do everything the right way.

<div style="border">

THE RULES

LEAVING THE CLUB
WITHOUT GETTING HURT

There are several steps customers can take to make things significantly easier for all of us—provided what little common sense they seem to possess can find a way to penetrate the chemically induced haze they're all in at the end of a typical night. If you concentrate on doing some of the *little things* well on your way out, it'll save us all from worrying about the *big things.* Like having you arrested.

DON'T GET INTO A FIGHT
AFTER LAST CALL.

Once the DJs announce last call, you should be making your preparations to leave. You should not be arguing with other patrons, talking shit to bouncers, or doing anything other than settling your tab, retrieving your coat, and figuring out how you're getting yourself home. Once last call is made, bouncers start seeing the light at the end of the tunnel. We're thinking about diners and omelets and sleep. The misery is about to end,

</div>

going home is imminent, and if you decide to start shit with "Carmine's boy" after last call, you're extending our night. Extending a bouncing staff's night will invariably end up exploding in your face, and this explosion is likely to hurt in the morning.

DON'T STAND IN OR IN FRONT OF THE DOORWAY.

If you're blocking the door, how are people supposed to leave the club? When I point out the fact that you're obstructing the flow of traffic, why am I the asshole? Why do you get mad when we tell you to move? Is it because it's the inherent right of every guido to block staircases and doorways at every club in Manhattan?

REFRAIN FROM EXCESSIVE LOUDNESS.

Guidos love the sounds of their own voices, especially when their minds have been altered for several hours. They shout at their friends. They shout at "the bitches." They shout out the lyrics to rap songs as we try to keep ourselves from dozing off at the door. They shout rhetorical questions of dubious importance to the rest of us—"YO, WHERE THE FUCK IS MY BENZ?"—leaving us wanting less and less. Please, just leave.

DO NOT ENGAGE IN LONG, MELODRAMATIC GOOD-BYES WITH BOUNCERS WHOSE NAMES YOU DON'T EVEN KNOW.

If we're not friends, and you actually believe my name is "Sergio," we don't need all these extended hugs, handshakes, and promises to see each other soon. We know you'll be back tomorrow night in all your tacky Howard Beach glory, so a

simple, blanket "Have a good night, guys" will be more than enough to leave every bouncer at the door with a positive impression of you and your friends. There are few things on this planet worse than the maudlin guido.

DON'T DRIVE AROUND THE BLOCK, DOUBLE-PARK IN FRONT OF THE CLUB, AND BLAST DANCE MUSIC OUT THE WINDOWS OF YOUR WHITE ESCALADE.

Why would anyone, after being bombarded by that shit all night, want to play it in their car on the ride home? Why would you think anyone's impressed when you do this? You're practically begging the NYPD to pull you over, and we've yet to see a "hot piece of ass" go bounding off the sidewalk and into one of these cars, so it's advisable to avoid the practice.

DON'T TRY TO WALK OUTSIDE WITH YOUR DRINK.

Just finish the damned thing and leave it on the bar. If a bouncer tries to take it away from you, don't stand there and argue your right to walk down a New York City sidewalk with an open container. This is why the city has the Open Container Law. We're doing you a favor here—the police are everywhere at closing time in West Chelsea, and a guido outside with his Grey Goose on the rocks is a summons waiting to happen.

DON'T TOUCH THE BOUNCERS ON YOUR WAY OUT.

People are generally clean going in, but when they leave the club, they're dirty. They're filthy. They're sweating and their

STDs are festering and they've been grinding against one another on the dance floor all fucking night. This septic parade leaving the club at four disgusts us, and the last thing we want—most of us, anyway—is for anyone to be rubbing their exposed flesh against us, following a night of God knows what-all at a nightclub.

IF YOU LEAVE, YOU'RE NOT COMING BACK IN.

Make sure you have your shit together, and your people together, before stepping out onto the sidewalk. Bouncers are tired. We're fed up. With every cock ring who leaves, we're another step closer to our beds. Allowing you to "swim upstream" and walk back inside violates just about every principle we believe in as human beings.

DO NOT ENGAGE IN PUBLIC DISPLAYS OF AFFECTION (PDAS) IN FRONT OF US AT FOUR THIRTY A.M.

Okay, guido, you've met your beautician, and now, before you go your separate ways, it's time for one last swapping of the spit. For a heterosexual male, there's really no greater thrill in life than meeting an attractive female who chooses to reciprocate his affections. I'm happy for you, because I'm all in favor of Guido Love. Just walk around the corner before you jam your tongue down her throat, will you please? That's not the kind of shit we want to look at after spending eight hours watching you have seizures on the dance floor.

And no, I didn't find your keys or your cell phone.

17

TINDER

ou know something?" Ray said on a rare warm night in March. "I think the two of us wound up doing the front because none of these other pussies wanted to stand out here all winter."

Spring was coming, and I'd spent over three months at the door without any major fuckups. There'd been a few stupid little hiccups, but I hadn't done anything to draw management's attention, and as far as I knew everyone was happy with my work. Migs had set us up nicely to run our various scams and shakedowns on the people in line, and the money I was pocketing was so good that I'd decided to quit my "day job" and live on what I was making at Axis. Working three shifts a week, I was taking home nearly $1,500 in extort-the-customers cash alone—more than enough to cover my expenses and start saving for *something*.

What that something was, I still had no idea. Pushing thirty, I still occasionally toyed with the idea of going back to college, but what bothered me about the concept was not *wanting it* badly enough. Amanda brought up the subject frequently, like everyone else in my life had been doing for years, but I hadn't yet reached a point in my life where I simply *had* to be a college graduate.

"I don't understand," she said one night over breakfast in Whitestone. "You got what you wanted. You're only working on weekends, you have all the time in the world to do whatever you want, and now you're putting money away. What's the problem?"

"I don't know what I want. You really want to know, I'm kind of happy right now."

"How can you be happy working that useless fucking job three nights a week and *not doing anything else*?"

"You did it," I replied. "You're doing the same thing now. You've been talking about quitting for months, but you're doing the same shit I am."

"I've been taking care of my father, asshole. I haven't been sitting at home fucking around on the Internet looking for nineteen-year-old girls to have sex with."

"Nice! That's hot!"

She punched me in the shoulder. She'd been doing that a lot lately. "I'm serious. When you're standing outside in the cold all night, don't you think about this stuff? Or when you have your four days off, and you're lying around your apartment with your hand in your pants, don't you ever wonder what you're doing with your life?"

"All the time," I lied.

"How long have you been working at Axis now? A year and a half?"

"Yeah," I said. "A month longer than you, to be exact."

"I've worked for Christian a lot longer than that, so don't even start. I know what I'm talking about. You know full well what that place has turned into, and that's exactly *why* you should be thinking about something else."

She was obviously right, but eighteen months into my new "career," the club had become my reality. Like it or not, I was turning into a "club guy." For months, Axis had been my only source of income. On days I wasn't bouncing, I spent hours in the gym, ostensibly so I could look better at the door when the

weather started getting warmer. I was worried about that sort of thing now. I was sleeping until two in the afternoon every day, making all my bank deposits in cash, and the address book in my cell phone was now filled to capacity with names like Tony Blaze and Frankie Fish.

"You *should* be a teacher," said Johnny. "Go ahead and take it easy for once in your life."

"It's always something I bounced around in my head, but I don't know if I wanna go back to school right now."

"Fuck, if I didn't have all these years on the job, *I'd* go to college and do it. That job's a fucking scam, man."

"Sure it is," I said, "but like I keep telling everyone, I'm okay right now. I don't know if I like the idea of sitting in a classroom with a bunch of kids ten years younger than me."

"As opposed to what? Working? Fuck that. You're fucking stupid. Teachers get every fucking holiday off, the job's easy as shit, the money's pretty good, and you spend the whole summer sitting on the beach. Who the fuck would turn that down? You can even keep doing this shit one night a week if you wanted. Make what you're making as a teacher, then work the door somewhere one night a week for a few hundred, and you'd be doing pretty good."

"I dunno, man. Maybe in a couple of months I'll start thinking about that shit. I like things the way they are right now. I go to work, I make my money, and I go home, and I do what I need to do during the week."

"That's some piece-of-ass girlfriend you got there," he said. "I don't know how the fuck you managed to pull that off."

"Neither do I most of the time. Especially when she does nothing but tell me the same kind of shit *you're* telling me."

"Listen. I'm older than you, but I'm no fucking father figure, so I'm not about to start giving anyone any advice. Who the fuck would I be to give you any advice? We both work in the same job, and *you* make more money than *me* for chrissakes. All I'm saying

is, you want to hang on to a girl like that, you gotta think about more than what you're having for dinner tonight, you know what I'm saying?"

"My life," I said, "doesn't revolve around hanging on to her."

"Fine, but think about what I'm saying for yourself. Look around this fucking place. Look at all the assholes who work in this business as their whole career. You got people who work here part-time, like most of the bouncers, and they're normal. You can go up to them and have a conversation, and they know exactly what you're talking about because they're going through the same things themselves. Then you got the club people who do this shit full-time. Look at them all. You want to be like that? They're so far removed from fucking reality, I want to send them all to Iraq and make them realize what's *really* going on in the fucking world, 'cause they have no fucking idea. You really want to get like that? 'Cause if you think you're gonna make a living in this business, and *only* in this business, that's exactly what you're gonna turn into."

FROM EVERYTHING I'D heard, it was nearly impossible for more than two guys, coming together, to get into Axis when we'd first opened to the public. If you were a man, and showed up with a male friend, the only way you'd be able to gain entry was to have attractive women with you—preferably several. As popular as the place was, we could afford to keep the ratio stacked in favor of our female patrons, which meant, of course, that things were *really* stacked in favor of the lucky men who'd managed to get in.

In the nightclub business, the idea is to keep people out in order to make them want to come in. Throw down a set of stanchions in the middle of the Gobi Desert, with a velvet rope clipped between them, and you'll eventually see a guido wander out of the dunes and step over it. That's how it works. You tell people they *can't*, and they'll go to the ends of the earth to prove to you that they

can. You keep people out of a club, and they'll come back, night after night, until they finally get in—which is precisely what club promoters and owners know all too well about the public psyche.

Men with money don't want to see other men with money. They don't want to sit with them, or drink with them, or urinate next to them. When they come into a club, they want to see nothing but beautiful women. They don't want to step into a "sausage party" or a "swordfight," which is exactly what you get when the wrong element—the locals—start to infest your nightclub. Men with money will only spend that money in a club if there's a chance they're getting laid. Men with money will only come back to that club and spend money again if they've gotten laid, or at least come close.

When Axis morphed into the guido paradise it had become after eighteen months, the criteria we used to decide who was getting in had changed as drastically as the demographic inside. Gone were the days of flamboyant homosexuals with bullhorns, handpicking the crowd based upon the aesthetic Christian wanted. That scene, hackneyed though it was, no longer existed at our door. Instead, we had Vince and Migs haggling over the logistics of hosting bachelor parties and random teams of drug-dealing Brooklyn guidos in the VIP rooms.

Migs tried desperately to maintain some semblance of standards at the door. The last thing he wanted was to sell out to Vince's notion that the club needed to let in whomever was willing to spend enough to reserve a table, if it meant compromising the safety of the security staff—something a preponderance of guidos inside would most assuredly do. Some nights, when Vince had his way, you'd walk inside and the place would look like a damned Gold's Gym franchise somewhere in the wilds of Bensonhurst. The center of the main room would be teeming with juicehead guidos, with women—vastly outnumbered, most times—floating around the periphery, afraid to venture *into the hive* for fear of being forced to interact with some substandard guido specimen

who'd be as likely to slip GHB in their drinks as he'd be to ask them to dance.

Christian respected the hell out of Migs. At least that was the impression I'd gotten after working up front for a while. He'd had Migs running security at three of his clubs before opening Axis, and Migs was given the freedom to do whatever he felt was necessary with his bouncing staff. Admission, however, was something else altogether. Where Vince was involved, so were copious amounts of cash and credit card charges, and the business he'd brought in over the years seemed to trump—in Christian's mind, and on his ledger—the fact that Migs had kept Christian's investments so well protected for many of those same years.

The problems between Migs and Vince were getting worse every night. In the general admission line, which was where I checked IDs with Ray, Migs had full control of the flow of customers who were coming into the main rooms. If a group of ten guys came to the door looking to get in, we were still able to tell them to go elsewhere if we thought they'd be a problem inside. Figuring *that* out, once you've seen enough of these people in action, wasn't difficult to do. The trouble, as it had been for several months, was with the VIP clientele.

The customers Vince brought into his rooms weren't bringing women to the club. To them, taking "sand to the beach" was just about the stupidest thing a man could possibly think to do. Instead, they were coming to Axis *in search of* ass. Problem was, that's all Vince was pulling in—groups of younger, violence-prone, drug-dealing guidos, who weren't exactly in the mood to cavort with other groups of younger, violence-prone, drug-dealing guidos. When you fill a cramped VIP room with five or six groups of such people, it usually doesn't take long for something very, very bad to happen.

It doesn't require much to set them off. Sometimes it's something personal. Other times, it's business. Always, it's about property and "turf," whether the turf is a section of a couch that a

guido thinks he's paid for, or a section of the club, for which he believes he's secured the exclusive right to peddle his wares. One word—one small sign of neighborhood disrespect—and *it's on*. Stupidities are exchanged, punches are thrown, and three dozen bouncers come running to put an end to something that should never have happened in the first place.

"Look at this shit," said Ray one night that early spring. He was hunched over the podium with a highlighter, doing whatever the hell he did with the guest list before the lines started forming.

"What shit?"

"The list. Vince has fucking twenty-two guys in one fucking party going down to the VIP."

"Are you serious?" I asked, peering over his shoulder. "Does Migs know about this shit?"

"Does it matter? He can't do anything about it. I know who these motherfuckers are, and I guarantee you they're buying a ton of bottles and shit. Migs can't do a damned thing."

"Who are they?"

"The one kid's a drug dealer from Queens," he replied. "I don't know who he's bringing, but I'm sure the rest of them ain't exactly model citizens. I'll tell you what, though. I don't care how much money these assholes spend. I can't see having that many guys come in together. Last year? Christian wouldn't even let Vince bring bachelor parties down there. I hate this fucking place."

IT DIDN'T TAKE any kind of fancy bouncer-instincts to realize that twenty-two guys, all connected with the same group and congregating in a confined area of the club, were destined to be a major problem. Guidos are territorial. They're also loyal, some to a fault, to the "pack." I knew the machinations of groups like this all too well because I'd lived that life already myself—as a young, hyperaggressive outerborough male who'd jump up swinging at any slight, whether real or imagined.

Migs, predictably, was incensed. As Ray had said, however, he

was powerless to do anything about it, because Christian wasn't about to say no to the five-thousand-dollar minimum the group represented.

"What the fuck *is* that?" I asked. "Who goes out with a group of twenty-two guys?"

"It's a birthday party for that drug-dealer kid Blaze."

"Blaze? How many fucking guys named Blaze do we have in this place? Isn't there a bartender named Blaze something-or-other?"

"I think one of the promoters is named Stevie Blaze or some stupid shit like that, too," Migs replied.

"You know what I need? I need a good club name. I shouldn't be going by my real name in here. I need some bullshit alias like all these guys have, so I can be a legit club guy and get accepted."

"How about *Doorman Fat*?"

"You're a dick," I said, taking a swig of the coffee he'd bought me. Migs had gotten into the habit of bringing coffee for me at the beginning of every shift—a practice which further solidified my support of him in his dispute with Vince. "Seriously, what are you planning on doing about it?"

"What *can* I do? I can't keep anyone out anymore. All I can do is stick a few extra bouncers outside the VIP hallway and make sure they keep an eye on everything. Hopefully we can get through the whole night without anything happening."

"Yeah, okay."

"You know what pisses me off about it more than anything else? When they do shit like this and something breaks out, people get hurt. Like, if there's any girls down there, and all the sudden two dozen coked-up fucking guidos start going at it, some poor girl, who had nothing to do with any of it, is gonna get run the fuck over, and it's bullshit, because nobody in his right mind, except greedy motherfucking Christian, who isn't the one who has to deal with this shit, would let twenny guys come into a fucking club together. *Nobody.*"

"You know what I don't get about it?" I asked.

"What?"

"You saw these assholes when they came in, right?"

"Yeah," he replied.

"Why the fuck did like ten of them show up with hats on? I mean, this fucking guy Blaze, if he has enough pull to get Vince on the phone and reserve tables for twenty-two guys here, he *has* to know the fucking deal, right? He's gotta know that nobody wants him and all the rest of his prick friends in the club, so why do half of them show up looking like jerk-offs, wearing their hats all crooked and giving Vince a hard time when he told them about the dress code?"

"Because these dumb fucking kids don't care. They all think who the fuck they are, 'cause they're out selling this shit and they got more money than kids that age know what to do with. They're no different from all those little pussy investment-banker fucks that used to hang out here, only guys like Blaze are too dumb to know what's going on. He's got his little jerk-off posse that works for him, and they do nothing but suck his cock all day, so he thinks the rest of the world should be doing the same thing."

"I hate this place," I said. "I really do."

"Don't worry about it. The kid's a little rat-fuck. Let him come in and have his little fun. In three years, he'll either be dead or doing a twenny-year bid. That's the way you gotta look at it. You'll go outta your mind otherwise."

What we didn't realize at the time, standing up front, pissing and moaning about the situation, was that Blaze's "bid" was slated to begin a tad earlier than Migs had it scheduled to. The radio call we'd all expected came in sometime around three. It came from Kevin, the bouncer who'd taken over for me inside the VIP doors, and the urgency in his call made it obvious who was involved.

"VIP! VIP! VIP! VIP! All security to the VIP!"

"You guys go in," ordered Migs, who'd been up front for most of the night. "I'll get someone to watch the fucking door."

I started toward the lobby, but Ray grabbed hold of my arm and spun me toward the street. "Go this way. We gotta run around the outside."

Together, we sprinted down the street, cut left into an alleyway, and ran toward the outside entrance of the VIP rooms. There was nobody outside. Louis, the bouncer Migs had assigned to oversee Vince's admissions policies, had abandoned his podium and run inside. From down the alley, we could already hear the sounds of the fight. On the run, I pulled off my sport coat—I always wore a T-shirt underneath—threw it on the lid of a Dumpster adjacent to the entrance, and yanked open the door.

Every night in America, there are multiple felonies being committed in nightclubs. Take me to a club, and I'll show you a boatload of offenses in progress at any given moment. When you run headlong into a fight situation as a bouncer—even if you've been doing the job for years—it occasionally occurs to you, as you arrive at a call and see what's happening for the first time, that people could be thrown in prison as a result of what they're doing right there in front of you—which is exactly what I was thinking that night as I opened the VIP door and ran into an utter and absolute *fog of bouncing* melee.

It's hard to decide what to do when you're among the last bouncers on the scene, which is what Ray and I were, after having run around the block from the front of the club. Break down any nightclub brawl and it's nothing more than a series of fights happening in close proximity at the same time. There's no "whole." Some of these fights are contested one-on-one. Others involve a single combatant trying to fend off multiple attackers. Usually, in cases like this one, when nearly two dozen people are involved, there'll be one little prick who moves from individual scene to individual scene, cheap-shotting anyone he can catch looking in the opposite direction.

Much of the action had gone to the floor, and several violent wrestling matches were in progress when I opened the door. I nearly slipped on one of the many pools of testosterone that had formed on the expensive carpeting. When you run into something like this, there are few steps you can reasonably take, mentally, before you'll need to engage. You make an immediate assessment of which group of bouncers needs your help the most, and then you dive in and do what you can to help them. As soon as I'd entered the room, I saw that one customer—a member of Blaze's party—had his arms free and was swinging at a bouncer who was bent over trying to pull someone off the floor.

As quickly as I could, with the agility of a *jaguar,* I stepped over several bodies and wrapped my right arm around his neck, applying what's known in jiujitsu parlance as a rear-naked choke. This move is a favorite of experienced bouncers, because it very effectively stops people from doing whatever it was they had planned to do. If you try and secure someone's arms in order to stop them from swinging, there's nothing for them to worry about other than getting their arms free. If that's all you do to them, they'll simply continue to swing. Stop them from breathing, however, or cut off the blood supply to their brain, and they're no longer concerned with anything except making *you* stop. You get behind them and sink in the choke properly, driving your hips into their lower back, and the only weapons with which they can fight back are their arms and their abdominal muscles.

"Take him out! Rob, take him out!"

Something else you'll always notice, in the midst of all the confusion surrounding a brawl, is that there's always someone around to tell you what to do. Most times, you'll never even know who's giving the orders. It's always just a disembodied voice—someone who's been watching what you're doing—telling you what to do and which way to go. In my eighteen months at Axis, having been involved in dozens of fight situations, *the voice* was always there.

The problem with trying to drag someone out in a rear-naked

choke—or in any sort of hold, for that matter—is that you're susceptible to the aforementioned random cheap-shot artist. Guidos don't take kindly to seeing their friends being choked by bouncers. My hands were occupied, leaving me vulnerable to the punch that hit me in the side of the head, knocking me over a set of cocktail tables that sat in front of the couches along the wall. The fact that I knew the punch was coming—I hadn't *seen* it, but you learn to expect such things—didn't make me any more prepared to receive it.

Ray, having seen me go down, turned and completely blindsided the guy who'd hit me, knocking him to the floor with a forearm to his jaw. He dove on the man and punched him in the face repeatedly. I picked myself up as quickly as I could, grabbed by the arms the customer I'd been choking, and resumed hauling him out the door. That was when everyone started to run.

"Yo, I been stabbed!" shouted Juan. "One of these motherfuckers stabbed me!"

Everyone who'd been in the room for the brawl scattered. Some scurried into the main room of the club. Others ran past me and the customer I was holding on their way out the door. A group of bouncers was gathered around Juan, who was still standing, holding his leg. I threw my guido—who still couldn't breathe properly and wasn't a threat—on the ground and ran back to the center of the room, where Juan had pulled his pants down to see how badly he'd been wounded. Someone had sliced him on the side of his leg, just below the hip, but he wasn't bleeding and obviously had something other than his own well-being on his mind.

"Mother*fucker*!" he screamed, sprinting toward the door. We all followed, resolved to get a major piece of the cocksuckers outside.

Someone had called the NYPD while the fight was happening inside, and several cruisers were parked along the street when we came out of the alleyway. The police were in the process of doing what we had come outside looking to do. Guidos were being

thrown to the ground, punched, kicked, and pepper-sprayed, and there wasn't anything left for us to do but find the guy who'd had the knife.

"That's the motherfucker!" shouted Juan, pointing at Blaze himself, who was standing on the opposite sidewalk, cursing at the police. "Right fucking there!"

Ten of us ran across the street, surrounding Blaze, who futilely tried to keep a parked car between us and him.

"Yo, it's over," he said, holding his hands in the air. "I got no problem wit' you guys. I don' even know what happened."

"Too late for that shit," said Ray, moving closer. "*We* decide when you had enough, motherfucker."

Kevin sprinted around the side of the car and tackled Blaze, ramming him into the sidewalk with an audible thud. Instantly, he was engulfed in a sea of black, being kicked and punched up and down his body. He tried in vain to cover his head, but the shots to his midsection simply kept coming. When he'd stopped moving altogether, I knew it was time to do something.

"Guys!" I shouted, pushing my way into the middle of the pack. "Guys, stop! Fucking stop! There's cops everywhere out here! He's fucking done! We don't need a fucking homicide!"

I had never seen anyone beaten so badly in my life.

18

TENUOUS

SCENE: In bed. The calls started coming in at eleven the next morning. Most people, figuring I'd had a rough night, waited until the afternoon to ask for my version of the events they'd seen on the news. Amanda wasn't quite as patient. The first thing I realized when the phone rang was that I couldn't bite down. I'd been hit in the jaw, and my molars weren't lining up properly when I tried to put them together. This made me angry.

ME: Can't you let me sleep a few more hours? My head is fucking killing me.

AMANDA: Are you okay?

ME: I'm fine. I'm not the one who got stabbed.

AMANDA: How's Juan? Is he out of the hospital yet?

ME: He was still there when I left. They had to disinfect the whole area where he got cut, plus somebody bit him, so he had to get some shit for that, too.

AMANDA: Someone *bit* him? Jesus.

ME: Yeah, he got bit. The fucking cops had him cuffed for a

ME: No, but I need to get some sleep. What the fuck are you call-
 ing me at eleven for, anyway?

AMANDA: I was bored.

ME: Bored?

AMANDA: Yeah, I was bored. I wanted to call and tell you that I
 was right.

ME: When I'm bored, I wish I was you.

AMANDA: Why's that?

ME: Because if I looked like you, I'd stand in front of a mirror and
 fondle myself all day. That would kill *my* fucking boredom.

———

NOBODY ON THE staff wanted anything to do with going
back to work that night. After a stabbing, you'd think the police
would've shut the place down for the rest of the weekend, or
that Christian, knowing the incident had been on all the local
six-o'clock newscasts that day, would decide to lie low and keep
Axis closed for a few days. Neither happened, though, and twelve
hours after leaving the hospital I was back up front, setting up the
door with Ray.

"We're gonna have to go testify," he said. "You know that,
right?"

"Yeah, I figured. I gave statements to like three different
cops."

"I know what's gonna happen, too. With all the shit goin' on
around here, the two girls getting killed and the guy who got
shot up the block, they're just gonna start shutting places down.
They're not even gonna bother with all these barricades and all
this shit. It wouldn't surprise me to see a lot of these clubs over
here boarded up or changing hands pretty soon." A string of
incidents—including the murders of two young women, Imette
St. Guillen and Jennifer Moore, and the shooting of a patron by
a bouncer—had drawn a shitload of unwanted attention to New

while, too, until someone explained that he was the one who got stabbed.

AMANDA: Where were you when they fired the gun?

ME: What gun?

AMANDA: They said on the news that someone fired shots at the police. You didn't hear any shots?

ME: That didn't happen. Or if it did, it happened later and didn't have anything to do with the shit we were doing. This is the first I've heard about it.

AMANDA: What time did you get home?

ME: Around eight. I had to give a statement to the cops, then we all went to the hospital to see if Juan was okay. And *then,* at the fucking hospital, there were *more* cops, and *they* wanted to take statements from us, too.

AMANDA: What'd you tell them?

ME: I told them what I saw and what I knew about what happened before the fight actually started. I said that twenty-two known drug dealers were in the VIP and started some kind of shit with somebody, and when the bouncers came in to take care of the situation, they attacked us. I didn't have much to tell them after that, because I didn't see the actual stabbing.

AMANDA: What about you, though? Maria said someone told her you got punched in the face.

ME: I did. I got sucker-punched in the jaw by some little fucker.

AMANDA: Did you press charges?

ME: Why should I? Ray jumped the fucking guy and beat the living shit out of him. After that, why should I bother getting involved? They took the kid away in one of the ambulances.

AMANDA: How's your face? Are you all black-and-blue?

ME: No, but my jaw is fucking killing me, and now you fucking woke me up and it feels worse than it did last night.

AMANDA: Sorry I'm concerned, asshole. I take one night off, and all hell breaks loose. I should know better than to give a shit what happens to *you,* right?

York's nightclub industry, and everyone working a door in West Chelsea was feeling the resultant pressure. You take your chances setting up your club in West Chelsea. The primary attraction for club owners is obviously location. You're opening your doors for a group of customers that's already been established. They're all just outside, every night of the week in Nightmare Square, waiting to come in and work their magic. It doesn't even matter what sort of space you've created. You can spray-paint some French phrase on a West Chelsea garage door and stick three toothless whores outside, holding clipboards, and you'll still have a line a mile long your first month in operation. That's the way things are down there.

The problem is that at any given time, there will only be two or three clubs in the area—out of at least a dozen so-called *mega-clubs*—that could actually be described as "happening." The rest will operate in an Axis-like purgatory—overrun by the B&T crowd and counting down the minutes until they close up shop, redesign, and reopen under a new name. When the initial euphoria of "hotness" wears off, there's always a ready-made gaggle of locals waiting to come in, and that—as evidenced by the problems Christian was now facing at Axis—is where your troubles begin.

You'll make your money, because the shitheads will always come. They'll come and they'll spend money, and your bottom line won't look any different from the way it did when the crowd wasn't coming in from Long Island, but you're not striking a favorable bargain for yourself in the process. When someone gets stabbed—or kidnapped, raped, or shot—you attract the attention of the city. Next thing you know, you're exposed in the media, everyone on the city council is lobbying to have your ass shut down, and now you're doomed, until you finally give up the fight, to a seemingly endless period of litigation, fines, payoffs, and court appearances.

"I don't want to get involved with the cops," I said. "My life's bad enough without bringing *the law* into it."

"It sucks. I've done it before. You gotta go to court and meet with the assistant district attorney, who makes you wait all fucking day and asks you all kinds of stupid shit. And then, if they charge the guy with anything, you gotta go to the grand-jury hearing to testify in the indictment. *Then,* if the guy gets indicted, you have to go to the fucking trial and waste even more time there. Sometimes they call you in, and you gotta take the day off from work, and they don't even talk to you at all."

I COULDN'T UNDERSTAND why anyone would want to come to a nightclub where someone had been stabbed—and gunshots were allegedly heard—less than twenty-four hours earlier, but the line began building a good half-hour before we opened. We could always count on a solid core of Saturday regulars at Axis to provide enough tackiness and stupidity to tide us over until we'd see them again the following weekend, so I suppose I shouldn't have been surprised to see that our initial business had the potential to be brisk.

Migs wasn't exactly in a talking mood. "We gotta clear everyone out of here in fifteen minutes," he said, handing me a cup of coffee. "That party has to be out of the VIP room by the time the line starts up."

The club had been booked since seven o'clock for a private party for the staff and customers of a Mercedes dealership in Bergen County. Walking through the place to get to the door, however, you couldn't tell a damned bit of difference between the people from the party and the regular crowd you'd see at two in the morning. All this club bullshit—the drinking, the coke, the shitbag music—was like a cancer that had invaded the entire metropolitan area, and even Axis's private parties were in on the act.

The previous summer, I'd been invited to a block party on Long Island, where I witnessed this infestation firsthand. When people have block parties in the New York suburbs, they hire DJs, who spend hour after hour playing the same songs you'd hear in night-

clubs. People, as if threatened at gunpoint, run out into the middle of the street and dance. You wouldn't believe it could happen in such neighborhoods until you'd seen it for yourself—until you'd seen someone's eighty-five-year-old Italian grandmother rocking back and forth to the strains of some borderline illiterate shouting into a microphone about "culos" and "pimps" and "niggas." Nobody was safe, evidently.

"Migs, I got a problem in the ladies room. Can you come back here?" It was Kevin, who'd been working inside the main room during the party.

"Can you be more specific? I'm a little busy right now."

"The Spanish lady back here has a sick girl in one of the bathroom stalls, and I gotta get her to the back door."

Migs turned to me. "Go take care of that for me? I gotta be up here when Vince comes in, and I don't need this stupid shit right now."

"SHE SAYS THE stall door's been locked for more than five minutes, and that she keeps trying to knock on it, but nobody's answering."

"You know you can open these things with a coin, right?" I said, pointing to the door handle.

"Yeah?"

"Yeah. That's not a key lock. All you have to do is take a dime and turn it, and it works just like a key. You never did that before?"

"No," he said. "I never thought of it."

"Neither did I until Juan showed me how to do it one night when we were looking for cokeheads in here. They think they got the door locked, and then we come out of nowhere and open it up with a fucking dime. Scares the *shit* out of everybody."

I fished a dime out of the pile of change in my pocket and put it in the slot on the handle. "Did the attendant even see who was in here?"

"She said she just got here."

"Oh, fuck."

The first thing that came to mind when I opened the door to the stall was that she'd be very attractive if someone ever took the time to clean her up. I didn't think, however, that I could get out of my head the image of her lying prostrate on the floor in a pool of her own vomit and urine, if we were ever to start dating. When I'd awaken next to Amanda, I *didn't* imagine her sleeping in her own bile, and *that* made all the difference, I think. Then I wondered if these people actually *dated* at all. Did they? Or did a blow job, a toilet seat, and a bag of coke pass for courtship with this crowd?

"Is she breathing?"

"Yeah," I said. "She is. Help me get her up."

"Motherfucker! She fucking shit herself, bro!"

"Christ. Fuck this, man. I'm not touching her. We should call an ambulance or something."

WHEN YOU COME across something like this, you're obviously worried about whether the girl has been drugged or injured or sexually assaulted. These are things that happen—usually at the same time—on a regular basis here in New York, and I called Migs thinking another livelihood-threatening situation had been tossed in our lap. We couldn't revive her no matter what we tried. Even spring water that had been on ice for hours had no effect when we poured it over her face.

Migs found a driver's license in the girl's pocketbook. "Go have the DJ make an announcement for her friends to come back here," he told Kevin. "And tell him not to be an asshole about it."

"You call a bus yet?" I asked.

"Yeah, it should be on the way. You think she's on something she took herself? I doubt anyone at a party for a car dealership's gonna drop GHB in her drink."

"Who the fuck knows? Maybe she's diabetic or something."

"Why?" he asked. "Diabetics pass out like this?"

"I have no idea. It's just a thing I say when shit happens to people."

The girl's friends, a trio of minimally dressed Bergen County guidettes, came from the dance floor as soon as the announcement was made—which was still a good ten minutes after we'd first discovered her in the stall. We'd been tending to her the entire time, trying everything we could to wake her and calling an ambulance, while her friends had failed to notice the fact that she hadn't come back from the bathroom. This, of course, didn't stop them from blaming us for the entire situation.

"Why," demanded one of Migs, "was she in there for so long with the door locked before someone went in and checked on her?"

"Because the bathroom doesn't have an attendant until the club opens. When the attendant got here to start setting up, she tried the door and called security."

"But she was in there unconscious! She could have died in there, you fucking asshole!"

"I'm the asshole?" Migs asked. "You don't notice that your friend's still in the bathroom after twenty minutes, because you're drunk and you're dancing, but *I'm* the asshole?"

"Fuck you! She should sue this fucking place!"

"For what? Letting her come in with you three?"

"You fucking . . ."

"Listen," Migs interrupted. "Instead of standing here yelling at me, why don't you go over and talk to EMS and see where they're taking her?"

I'D NEVER SEEN as concentrated a police presence in West Chelsea as there was the night after the stabbing, and it seemed as though most of the NYPD's efforts in the area were focused on watching every move Axis made. We were told, in no uncertain terms, not to "fuck around" that night. Each separate piece of ID

handed to me was given at least a half-minute of scrutiny—and a slide through the scanner atop the podium—before being handed back. With ambulance calls on back-to-back nights, we knew the club was on *someone's* list, and Ray and I weren't about to put our jobs at risk by being sloppy at the door.

I found out from Migs that the girl we'd found in the bathroom was fine. She'd been drugged, probably by some asshole she worked with, but she had regained consciousness in the hospital and wasn't in any danger. Still, two incidents in less than twenty-four hours—and especially the stabbing—had certainly attracted a significant degree of unwanted attention, and Christian wasn't pleased about the state of the club.

"He wants a meeting tomorrow night," said Migs.

"We're closed tomorrow night."

"That's why he wants to have a meeting tomorrow night. He wants to get us all together and tell us what assholes we are because we let someone get stabbed."

"It's his own fault," I said. "When you've got these guys promoting and bringing in these fucking crowds, and Vince trying to get people inside at all costs, that's what you're gonna get."

Actually, it was refreshing, in a rather perverse sort of way, to hear that Christian intended to address us as a group after everything that had happened. Most of his employees—the majority of whom had never even met the man—tended to badmouth him left and right, but I was interested in hearing what he had to say—especially considering the fact that working his door had been my full-time job since the beginning of the year.

"I'll give the place six more months," Migs said. "I mean, that'd be the quickest he's ever had to pull the plug on a club, but this shit's ridiculous. It's not even worth staying in business in this area anymore."

"Where's better?"

"A lot of places in the city are better. Meatpacking's pretty bad, but if you go ten blocks south of here, you don't get all the bullshit

you have on these couple of blocks. I'll tell you something. I told Christian not to open up down here. This area's been shit for years. If you want to have a decent place in Chelsea, and keep the people you want coming down, you gotta spend a fucking *fortune* on promotions and acts and shit like that, so your money doesn't go down the toilet like this. Christian won't do it."

"Acts?"

"Famous DJs and shit like that," he said. "You bring in the right kinds of acts, and it can keep a club in business a lot longer than it took for us to get invaded by these assholes. You get some famous DJ with a following, and set him up as your house guy, you can keep yourself rolling for at *least* a couple of years. These fucking hacks we got playing here? They suck. Nobody wants to come see these idiots."

That *Groundhog Day* element was a major part of the problem. You'd come into Axis and the experience was always the same. There'd be no difference between a Saturday and a Tuesday. Christian seemed to think this consistency was what sold people on the place, but what he failed to realize was that he hadn't made this sale to anyone worthwhile, because nothing about the place ever changed. The house DJs played the same shitty songs, over and over again, night after night, until I knew their playlists by heart. They never, ever varied. People would try the club once, like it, then come back and get the exact same fucking thing for their money—and that doesn't work. Nobody in New York wants to pay for the same thing twice.

"It seems like you think this is a done deal."

"It is," Migs said. "All he's gonna tell us in the meeting is that he knows the place is a shithole, but that he's gonna keep milking it for as much as he can get out of it until he can't get anything out of it anymore."

"And when's that? When somebody who works here gets killed?"

"Christian's not stupid. You guys all think he's upstairs doing

coke all night, but the guy knows everything that goes on here. *Everything*. You think he doesn't know who you are? The guy probably knows your social security number by heart. He knows exactly what's happening to this club, and believe me, he's *pissed*. He dumped a lot of money into the place. He's pissed at himself for opening up in this neighborhood, he's pissed at the promoters for bringing in such a shitty crowd, and he's pissed at the city now, because they're gonna start fucking with him, like they always have."

I thought about this for a while. "Pissed at the promoters? Does Vince fall into that category?"

"Vince, that cocksucker, is the only one here Christian really wants to keep around. I can't do shit about Vince. If it came down to keeping me or keeping Vince, Christian would choose Vince in a second, because Vince is the guy who makes him all his money, even though he's a world-class piece of shit and I'd like to cut his fucking balls off for all the money he steals."

19

DITCH

Christian's so-called "transitional meetings" weren't anything new for his long-time employees, who were painfully aware of his salvage-the-situation managerial style—the one where he'd let things go wrong indefinitely, then come down from above to fix the blame on everyone else just before his businesses imploded. The way they told it, he'd been forced to have one of these at every single club he'd ever run. The thing *I* did right, that other employees new to the business hadn't, was hooking myself up with veterans like Johnny and Ray—bouncers who'd been through the whole Manhattan nightclub cycle before, and who could help me cut through the bullshit well enough to realize that things weren't, in fact, going to get any better.

Clubs don't make comebacks. You don't start out posh, go guido, and then scratch your way back to the top of the mountain. This doesn't happen, no matter what pack of lies a club's managers and promoters throw at you to make you think you're still working at a place that *counts*. No matter what they say, nothing you do counts once the B&Ts come rolling in. You don't count, and you'll never count again.

Of course, Christian didn't want any staff of his to think in these terms. Of all the clubs he'd ever been associated with, it was Axis that was most closely identified with the Christian Gold trademark, because Axis was the first place he'd created from the ground up. He'd hired everyone that had anything to do with building the place, from the architects to the interior design people, and the sudden repudiation of Axis by the Manhattan cognoscenti was, to him, a rejection of Christian himself, and everything he believed he'd meant to the nightclub industry in New York.

When the rich fall from grace, people like me never see it happen until it makes the news. You look at what they *have*—the house, the cars, the boats and the bitches—and it doesn't ever occur to you what they *owe*. It's misguided not to think in these terms, because what they owe is part and parcel of how they'd arrived where they are in the first place. We all owe *something*. They just owe more.

The difference for Christian, where Axis was concerned, was that he no longer owed anyone, at least financially. Maybe he owed something to the Mob, and maybe that was why so many of them could be seen floating around the club at all hours, but that was something I wasn't concerned with. I'd never know that sort of thing. Axis, by all accounts, was Christian's and Christian's alone—his money, his risk, and his reputation in the industry. Eighteen months was too soon for a fall, though. Clubs in Manhattan, especially in West Chelsea, don't typically slide that quickly, but Axis had. We'd fallen so far, so fast, that half the people coming down the block weren't even sure we were still in business until they'd walked past and seen the lights on for themselves.

Axis? No. . .You don't go there.

Even floundering, though, Christian had style. When the emperor has lost the kingdom, you get to hear him speak one last time and you realize why he'd been the emperor in the first place.

Axis was Christian's room. You could tell it was his room when he came out to speak to us. He knew how to perform, and how to use his height—all six-feet-five-inches of it—to his advantage when addressing a group of men to whom size mattered. This wasn't Zev, bitter about being ripped from his upstairs cocaine pit and forced to meet with an employee—chain-smoking, muttering, eyes to the ground. Christian was polished—the former vanguard of the Manhattan nightclub industry, but a vanguard nonetheless—and spoke like a man who knew his topic.

"Guys," he began, "most of you do this part-time. You've all got lives and you've all got full-time jobs, or you're going to school, and everyone's trying to move forward. I get that. You may not *think* I get it, but I do. I understand what you're all going through because I've been in your shoes. I didn't just start out owning nightclubs and drinking champagne with Rande Gerber and the rest of these guys.

"You know how I started out in this business? Well, for those of you who don't know me, I was a promoter. I started out as a promoter. Not even a promoter. I was the guy who stood in front of the club and handed out those stupid fucking postcard flyers you see all over the sidewalk. That was my first job in the club business. I'd stand in front of Limelight and have all these assholes from New Jersey slapping these things out of my hands all night. I didn't even want the job. I was going to college, and I needed the money, and someone offered me fifty bucks to stand out there and hand these fucking things out.

"And what happened was, I was so good at getting abused every night that they stepped me up to full promoter. I don't know what else to call the job. I went out and pumped the shit out of people on these places. Limelight, The Tunnel, Webster Hall—you name it, I sold it. I got a commission off of everyone who came in with one of my passes. It's a stupid fucking job, and I hated every minute of it, but I did it. It's sure as hell not what my parents wanted me to do. I mean, my last name is Gold. You know what

that means, right? You think my parents were happy I dropped out of college to bring drug addicts into clubs for a living? They wanted a dentist, and they got a fucking party promoter.

"But the one thing I did was do the job right. I did it the best I could, and I *got* people to come to these clubs. Anybody here remember The Tunnel? The Tunnel *sucked*. You couldn't have a good time at The Tunnel if they filled the champagne glasses with hundred dollar bills, but I helped fill that place, every single night they were open. Hell, I *did* fill that place, practically by myself. Everything I got in this business, I earned, customer by customer. One by one. I built this place on that. Flyer by fucking flyer I earned the roof you guys are standing under.

"And as much as you guys think I'm upstairs not giving a shit about anything that goes on here, I haven't forgotten that for a minute. I haven't forgotten what got me into this business, and I haven't forgotten what it's like to be in your shoes, bringing in business and making a club work. You guys are incredible at that. We're filled here every night. You may not like all the people coming in our doors, but you can't argue with the fact that we're packing out every single night.

"I'm sure everyone's noticed that things have changed quite a bit over the past year. This isn't the same place I opened up almost two years ago, but that's the way it works in Manhattan. You can promote and promote and promote until you're blue in the face, but you can't stay on top forever. It's impossible. That shouldn't matter to you guys, though. There are people here, and they're spending money, and they deserve our best no matter *who* they are. We're all making money, right? Is anyone *not* getting paid?

"This place may not seem like a team to you, but it is. We're all making money together. If one part of the team starts fucking up, we're all screwed, every single one of us. I want to make it clear to everyone—here, tonight—that we have to stay on top of everything from now on. You all know we've had some problems

recently, and that we're pretty much up shit's creek with the city and the police department. I want to change that. I want to run the tightest club in Chelsea.

"I want the mayor to say, 'I want to clean up all the clubs on the West Side, but we can leave Axis alone because those guys run a clean operation.' That's what I want, and the only way I'm ever gonna be able to do that is if everyone here makes a concerted effort to help me. It shouldn't be that hard, guys. That's what we're paying you for. You don't like it? Go down the street. See how they treat you down the block, because it sure as hell won't be anything like this.

"You can't disrespect your job, guys. I know most of you are part-time, but you can't come to work with a lack of respect for what you're doing here, because I can't have it. You're part-time, but for a lot of us here, this is our living. This is our career. Some of you may not think much of what we do, but this is what puts food on my table. When you disrespect *your* job, you're disrespecting *my* job. You're shitting on my career and my life. Whether you like me or not, you have to admit that that's not fair.

"Put yourselves in *my* position. Would you hire people who came to work and took a shit on everything you've built? On something you've staked your entire life on? I'm not saying anyone's doing that, but that's how it feels sometimes. I can feel that vibe starting up with people here, and I want to stop it now before it gets out of hand. This is a job. I know it sucks sometimes, but I need people here who'll come to work, respect what they do, and do their best to make sure we stay in business and everyone can keep putting money in the bank."

"THE GUY'S GOT a point."

"Fuck him," Ray said. "Just fuck him. That's the same fucking speech he's made every time one of his places went in the shitter. Read between the lines. You know what he's really saying? He's saying that he set things up all nice and perfect, and shit went bad

and Juan got stabbed because we're coming to work and disrespecting him. Get the fuck out of here with that shit."

"I'm burned out already, though," I said after a while. "I come in here and mail this shit in most nights, and I haven't even been here that long."

"So? What'd you expect? Look at this fucking place. You really think you were gonna come in here every night with a smile on your face and be all happy about standing around with this human fucking garbage for eight hours?"

"No, I knew what I was getting into. I'm just saying he has a point about getting what he's paying for. If the guy's gonna come across with a paycheck every week, part of earning it is knowing what you're in for and dealing with it without getting all lazy and stupid like some of these guys inside do."

You start off bouncing and you think, "Hey, I've got something here," but that spark disappears before you've ever really settled in. You burn out. You get wiped. You tire of the drunks, the drugs, the nonsense and the selfishness of it all, and there's nothing left to do after a while but to simply hate it. Clubs are nothing but giant miasmic stinkpots that bind your feet, hold you to a fire, and burn out any enthusiasm you came into the job with. It happens, and there's nothing anyone can do about it, but if they're still paying you, you have to do your job, which is what I was trying to get across to Ray.

"Don't get me wrong, man," I said. "I'm not saying I actually *like* working here anymore. I don't. I don't know if I ever really did. I don't even want to come to work anymore, but if I'm gonna be here, I'm gonna earn my money. I don't give a shit who Christian's blaming for all the problems last week. None of it's *my* fault, I can tell you that. I got my head down and I'm making money, and that's all I give a flying fuck about these days."

"That's how you gotta be . . ."

"You think I was actually *listening* to him? Fuck that, man. The only thing I was listening for in there were tips on how to keep my

job. That's it, because none of the rest of this shit matters. All that team bullshit? Respecting his career and all that shit? Dude, the only thing this job is about is *me* surviving. That's all."

I WALKED TO a deli on Tenth Avenue and bought a cup of coffee. Nightmare Square has always looked so goddamned *pedestrian* to me in the hours before the clubs open. Before the police barricades go up and before the crowds arrive, it's nothing more than West Side warehouse space. If you've ever driven through the area, you wouldn't have a clue what we're selling inside. You wouldn't have known why I was even there. If you'd driven past that night, what you'd have seen was exactly what I was—a guy in a sweatshirt and jeans, sitting on a barricade in front of a rolled-down garage door, waiting for his girlfriend in the Manhattan night air. Nothing more, nothing less.

"Hey."

"Hey."

She kissed me softly on the lips. "I have something to tell you."

"What?"

"I quit. I just gave Christian my two weeks'."

I stepped back. "Are you serious? Why tonight?"

"Why not tonight? Why not last week? Why not last year? What does it even matter? I was gonna do it eventually, so why not do it when everyone's here and they're all in the mood to listen?"

"I just figured you would have told me first is all. Fuck, I talked to you before the meeting started and you didn't say anything."

"I decided while he was making his speech," she said. "I thought about it, and he's right. The people they need working here now are people who buy into all this shit, and I don't want to do that. All the stuff going on here is too much for me."

"Okay, fine. I understand that. If you think it's the right time to quit, then quit."

"I do think it's the right time. It's the right time to leave a lot of things behind me."

We rounded the corner onto Eleventh Avenue and headed north, toward the garage where I'd left my car. "What's that supposed to mean?"

"You know you're a great guy, right?"

"Well, no, I don't. Not really."

"No," she said. "You are. You may not know it yet, but you really are. You try to put up all these smokescreens and you keep everyone away, but you're a good person underneath all the bullshit."

"What's your point?"

"My point is that you talk too much, and I've been taking notes. This whole time, I've been taking notes. My point is that I have to protect myself here."

I stopped walking. "I talk too much?"

"Every story you ever tell me about the club is the same. There's always a girl involved, and she's either shitting herself, or hitting you in the face with a glass, or waving a bloody tampon in your face. You know how that makes me feel?"

"That has nothing . . ."

"Let me finish," she said, cutting me off. "And the way you talk about your ex-girlfriend. The things you say. It makes me wonder how you talk about me to your friends."

"Oh, and you're just filled with sugar and spice when you're pissing and moaning about all the guidos you're pouring drinks for every night, and how you feel like you're being sex-trafficked all the time. I'm not allowed to complain without you reading something into it?"

"I'm not . . ."

"Let me refresh your memory a little. *You're* the one who came up with the tailpipe concept. *You.* You're the one who said, and I quote, that you wanted to 'hook up a hose to my tailpipe and gas these fucking people out,' and now you have issues about the way I talk about women?"

"I'm not talking about the customers. I'm talking about me,

and what I want out of a relationship. Whatever it is, I'm not getting it from you."

We walked through the garage and I handed my ticket to the parking attendant. "What is it that you're not getting?"

"I'm not getting *you*. Nobody's getting you. The people you work with only get some tough-guy version of you that you've made up for yourself. Your family gets the asshole you. I don't even know what you *I'm* getting, but whichever one it is, it's what you think you have to show me to keep me around. What are you like when nobody's around, Rob? What are you like then? That's what I want to see, but you're never going to let me see that."

"You think I'm being a phony right now? I'm fucking coming out of a work meeting for chrissakes. The last thing I'm thinking about right now is putting out some kind of image for you."

"Take this," she said, handing me a twenty to pay the attendant.

I already had my wallet out. "Put it away. I got it."

"Has anyone you know ever died?"

"You already know the answer to that. You know about my father."

She looked out the garage entrance to the sidewalk. I sensed she was debating going home on her own. "Then why do you take everything for granted? Every time you talk about doing something better with your life, it's all in some kind of pie-in-the-sky future scenario that you think is gonna happen, but every day you just do the same damned things, over and over and over, and none of it has anything to do with making your life better."

"What the fuck does that have to do with people dying?"

"It means that nothing's guaranteed. You come to my apartment, and you fuck me, and you leave, and no matter what I do, you won't stay. It's like, once it's over, it's over, and you go on and do whatever you want to do, like it's set in stone that the next time you call me, everything's gonna be okay and you can come over and fuck me again. I'm not a guarantee. I'm nobody's

guarantee. There *is* no future for you if you don't get off your ass and do something about it."

"Are you finished?" I asked, taking my keys from the attendant.

"Rob, I need more. I need more and I don't think I'm ever gonna get it from you."

"Seriously, are you done?"

She made no move to go around to the passenger side. "You're *mad*?"

"Let me know if you're done, 'cause if you are, I gotta go home."

"Jesus, yes," she said. She was crying. "I'm done."

20

PULLEY SYSTEM

I probably should have cared more. I should have been devastated that a girl as *smoking hot* as Amanda hadn't seen fit to keep me on. I should have been stopped in my tracks by her tears, and I should have chased her down the sidewalk and stuffed her in my car, by force if necessary. She was easily the most attractive and most intelligent girlfriend I'd ever had—and the only one I actually *wanted* anywhere near me after sex—but something refused to click when she stood there in that parking garage and stared at me with tears streaming down her face.

SCENE: Up front, on the sidewalk. Angry. Infuriated. Enraged. I was angry at my life; pissed that Amanda had been examining everything so closely the whole time and pissed that after all of it, I'd once again been found wanting.

ME: Can you put me inside tonight?
MIGS: Are you serious?

ME: Yeah, I'm serious. I want to be inside tonight.

MIGS: I can't do that. You know I can't do that because I have nobody who can work out here. If you want me to pick somebody out, you can train them tonight and I can put you inside permanently. Is *that* what you want?

ME: What would you do if I called in sick?

MIGS: You didn't call in sick.

ME: But what if I did?

MIGS: You haven't called in sick since I hired you, so that's not something I usually think about. What the fuck is this about? You trying to keep an eye on your girl?

ME: She doesn't even work here anymore. She quit. And she's not my fucking girlfriend anymore, anyway.

MIGS: She dump you?

ME: Of course. What the fuck did you think was gonna happen?

MIGS: When was this?

ME: Last night.

MIGS: So in other words, this girl dumped you last night, so you want me to put you inside the club so you can be a loose fucking cannon and wait for a fight to start so you can run in and tee off on somebody, right? You want me to put you inside so you can take your frustrations out on one of these motherfuckers?

ME: If you don't mind.

MIGS: Ordinarily, I'd be happy to help, but who the fuck am I gonna put up front? You have to stay up here, 'cause I don't have anybody else, and I can't get stuck up here doing this when *you're* already here. I'll make you a deal, though.

ME: I'm listening.

MIGS: After two, if there's a call inside, which you *know* there will be, you can go ahead and run in.

ME: Yeah?

MIGS: Yeah. Just don't do something stupid and get yourself fired. That's all I ask. You want to fuck with somebody? I'm

not gonna be the one to stop you, but just make sure you don't dick me over. And until two o'clock, keep your mind on what you're doing up here. The cops are still out, and they're gonna be watching every move we make.

———

"DID YOU EVER work with Jimmy?" asked Ray. "The guy who used to stand over by the side of the stage?"

"No. I never really talked to him. I still haven't figured out how he got fired."

"*That* was fucked up. You wanna talk about a guy going off the fucking deep end? That was one of the saddest things I've ever seen happen."

"Why?"

"Because Jimmy was a good guy," Ray said. "He was a good guy, and he started having problems with his marriage, got separated, and got all messed up by this fucking cunt of a stripper he was banging from that titty bar he's working at now."

If you're not afraid of the work and you show up on time every night, there are very few ways to get yourself fired from a bouncing job. It simply doesn't happen. The true essence of bouncing is that there is no essence. It's assumed when you're hired that you're the sort of person who can deal with all the bullshit without turning tail and running—that at some point in your life you've become desensitized to all the bad parts of the job and you've figured out how to handle things. If confrontations are nothing more than a night's work for you, and you can do a few things with your hands, you can be a bouncer. And once you're *in*, it'll take a hell of a lot to land yourself *out*.

"I never really heard what happened that night."

"He went after Migs is what happened," Ray said. "And the fucked-up part of it all was that when Jimmy walked out on his wife, Migs got him *both* of his jobs. He gave him his job here, *and*

set him up with some off-the-books driving job during the day so he wouldn't get killed with child support."

You show up for work and the head bouncer says, "Stand here." So you stand there. Then he says, "Watch the crowd." So you watch the crowd until you see two giant juicehead guidos start throwing punches. When this happens, you run over as fast as you can, put one of them in a bear hug, and haul his greasy ass out the door. You shove him in the back so he doesn't turn and swing, slam the door on him, and tell the doormen you've thrown somebody out, and then you go back to where you were standing and repeat the process. This will happen again and again until it's time to leave, at which point you'll pick up an envelope filled with cash and go home. This is *wheat*. The remainder is *chaff*.

"I know it had something to do with his girlfriend," I said, "but I never really asked because I didn't know the guy all that well."

"She's the reason we can't have our wives or girlfriends coming in the club."

Don't shit where you sleep, I say. It was bad enough that I'd been dating a girl who worked at the club, but at least she was relatively safe—most times, at least—from the groping and the drugging and the raping while she was doing her thing behind the bar. Having her there as a customer? Having someone you care about exposed to the *general population* for several hours while you're trying to care about what's happening in the rest of the room? It's not something you'd want to have happen voluntarily.

"There were a couple of months in a row where she was down here every night," Ray continued. "Every fucking night she was here, and there was always a problem."

"What? With her?"

"With both of them. He'd go off and hang out with her when he was supposed to be at his spot, and the place was so crowded, so who the fuck's gonna notice? You'd go next door to take a leak, and he'd be sitting in a chair, sleeping, with her on top of

him. And then, when she was walking around in the main room, he'd actually follow her around with drink tickets."

"Why didn't Migs say anything?" I asked.

"He did. He talked to the guy about it all the time, but he kept letting shit slide because he knew Jimmy was going through a rough time with his divorce. We all figured he'd just get through it and go back to being normal again, whatever the fuck normal is for anyone who works here."

Girlfriends and wives *do* come down, and that's the problem. Unless you're capable of ruling your world with an iron fist, there's usually not much you can do about it. They hear so much talk from you about the club and about the guys you work with that they simply have to see it for themselves. They need to see that part of your life. They need to see if the stereotypes about pussy-getting bouncers carry any weight in your case, and they *all* want to make sure you're doing the right thing.

You won't have any problems with the "nice girl" when she comes down. The nice girl will tacitly acknowledge that you have a job to do, and she'll let you do it without turning you into a babysitter. The nice girl will only visit once, because she knows better. The "not-so-nice girl," by contrast, will still insist on aggressively demanding your attention, despite the fact that you're on somebody's payroll with responsibilities having nothing to do with her. She'll think your job isn't really a job, because it takes place in a nightclub. She'll pretend not to understand when you tell her otherwise.

"So why'd Jimmy go after him?"

"Because this fucking stupid bitch used to get in fights every time she came down here. That's why. She was out of her fucking mind. I mean, she was hot and all, and it's definitely a score for a thirty-eight-year-old guy to be banging a twenty-two-year-old stripper, but there's a reason women become strippers, you know? They're *all* fucked up. They'll give you this whole rap about being single moms, or just doing it to get through school, but they're *all* fucked in the head."

I never begrudged any bouncer a visit from his girl. I wasn't the one who'd made the rule. If he felt like showing someone around, or walking her to the bathroom, I'd happily cover for him, because chances were he'd earned that much with me. When the women involved are psychotic, however, it's a different story altogether. When they're starting trouble and creating problems for everyone on the staff, there has to be a line drawn. When it happens every single night, bouncers eventually stop blaming the girl and start resenting the coworker that's been abusing the "privilege" of bringing her in.

"She got in a fight with some girl, and she was slapping her around pretty good. Pulled out a big chunk of this girl's hair and shit. The girl's boyfriend grabbed her and punched her in the face, and she tried to hit him with a glass. This was right around where Jimmy was standing, so he saw the guy hit her and he flipped the fuck out. Bouncers were throwing the guy and girl out one door, and they were throwing his girlfriend out another door, and three or four guys were hanging onto Jimmy to make sure he didn't try and kill the guy."

"Did he calm down once our guys got a hold of him?" I asked.

"Well, yeah, but they brought him out to where she got thrown out, and he blew a fucking gasket when he saw she got hit. She had a big scratch going across her face. He saw that and he wanted to go after the guy that hit her."

"I don't blame him," I said, "but it's a little ridiculous that his girl's the one getting him involved in this shit while he's at work."

"That ain't the half of it. He tried to run back around front, and the bouncers, thinking they were helping him out and trying to save the guy's job, wouldn't let him go. Migs came back there and told everyone to hang on to Jimmy until he calmed the fuck down."

"Did he?"

"Yeah, he did, but when they let go of him he took a run at Migs."

"What'd Migs do?" I asked.

"He had five guys out there with him. Jimmy wasn't gonna get

within ten feet of him. He fired the guy on the spot and told him to get off the fucking block or he was gonna have him arrested."

"Damn."

"You know what the worst of it all is?" Ray asked.

"There's more?"

"Migs understood what the problem was. He ain't an asshole. Somebody hit the guy's girlfriend and he wanted to get back at him. No problem. The worst part of the whole thing is that after all this fucking guy's been through, and after everything Migs did for him, he didn't call Migs the next day to apologize. If he did that, he'd still be working here. He'd probably have this door by now and you'd be working inside. That's how bad this guy lost his mind over some stupid bitch of a fucking stripper."

What happens sometimes with women is that you're fooled by the packaging. It's like buying some shiny little red car without realizing the oil hasn't been changed in a year and the heads are about to crack. Jimmy's girlfriend had been rotting from the inside out, and everyone knew it but him. Amanda wasn't like that. Our relationship hadn't been anything close to that. Had she been a "normal" girl who didn't work with me at the club, you never would have seen her set foot in a place like Axis.

Still, being in a relationship—and ending one, for that matter—presents the bouncer with a choice. This choice is more difficult for us than it is, say, for an accountant, because our friends and the people we're in relationships with often don't look at bouncing as a "real job"—as if the money we're taking home at the end of the night is somehow less green than what we'd be making by sitting in a cubicle or swinging a hammer for a living. It's not really "work," so they think you couldn't possibly choose *it* over *them*.

The way I saw things, home was home and work was work, and there wasn't going to be any crossover between the two for me. I needed the job. I needed that envelope so I could eat, drive, and keep a roof over my head. Jimmy needed his stripper more than he needed these things. I simply wanted to live.

AGED

ou might get your wish tonight," said Migs, who'd just tossed the guest-list clipboard, frisbee-style, onto the podium top in frustration.

"Why?"

"Fucking Vince has a couple of guys from Blaze's crew down in the VIP."

"How'd they get in?" I asked. "And how the fuck does Blaze still have a crew? Shouldn't they all still be in jail?"

"He doesn't. Or maybe he does. I don't fucking know. Vince swears up and down that these guys had nothing to do with it, but if you're enough of an asshole to go to clubs with Blaze, I don't think you should be allowed in anywhere, period. Christian says otherwise, though, so there's nothing I can really do about it right now."

"Did anyone check them for weapons?"

"Vince had Kevin do it," he replied. "Or so he says. Christian's pinning the whole stabbing on Juan anyways, because he was selling shit for Don the bartender."

"So he thinks it was some kind of drug hit? Bullshit. I'm not buying that. That fight was going on for a good five minutes

before Juan ended up getting stabbed. And anyway, if Christian knows Don's selling shit, why's he still working here? Real clean fucking operation he's running here, right?"

"Just be ready to run inside. Anything happens, I want both of you with me. I already told people to get up here and watch the door in case we gotta run in. I don't really give a fuck anymore, to be honest."

NIGHTCLUBS SOMETIMES HAVE what you might call "bad nights"—nights where we know about existing problems ahead of time. I've never understood the concept of the "bad night"—at least not the part where clubs know about trouble in advance. If the management of a club looks at the guest list and sees a group that's been a problem in the past, you'd think the group in question would be flagged. You'd think they'd be denied entry. You'd think the head of security, having offered a rational argument as to *why* it's a bad idea to let them in, would have the last word on the subject.

That wasn't the way things worked with Vince and Christian. Even if you were associates of a crew that had stabbed a bouncer and essentially cleared out an entire side of the club because of your failure to control your own behavior, you'd still be allowed in the following week, provided you handed Vince a credit card and promised to behave.

Migs believed that proper club security entailed hacking problems off at their roots before they were given the chance to develop. Christian wanted revenue. When your nightclub goes guido, these two goals are incompatible. Dealing with the consequences of exactly who was providing Christian's revenue was the responsibility of Migs and the bouncing staff, and nobody was prepared to listen to the lone voice in the wilderness when he pointed out the absurdity of inviting guido trouble into one's home.

"Where's Johnny?" I asked Ray. "I didn't see him when I came in."

"Oh, fuck. You didn't hear?"

"Hear what?"

"He quit," Ray replied.

"What? Why? He didn't call me or anything."

"He told Migs there's too much shit going on and he can't risk anyone coming in and making him. I don't blame the guy. There's cops everywhere around here now, and the guy's got a pension to protect. For the money he's making here? Fuck that. I wouldn't risk it either."

"When are *you* leaving?" I asked.

"Me? Probably never. Why?"

"Because it seems like everyone I liked on this job is dropping like flies."

AFTER NEARLY TWO years of bouncing, I hadn't learned a damned thing about what happens in clubs, because nothing happens in clubs. Nothing at all. A few thousand people stand around and get fucked up. Sometimes they go to the bathrooms to relieve themselves. Afterward, they return to where they were standing, and they proceed to stand there for several more hours. Occasionally, they dance. Men look stupid when they dance. Women don't, so men follow them around and try to solicit them for sex.

"What happened with the girl?"

"I didn't like her feet," I said.

"Bullshit. She had good feet."

"You looked?"

"I don't say anything about girls' feet if they're with my friends," Ray said. "You wouldn't want me making comments about your girl's tits or her ass, right? It works the same way with feet. But since you ain't with her anymore, I can tell you she had nice feet."

When the men follow the women looking for sex, the mating ritual ensues. When you see this ritual for the first time, it'll

occur to you that nightclub customers might be several steps beneath you on the evolutionary scale. The women shake their tail feathers. The men strut and preen. Sometimes, they fight over the women. This is what animals do in the wild.

When the customers fight, bouncers throw them out. Outside, they carry on and say stupid things. Sometimes they say things that are so stupid that we feel sorry for them. They're all experts in the use of the double negative. None of them did nothing. All of them did something. I throw them out and then I listen to them for a while. Listening to them makes me tired. It makes me want to go home and go to sleep.

"I hate nights like this," I said.

"Why?"

"Because I don't need this shit."

"I thought you wanted to tag somebody tonight," Ray said. "I heard you telling Migs you wanted to take a shot at somebody."

"Yeah, but I don't want a *reason* to take a shot at somebody. I just wanna stand here and do my job and then get the fuck home without anyone getting in the middle of it."

"I hear that."

When I first started working in West Chelsea, before I'd discovered the simple pleasure of escaping to my car at the end of a shift, I'd take the subway into Manhattan. I eventually started using the Long Island Rail Road, because it was easier. You take the Long Island Rail Road out of Penn Station, which is a very unpleasant place. At four thirty in the morning, every drunk from every bar and club in Manhattan is waiting in Penn Station to take the train home to Long Island. They shout, they fight, and they throw up. The things they do are *socially unacceptable*. These people made me very tired, so I decided to drive to work instead of subjecting myself to these problems. It makes things difficult when people make too much noise in public places at four thirty in the morning. These people are called cocksuckers.

"So what's she gonna do?"

"I don't give a shit," I said. "To be honest with you, I kind of got sick of her trying to give me advice all the fucking time."

"What kind of advice?"

"Every conversation we ever had eventually came down to her telling me to quit this job, that working in clubs was a dead end, and that I'd end up with problems if I didn't start planning ahead and thinking about what I'm gonna do with my life."

"Fuck that," Ray said. "Who needs a fucking plan, anyway?"

I've found, through the years, that people are generally nice. They're even nicer when they're around their mothers. When people go to nightclubs, they're not quite as nice as they are around their mothers, most times. I was always very polite to my mother, except when she was yelling at me for being such a disappointment to the family. If the whole world would simply act the same way in public as they do around their mothers, society would be a lot better off. Most people don't take their mothers to nightclubs, but some do. This may sound like a nice thing to do, but people who do this aren't what you'd call normal. I've never taken my mother to a nightclub.

Most customers think bouncers are stupid. Most bouncers think the customers are stupid. I'm sorry to break the news to you, but we're the ones who are right. We win the argument here. We're being paid to be at the club. You're paying us so that you can come to our place of business and dress and act like fools. You're also doing various things that will damage your health. Eventually you'll meet and have sex with someone who'll give you an incurable venereal disease or a wart or a sore. When you really think about it, this isn't a very productive thing to spend your money on, but you won't think about it, because nightclub customers aren't very good at thinking.

"Everyone behaving down there?"

"Fuck everyone," Migs replied. "Anything starts happening, the first thing I'm doing is calling the fucking cops. I don't care anymore."

"That's some attitude to have."

"Fuck you too, then."

"What time is it?" I asked.

"One thirty. Don't worry. It's coming."

Sometimes the customers make us so angry that we have to strangle them, but this is perfectly acceptable, because it's what the club is paying us to do. They say, "You remember that time when Kevin choked that guy? That was awesome. He's a very good bouncer." Being a very good bouncer is kind of an unimportant thing to be unless that's what you're paid to be, in which case you may as well try to do the best you can. This sometimes involves making the customers uncomfortable, which is fine by me, because I don't like the customers.

Nobody should take this personally, because bouncers don't like very many people in general. If we liked people a bit more—if we were a little more sociable, perhaps—maybe none of us would have had to become bouncers in the first place. Maybe we'd come off better in job interviews. If I'd had more charm and maybe what you'd call a "winning personality," people would have been more tolerant of all the mistakes I made when I was younger.

When people who make lots of mistakes get older, though, the margin for error decreases and you have to stop making mistakes altogether. I tried very hard not to make any mistakes at Axis. This was a defense mechanism. When you make mistakes, you attract attention to yourself. This is what customers do when they come to the club. When they do this—when they attract attention—it's a grave mistake, because they make themselves look stupid. I only looked stupid at Axis once—when I couldn't keep my mouth shut and caused a problem for Migs.

When you don't make any mistakes, the people you work for think you're a very good bouncer. I was a very good bouncer at Axis. I was a terrific bouncer at Axis, which meant that I was very good at doing nothing most of the time. It meant that I was good at standing in one place and killing time and talking to people and

laughing at them. I didn't laugh at people because I liked them. I laughed at them because I hated them, but this was fine in the grand scheme of things, because I was a bouncer. I was *nobody*.

I was nobody, because bouncing is silly. What I learned in two years was that bouncing is a very silly job that contributes little to society. Bouncers have silly goals. Some of us—*all* of us—want to get laid. I didn't want to have sex with anyone I'd met at the club except for one time. This was a wise course of action, given what Axis had turned into. If I had worked someplace better, I'd probably want to have sex with the women who went there, but I didn't want that at Axis, because the people there were dirty and I didn't want a wart or a sore.

Sometimes you stand in front of the club, thinking about getting laid and avoiding warts and sores, and the time you were waiting for finally comes.

"VIP! VIP! VIP! VIP! All security to the VIP!"

22

MALEVOLENCE

It had to be humiliating for him. It simply had to be. To have a grown man lay me down in the street—as if I were a petulant child who'd spilled too much of my precious Grey Goose—is something I'd never want for myself. You're born, you're raised, you go to school and have people help you try and make something of yourself, and you end up with your head gently placed in the street because you've become a danger. The world—the bouncers in a nightclub being *the world*, for some—had decided they could no longer tolerate this man. Me. I decided this on behalf of the world.

How must it have felt? I'd put him down. I choked him to the point of unconsciousness because I couldn't imagine any other way of dealing with him. When animals escape from the zoo, or elephants try to bring down the tent at the circus, they're tranquilized. They're shot with a dart that makes them sleep. It's necessary for them to sleep. The safety of innocent people is at stake when this happens—people who'd done nothing to deserve being mauled by a rampaging guido at three in the morning.

"Rob . . ."

He'd been running through the alleyway, coming at me as I ran

for the VIP entrance. Others were following—both bouncers and customers—but *he* was the threat. I was turning to run back to the front when he charged. We spilled out onto the sidewalk to the left of the front door.

"Rob, stop . . ."

He settled peacefully, once his oxygen supply had been closed. Or maybe I'd cut off the blood that was supposed to be flowing into his brain. I felt him go limp; felt his body relax. I kept squeezing because he wouldn't let it go. I had held on to him and told him it was over, but he wanted to fight and this was where we'd landed. He wouldn't quit. He turned on me. I kept squeezing because he'd turned on me.

There we were, fighting on the sidewalk, one man choking another. He wasn't a fighter and didn't know how to reverse the move—didn't know how to regain his leverage and contain the damage I was inflicting. A fighter could do that, but that wasn't him. He didn't know how to fight. He'd never learned. All some people know about fighting is how to become enraged and flail madly when they don't get their way. They don't fight. They attack. They assault. This one's idea of fighting was to hurl his body at me and pummel me in the head until I was done—the style of the undisciplined, drug-addled, drunken guido.

"Rob, he's out . . ."

Authoritative, strong hands had held him, stopped him, and told him "no more," but that wasn't enough. A bouncer had been stabbed the week before, but it wasn't enough. I'd lost my girlfriend the night before, but he kept on with it. He kept going—kept chasing whatever it was he'd been after that night—so I did the same.

What I needed to know, even while it was happening, was how it felt. How did it feel to be a grown man who'd had his head placed lovingly in the street by another grown man? What was it like the next day, to think about what you'd become? He was so angry—so fierce and intimidating and mean—and yet he was set

down to sleep in the street by a man who wasn't his father. Why do we do these things?

"Let go of him and step back . . ."

Migs told us things in meetings. He said we'd all had "futures," and that we wouldn't want to jeopardize those "futures" by doing anything stupid. He told me this exact thing on the sidewalk that night, but this man's anger *offended* me. It offended me because it wasn't real. It offended me because there was so much going on in the world—hundreds of thousands of people our age were at war; many, presumably, from our own neighborhoods—and because nightclub problems are *nothing*. You don't hurt someone because of things that happen in nightclubs.

Two buildings had been destroyed down the block. People this stupid guido had gone to school with were rummaging through caves, at that very moment, looking for the man who was responsible, and here this guido was, running wild through an alleyway adjacent to a nightclub, because of a slight in the VIP room. A lifetime's worth of *my* frustrations, and *he* was angry. I stopped him because this was nothing to be proud of. I squeezed him because it was too much. I squeezed him until his arms and legs stopped moving. I squeezed because I couldn't think to do anything else.

"Rob, he's done!" shouted Migs. "The cops are here. Get the fuck off him!"

There was a crowd around us as I laid his head on the sidewalk. Women were crying. Guidos were cursing. Migs grabbed me by the shirt and pulled me to the other side of the door as the police tended to the man I'd been choking.

"Take your jacket and your radio off and get the fuck out of here."

"What?"

"Just take your shit off and go," he said. "The guy's fine. He's already moving. Just take your shit, get to your car as quick as you can, and get the fuck out of here. I'll call you in a half hour."

"Am I fired or something?"

"No, just fucking go. You gotta get out of here before the supervisors get here and that guy wants to press charges. I'll cover for you, but you gotta get the fuck away from here."

FUCK IT. JUST *fuck it.*

If they hadn't pulled me off him, I would have killed the man. I know that now. I would have tightened my grip around his throat until his heart stopped—and after that, I would have squeezed him even tighter. I would have done this because I was tired of my life, and tired of where it had taken me. I was sick of the eyebrows and the striped shirts and the hair gel. I was exhausted by the broken English and the DWI convictions and all the piss-poor excuses for two years' worth of inexcusable behavior.

Some people can tolerate these things. They can get a job bouncing and sit through the misery of standing amid the seas of nightclub humanity, year after year after year, and it won't do a damned thing to them because they're armor-plated. I wasn't. When people behaved poorly, it made me mad. It infuriated me. I wanted to do something. I wanted to change things. I wanted to take the customers aside and let them know there was another way to act; that there was another way to do everything—a way that didn't involve inflicting themselves, and all their miserable, chemically enhanced psychoses, on me and the rest of the planet.

I hadn't come out from under a rock to get a job bouncing at Axis. Most of the bouncers I'd worked with hadn't, either. Some had, but most hadn't. Some dealt drugs, stole money, abused people, and relished the violence, but the vast majority of the men I'd worked with were decent, law-abiding, temperate human beings who simply wanted to exist, just like me. They had careers to advance, families to protect, and mortgages to pay, and the atmosphere surrounding the West Chelsea club district was just as foreign to them as it was to me.

This camaraderie is what keeps you going as a bouncer. If you're on the right staff—teamed with the right group of guys—you'll

make friends you'll want to keep for a lifetime. After a while, bouncing becomes more than simply a job you do, because you start looking forward to going to the club and being with your friends. You want to protect them. When fights are called, and you all have to run to the scene of some guido bullshit and do what you're being paid to do, you want to get where you're going as fast as you can, because you know you're a part of something, as stupid and as useless as that something may seem from the outside.

What you learn after a while, though, is that you're gearing yourself up, night after night, for a losing battle. You're on *their* turf, and they've got you hopelessly outnumbered, so you do the best you can to simply hang on and make your money. You punch in, keep your head down, collect what you can, and then you punch out and go home. The smart bouncer does no more than this. He doesn't let his relationships cross over, and he doesn't get caught up in all the little squabbles that inevitably crop up in a business where most of the people you'll come across are among the most narcissistic sons of bitches on the planet.

Bouncers have each other, though. For two years, I'd had Migs and Ray and Johnny and an entire boatload of grown men who'd readily drop what they were doing and run across a crowded room if they'd sensed I was in any kind of trouble. That's something you can't buy. It's something you *earn*. You earn it by doing the same for them. You earn it—even if you haven't the faintest idea what the fuck you're doing—by showing up every night, running to calls, and having the backs of the guys you'll want at yours when things go to hell.

Migs had my back. He'd had my back when he took a chance and hired me after I'd been out of the game for several years, and he'd had my back when he sent me home and covered for me with the police. That's how good bouncing works. It works by winning small victories, because you'll never win the major ones. It works by keeping your friends out of trouble, because the bouncer will never be in the right, no matter how "right" you are when you're

trying to protect yourself and everything you've worked for from being taken away by some coked-up, drunken mutant who'd like nothing more than to ruin your life the same way it had probably been done to him.

Taking, after all, is what the nightclub business is all about. It takes and takes and takes, and gives nothing back. The entire thing is a setup. It's a scam. It's a great big mound of shit, all painted up in pastels and fluorescents and hosed down with enough cologne and perfume to disguise the stink. When you work there, and you linger long enough, the paint begins to run and the stench begins to rise and you see the thing for exactly what it is: a money pit designed to separate you and everyone else inside from your wallets and your common sense.

The customers buy in. First the celebrities, then the tourists, and finally the local trash, scraped up from the farthest reaches of New York's outer boroughs. They buy into the nightclub illusion hook, line, and sinker. They swallow it whole and accept it as real at the same time those of us who work there start waking up to the fact that it's a farce. They swallow it, and it tastes as sweet as candy going down, but it doesn't take long for the heartburn to set in. Everything they've swallowed wants to come right back up, and when they understand what's been done to them—the ruse they've fallen for—the customers get angry.

They get angry and they take it all out on each other. They get angry and they come after us. They hurt themselves. They kick open our doors and run as far away from West Chelsea as they can, back to the row houses and numbered city blocks they came from, only to forget by Wednesday what angered them the weekend before. That's what Grey Goose does. That's what Cristal does. That's what coke and meth and ecstasy and Special K do. They make you forget. They kill the parts of your mind that should know better, so you'll come back the following Saturday and part with your paycheck again.

What may have been an entirely insignificant event to most—

people are choked unconscious in clubs across America every night of the week, and nobody could give a *flying fuck*—was something much more than that to me. Because it was, I wanted no part of it any longer. And because it was, it was time to go and it was time I made a phone call.

I'VE WALKED THROUGH the West Chelsea area a few times since I quit, never looking for anyone, or anything, in particular. My life happens away from Manhattan now, so I don't find myself on the West Side anymore unless I've gone specifically to say hello to the people I used to work with. I go to the door and stand around with Migs and Ray and watch the line start to form, but I leave before things get too crowded. I don't ever want to stay, because I know what's bound to happen and I don't want to be anywhere close to it anymore.

You think things are bound to change when a nightclub goes bad. You wonder when the owner will come to his senses and start over with a new name and a new clientele. You wonder when the city and the police department will decide they've had enough and shut your place down—and take away your livelihood—but then you realize that it's never going to happen. You realize how much money there is to be made in the club business, even when the only people you're serving are those you wouldn't want within a thousand miles of you when you're not on the clock. You realize all these things six months later, when the club you've left is still open, and people are still lining up to go in, and none of the time you'd spent there meant a damned thing to anyone but you.

"What are you doing with yourself now?" Migs asked one night toward the end of the summer. He'd laughed seeing me come walking up the block from Tenth Avenue, thinking I'd come to ask for my job back. Bouncers come and go in this business. Mostly, they go.

"I've just been working all summer, trying to save up some money."

"Working where?"

"Jim Hughes didn't tell you?" I asked.

"You're shittin' me. You're back there again?"

"Yeah, just on Friday and Saturday nights. I'm a little over-qualified, but he gave me the door. I even get to sit down all night. I go get a stool, lean against the wall, and I read the paper. I haven't thrown anyone out all summer, believe it or not. I went back to driving during the day, too, but all that might be changing in a couple of weeks."

"Why?"

"I got some other shit going on right now. I'm coaching high school football a couple of days a week, and I'm thinking about going back to school and getting into teaching, like I always wanted to," I replied. "I figure it's about time I finish something I started for once in my life."

"Good for you. I always knew you weren't cut out for this business. You always were too much of a pussy." He picked up his coffee and took a sip. I watched the familiar pattern on the cup as he put it down, and looked at the people who'd begun to line up for entry. For a split second, I was a doorman again, but the feeling passed. "You still living in Queens?"

"Yeah, but I'm in Whitestone now. I'm renting a room from someone and saving the overhead until I figure out my next move." My cell phone vibrated in my pocket. I took it out and read the text message. "Listen, I gotta take off. It was good seeing you guys."

"Don't be a fucking stranger, man. You ever need to come back and work, you got my number."

———

SCENE: *Amanda is already waiting on the corner of West 4th Street and Sixth Avenue when I pull to the curb. I like her better in the summer, because she*

wears much less. She throws her bag on the floor of my car and kisses me on the cheek. Calling her on my way home that night was the wisest thing I'd done in years. It had taken some work, but she was in my car, which was all I could ask from my padded cell in purgatory.

AMANDA: You're a little late.

ME: How long you been standing out here?

AMANDA: About twenty minutes.

ME: How was class?

AMANDA: Boring, as usual. You'll find out eventually if you get off your ass and go register like I told you to. I could have taken the train home if you didn't want to come pick me up, by the way.

ME: I'm here, aren't I?

AMANDA: What took you so long? I thought you were leaving the house at nine.

ME: I stopped to say hello to Migs and Ray. We got to talking a little, and I didn't realize what time it was.

AMANDA: How was it?

ME: I can't believe that fucking place sometimes. Ten o'clock, and there was already a line starting up out front.

———

We drove through the Midtown Tunnel in silence. There'd been some sort of scare, and the city's security checkpoints were back in operation at all the bridge and tunnel entrances. The police were searching the back of every truck leaving the city. I wondered if they were checking for guidos across the river on the Queens side.

AMANDA: You always liked those two, didn't you?

ME: Who? Ray and Migs?

AMANDA: Yeah, those two.

ME: Yeah, I do like them. I like them a lot. Migs is a good guy. He told me if I ever needed a job again, all I had to do was give him a call.

AMANDA: Was that what you were talking about while you made me stand on the corner like some kind of prostitute waiting for you to show up?

ME: I guess. That and some other stuff. Just catching up.

AMANDA: Can't you just be friends with them outside of work? I've never understood that. If you all like each other so much, why don't you just start hanging out without having to see each other at the club?

ME: I don't think so. I think with most of the people I've ever worked with, it's more of a work friendship than anything else. I can't really imagine what Migs is like away from the front door of Axis.

AMANDA: So you like the people you worked with, and you get along like friends, and you talk and talk and talk and make me sit here waiting for you, but you'll probably never see these guys again unless you go back to the club, right?

ME: Probably not.

AMANDA: And you're probably not going back to the club anytime soon, so it's gonna be a while before you see them again, right?

ME: Right.

AMANDA: It must have been hard to leave tonight, then.

ME: Not at all. It wasn't hard at all.

———

ACKNOWLEDGMENTS

Bouncing, at its core, is a team sport. You spend hour upon hour, night after night, among people with whom you have virtually everything in common—and when it's time to "throw," either you can depend on them or you can't. Fortunately for me, I've worked for the past three years on staffs where I decidedly *can*. I'll never claim to be the greatest bouncer in the world—too many people to mention would dispute the fact if I did—but I'm not the worst, either, and if the men with whom I've stood on boxes for the past three years have developed even half the respect for me that I have for them, then I'm truly fortunate, indeed. This book is dedicated to them.

Next, I'm eternally in the debt of my incredible editor, Mauro DiPreta, for his patience and his willingness to place a blind bet on a horse who'd never even run a race, much less finished one. The same can be said of my agent, Eileen Cope, who plied me with beer and appetizers and convinced a major publishing house to do business with a complete jerk-off. Miracle workers, both.

Finally, in no particular order, people whose unconditional concern for my welfare—I have yet to figure out any rational explanation for this—made the writing of this book possible: Kent Martin,

Neils Martin (for allowing me to sleep on your couch a thousand times despite pissing in your closet and stabbing you), Andrew MacDonald, Brendan Reiser, Ryan Whitton, Jennifer Schulkind, Howard Miller, Heather Ann Snodgrass, Dan Tobin, Josh Behar, The Waiter, Dave Tate, Joe DeFranco, and Jim Wendler.

<div align="right">—Rob Fitzgerald</div>